EXPOSURE
PHOTO WORKSHOP

EXPOSURE
PHOTO WORKSHOP

Jeff Wignall

Wiley Publishing, Inc.

Exposure Photo Workshop

Published by
Wiley Publishing, Inc.
10475 Crosspoint Blvd.
Indianapolis, IN 46256
www.wiley.com

Published simultaneously in Canada

ISBN 978-0-470-11435-3

Manufactured in the United States of America

10 9 8 7 6 5 4 3 2 1

For general information on our other products and services or to obtain technical support, please contact our Customer Care Department within the U.S. at (800) 762-2974, outside the U.S. at (317) 572-3993 or fax (317) 572-4002.

Wiley also publishes its books in a variety of electronic formats. Some content that appears in print may not be available in electronic books.

Library of Congress CIP Data: 2007943803

About the Author

Jeff Wignall is a well-known photographer, writer and teacher and has been writing about photography for more than 30 years. He is the author of numerous bestselling photo books, including: *The Joy of Digital Photography*, *The Kodak Most Basic Book of Digital Photography*, *Kodak Guide to Shooting Great Travel Pictures*, and the million-copy bestseller *The Joy of Photography (3rd ed)*. He is the former *Camera* columnist for the *New York Times* and the former technical editor for *Photo District News*.

Jeff is also a frequent contributor to a number of photo magazines, including *American Photo, Outdoor Photographer, PC PHOTO Digitali Digitalis Foto* (Budapest, Hungary) and the *BottomLine Newsletters*. He is also a regular contributor to the *Black Star Rising* blog that is published by the legendary Black Star photojournalism agency. In addition, he has taught popular online courses based on his book *The Joy of Digital Photography* for both BetterPhoto.com and Bryan Peterson's Picture Perfect School of Photography.

He is also a radio producer and host and has been doing a regular radio show on WPKN, a non-commercial FM station in Bridgeport, Connecticut, for more than 15 years.

Jeff lives in Stratford, Connecticut. Visit his Web site at www.jeffwignall.com.

Credits

Senior Acquisitions Editor
Kim Spilker

Senior Project Editor
Cricket Krengel

Development Editor
Lynn Northrup

Technical Editor
J. Dennis Thomas

Editorial Manager
Robyn Siesky

Vice President & Group Executive Publisher
Richard Swadley

Vice President & Publisher
Barry Pruett

Business Manager
Amy Knies

Project Coordinator
Patrick Redmond

Graphics and Production Specialists
Carrie A. Cesavice
Andrea Hornberger
Jennifer Mayberry
Ronald Terry

Quality Control Technician
Caitie Kelly

Proofreading and Indexing
Sherry Massey
Shannon Ramsey

Cover Design
Daniella Richardson
Larry Vigon

Book Designers
LeAndra Hosier
Tina Hovanessian

for Lynne

and, of course: Sailor, TC, and Smokey

Acknowledgments

It's interesting that after completing a project as solitary as writing a book that there are so many people to thank, but there are lots.

First and foremost I would like to thank my friend (and former student) Mark Allin, Managing Director of Wiley, Asia, for introducing me to the nice folks at Wiley. Thanks also to Kim Spilker, Senior Acquisitions Editor, for offering the book to me and to Cricket Krengel and everyone at Wiley who helped in producing it.

Thanks to all of my former students: I've learned far more from you than you have from me (trite, but very true). In particular, I would like to thank Tom Callahan, Jennica Reiss and Gavin Zau for contributing photos to this book. Nothing could make me happier than to see photos by my students illustrating one of my books. Their photos are first-class professional images in every sense of the word.

Thanks also to fellow photographer and author Derek Doeffinger for the use of his photos and for replying to my endless technical questions. My appreciation, as well, to my good friend Brian Oglesbee for continually reminding me that great photos are always the result of much hard work and imagination. His book *Aquatique* (Insight Editions, 2007) is among the most powerful monographs ever published—ask your library to order it.

I am also very grateful to Alice, Brook, Julia and Sarah and their families for letting me use photos of them. Thanks as well to both the Perrigo and Cutter families — it's nice to have such attractive friends to photograph. Thanks to Professor Louie & the Crowmatix and Miss Marie for letting me use performance photos of them and for many years of wonderful music. Many thanks as well to Lynne and Sarah for helping to produce the sparkler photos (and for not getting burned fingers while we went through dozens of sparklers).

Contents

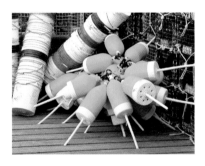

CHAPTER 3 Measuring the Light **51**

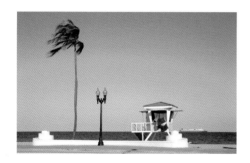

CHAPTER **4** Lens Apertures and Depth of Field **81**

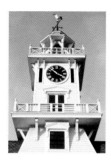

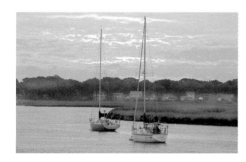

CHAPTER 9 Photography After Dark and in Existing Light 211

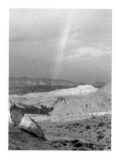

Introduction

During the writing of this book, an interesting thing happened that created an analogy in my mind for learning to make good exposures: my girlfriend Lynne rescued three completely feral kittens, tamed them and turned them into fun and loving pets. You might think the process of creating a meaningful exposure and domesticating feral cats are practically and philosophically unrelated, but they're not.

Extracting a good exposure from the wild and untamed world around you is very similar to catching and befriending a wild-born kitten. At first you are confronted with a subject that looks beautiful and interesting, but you just don't have a clue as to how to capture it and make it behave in some predictable manner. You only know that what you want (from the subject or the cat) is a creative and meaningful relationship. Until you gain some experience and knowledge, though, a lot of what you're doing is guesswork.

So you study everything you can find, you observe your subjects carefully and then you begin to make decisions that will lead you to your goal. And you do a heck of a lot of experimenting along the way. Will a sunset have more emotional impact if I intentionally underexpose it slightly? Can a feral kitty be litter trained? (Incidentally, yes to both.) You probably won't get as many scratches on your arms and legs wrestling with photography as you will with kittens, but then again, you just might.

Sometimes in learning these new tricks you succeed, lots of times you fail. And just as a kitten will teach you how to best handle its moods and disposition, so too will your experiments with exposure teach you how to best capture the world around you with your digital camera.

Learning anything new in art is always a fun and evolutionary process—you're gaining experience in how to take something you envision in your imagination and turning it into reality. And eventually knowledge and experience will catch up with desire and intuition.

In the case of a feral kitten, what you want is a pet that will sit on your lap, eat cat cookies out of your hand and be eternally grateful that *you* were the one that rescued it. In the case of getting good exposures, it's about capturing your singular vision of the world and making images that share that vision. Both are wonderfully interesting and exciting adventures.

In writing this book, as I watched three untamed kittens turn into affectionate and incredibly intelligent pets at the hands of an immensely patient practitioner (Lynne), I kept seeing the analogy between domesticating feral cats and capturing good exposures over and over again. It occurred to me that three things: patience, experimentation, and keeping your eye on the prize were the perfect guidelines for either endeavor.

I think that if you keep those three concepts in your mind and apply the technical information that I've included in this book, you will understand perfectly how to make exposures that reveal not just what you saw when you looked at a subject, but what you felt.

In the end, whether the result is a happy pet or a beautiful photograph, it will be something that you created and, from that, you should take infinite pleasure.

Jeff Wignall

Stratford, Connecticut

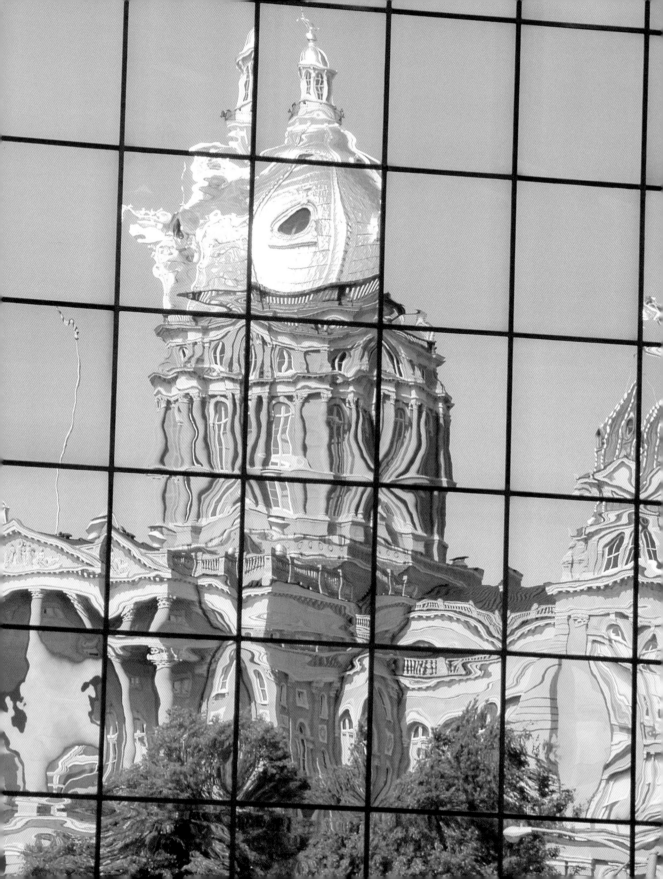

THE ART OF THE EXPOSURE

Good exposure in a photograph is one of those creative experiences where the result is often far greater than the total of the steps used to get there. If you've ever seen a potter at work, throwing globs of wet clay onto a spinning potter's wheel and shaping their object with an assortment of sticks, bits of wire, and dabs with a wet cloth, you've seen this idea in action. As the piece progresses, out of these mundane ingredients and almost childlike methods, gradually a soft, graceful shape emerges and transforms mere clay into an inspired work. The potter has a vision and is able to extract that vision from the materials at hand.

So too great photographic exposures arise from the most basic of tools and techniques. Yes, a good exposure is the product of routine technical choices such as metering correctly, choosing the right lens aperture and shutter speed, and setting the optimum white balance. But when these ordinary steps are combined in a purposeful way by a skilled craftsperson, exposure rises above the level of simple "correctness" and something fascinating happens: Exposure itself becomes a creative element in the photograph. Thoughtfully considered and well-executed exposure choices can transform an ordinary subject into a very extraordinary photograph.

Mastering creative exposure is about developing your ability to see your subject in terms of a finished image and to extract *your* vision from the world around you (see 1-1). And the key to doing that, of course, is to first understand exactly what exposure is — and what it takes to turn a good exposure into an inspired one.

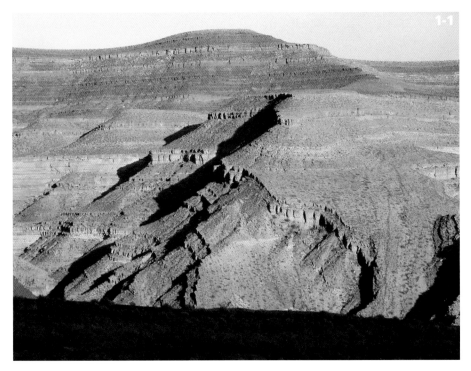

1-1

ABOUT THIS PHOTO
Colorful cliffs baked in late sun in southern Utah. Understanding exposure helps capture scenes the way that you see them. Taken with an advanced zoom compact digital camera and exposed for 1/100 sec. at f/7.4, ISO 100, on a tripod.

WHAT IS EXPOSURE AND WHY DOES IT MATTER

Although most photographs are made in exposures that last just fractions of a second, that brief instant is not so much a spontaneous event as it is the culmination of a long (hopefully not too long or you'll miss the shot) thought process on the part of the photographer — *you*. The process begins when you spot a potential subject, continues as you decide how to approach the subject (where to stand, what lens to use, whether the lighting is interesting enough), and ends the instant you press the shutter release button.

A lot of important questions — both technical and aesthetic — have to be (or at least, should be) addressed before you give your trigger finger permission to commit to your idea. And one of the most important issues that you have to contend with is setting the exposure. In fact, in terms of the success or failure of a particular image, probably no question you'll confront is as important as this one: How should I expose this scene?

You can choose the most brilliant subject, find the most startling and creative angle, and have lucked into a splendid lighting situation, but if you expose it poorly, you've tripped just before reaching the finish line. Ouch.

If photography is a new hobby for you, one of the first questions you may be asking is, "Exactly what is exposure and why is it so important?" Okay, granted, that's two questions, but they're both essentially asking the same thing. There are both simple and complex answers to this question, but I'll begin with the simple ones (don't worry, the more complex ones are far friendlier than you might think).

Despite the fact that this entire book is devoted to exposure and that the very mention of the topic seems to instigate a lot of passionate debate among photographers, the truth is that exposure — at least in its most basic concept — is pretty simple to define. A good or "correct" (and I have a *lot* more to say about that word in the coming pages) exposure is one that captures the overall *tonal range* (the range of dark through light tones) that your subject had in person. That's it. What you're trying to do in essence is to capture an image that shows the dark tones, the light tones, and all the tones in between pretty much as they looked to you in person (see 1-2). Or, at least, the way that you *thought* they looked.

x-ref Another question you may be asking yourself is, "Isn't getting good exposure the reason I bought an expensive camera in the first place?" I address that in Chapter 2, but buying a nice camera was a good decision.

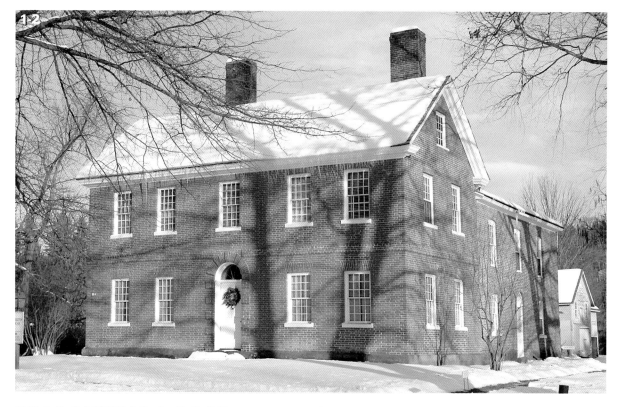

RECOGNIZING A GOOD EXPOSURE

When you create a good exposure, it means that you've provided your camera's sensor with just the right amount of light (or exposure) to record your subject's tones correctly. And like the old adage of not knowing what great art is but "knowing it when you see it," good exposures tend to resonate with quality — even if we're not sure what's creating that feeling. If you give the sensor too little light, you *underexpose* the scene and your subject appears darker than you remember it (or wanted it); subjects that would otherwise be bright appear gray and dingy instead of clean and white. If you give the sensor too much light, you *overexpose* the scene, and all of the tones in the pictures seem washed out and lacking detail in the brightest or highlight regions. In the comparison shots of a giant saguaro cactus shown in 1-3, 1-4, and 1-5, for example, you can see how changes in exposure change the tonal range of the subject.

Your exposure goal then is simple: you want to capture an image that is neither too dark nor too bright, but just right.

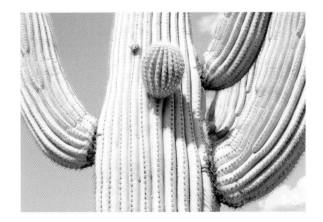

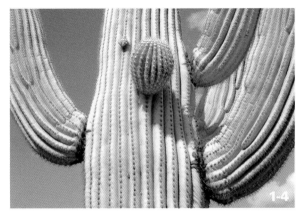

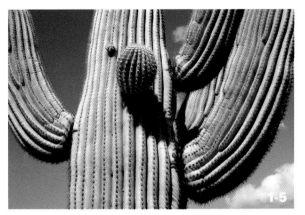

How difficult it is to get that perfect balance of tones depends largely on your subject. When a scene is filled with relatively average tonalities and the lighting is gentle and even, getting a good exposure is a fairly simple process. Your camera's automatic exposure system does a very good job of correctly recording the scene's tonal range. I found the colorful gathering of lobster trap floats shown in 1-6 while wandering a wharf in Maine and shot at the metered exposure. I trusted the metering system to do a good job with this simple scene because all of the tones were relatively even and there was nothing overly dark or light. It was literally a point-and-shoot photograph. Similarly, while the water garden scene in 1-7 has a mix of tones, none of them dominates the others and so a good, average exposure handles the scene quite well.

The more complex your subject is in terms of tonalities, however — with a lot of competing bright and dark tones, a severe imbalance of tones, or even a lack of tonal variations — the more challenging the job becomes. That's exactly where your personal knowledge and experience come into play. You need to know how your camera's light meter will react to all of that pretty snow — and what steps you need to take to help it record the snow correctly.

ABOUT THESE PHOTOS *This series of photos shows how exposure affects the tonalities of a scene. In 1-3, the sensor received too much exposure and therefore the tones and colors seem washed out and pale. In 1-4, the exposure was correct and so the tonalities appear much as they did to me in person. And in 1-5, the shot received too little light and so the image seems muddy and far too dark. All three taken with a 70-300mm Nikkor zoom lens and exposed for 1/100 second at f/8, 1/250 second at f/8, and 1/1000 second at f/8, respectively. All ISO 200 on a tripod.*

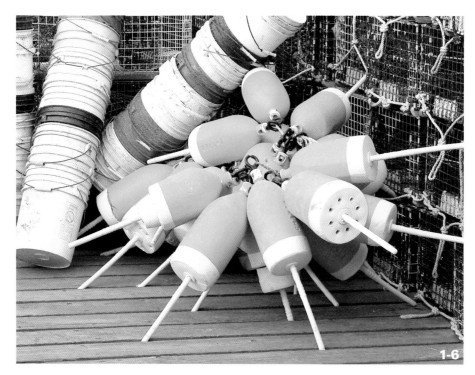

1-6

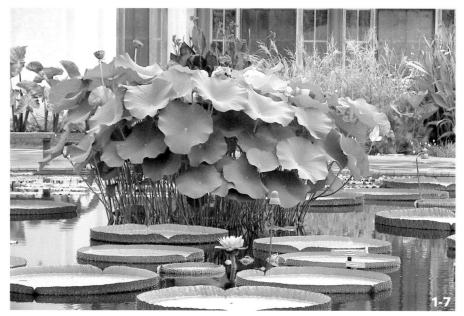

1-7

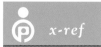

x-ref Photographing snow is tricky because it has a tendency to come out gray rather than white if you don't make the right metering and exposure adjustments. There are some simple tricks to photographing pure-white subjects, like snow, and I discuss these and other problem-exposure subjects in Chapter 8.

Contrast is one of the more vexing exposure problems you'll face and often it takes some practice and experience to learn to handle it well. For example, in the shot of red rocks in Sedona, Arizona, shown in 1-8, I was confronted by a very dark foreground contrasting with an extremely bright background. I had to make a decision about how to handle the scene because I knew from experience in similar situations that the meter would be fooled by the contrast. Conversely, photographing an oyster boat in fog on the Housatonic River near my home in Connecticut provided a scene almost totally devoid of contrast (see 1-9).

x-ref Metering is an important aspect of exposure, of course, and I devote all of Chapter 3 to the subject.

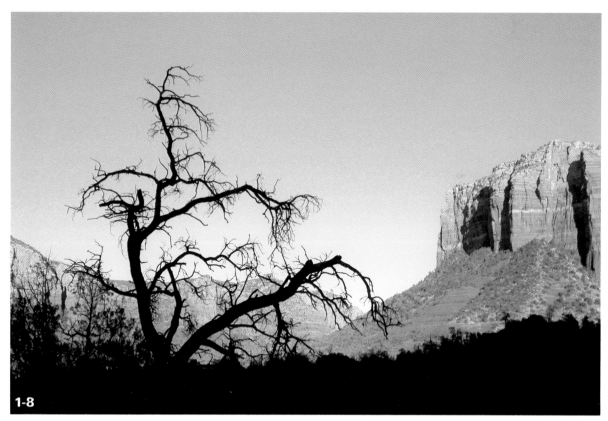

1-8

ABOUT THIS PHOTO *Contrast is a common problem in outdoor scenes. In this shot, I elected to set the exposure for the rock formation and let the foreground shadows go black while preserving detail in the brighter areas. Shot with a 20mm Nikkor lens at 1/370 sec., f/4.5 at ISO 100, on a tripod.*

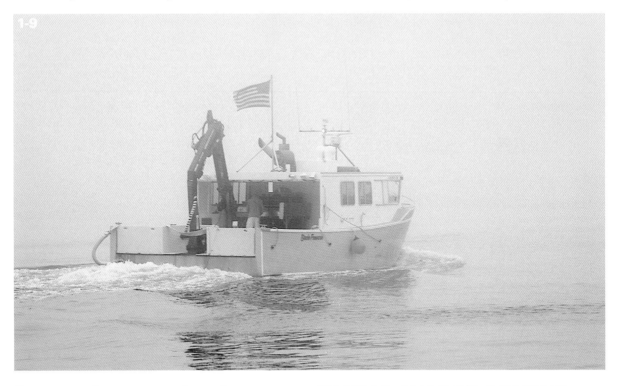

1-9

Getting a good exposure in tricky conditions may seem like an overwhelming challenge when you're first getting used to your camera, but it will become second nature very quickly. I've seen students who didn't know a blown out highlight from a lens cap at the start of one of my adult-education classes, mastering the basics of exposure in a matter of a few weeks. I'm always surprised, in fact, at how quickly their technique improves. It will happen for you, too. Things such as excessive contrast (1-10) and shadowy faces are traps that you'll recognize before you take a shot, and you'll have the technical tools in your arsenal to deal with them. The better your exposures are, the more powerful and successful all of your other creative decisions become.

TAKING CHARGE OF YOUR EXPOSURES

In the days before digital cameras and image-editing software (when dinosaurs still roamed the earth, as one of my friends put it), you either lived with the exposure mistakes you made, or you paid a lab to fix them for you. In my case, my father (also a photographer) built me a darkroom in our basement and I spent most of my high school years living the life of a troglodyte. I learned how to fix almost every exposure mistake imaginable until I had a moment of clarity (it took a while to experience that clarity, trust me), and I decided that it was far simpler to learn to make good exposures in the first place than to spend all of my waking hours (and most of my allowance) making good prints from bad exposures.

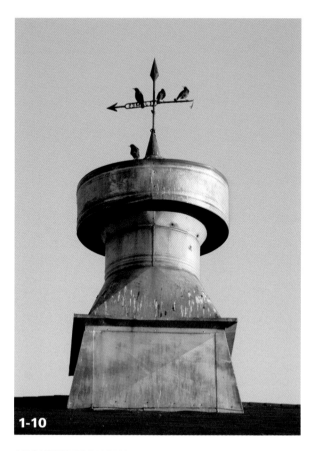

1-10

ABOUT THIS PHOTO *Once you're aware of it, you'll quickly learn to spot contrasty scenes like this old weather vane photographed in Maine. Exposure was 1/640 second at f/6.3 with a 200mm Nikkor lens; ISO 200, on a tripod.*

Even though digital-imaging software is fun to use and is capable of making all of the fixes that I made in the darkroom (and a thousand times more), it's far better for you to take charge of your exposures before they're even made. Fortunately, digital cameras include numerous features that help you do just that, as well as to view and correct mistakes immediately after exposure. Here are some tips on how to use your digital camera to take control of the exposure process:

■ **Study your camera's light-metering features.** The light meter that is built into your digital camera is remarkably accurate most of the time, even in difficult or complicated situations. In the shot of Maine's Nubble Light (1-11), for example, I relied on my advanced zoom camera's meter and it provided a great exposure in a tough situation. Using a light meter effectively, however, requires a good bit of knowledge about how it works and when it needs some guidance from you. In Chapter 3, I take an in-depth look at how your light meter works and the theory behind light measurement. For now, take time to study your manual and review your camera's metering choices so that as you read the chapter, you can relate it to your camera.

■ **Review your exposures on your LCD panel.** Professional photographers used to use Polaroid films to test exposures and only committed the shot to film once they were satisfied that the exposure was perfect. It was a slow and expensive way to test a shot, but much less expensive in terms of time and money than wasting actual film. With digital, the LCD panel on your camera provides you with the same ability to preview your exposures immediately. The LCD isn't foolproof because sometimes that small image has a lot more contrast and pop than the image file actually has, but it does provide you with a fairly decent advance look at your photos. Once you're experienced enough to know how to correct any flaws you see in the preview, you can re-shoot and correct exposure mistakes on the spot.

ABOUT THIS PHOTO *The relatively high contrast between the dark foreground and bright lighthouse didn't fool the meter of my zoom camera. Exposed for 1/90 second at f/5.9, ISO 100 with a 116mm Nikkor zoom lens, on a tripod.*

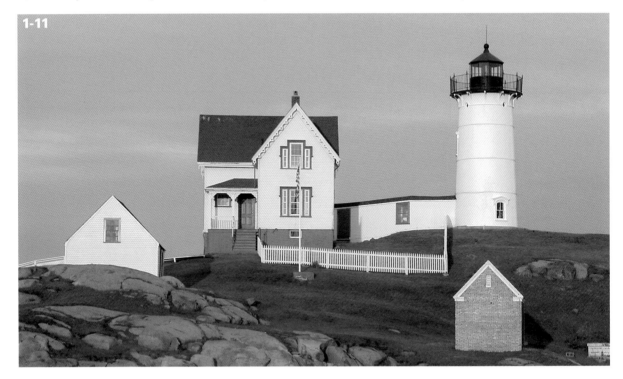

1-11

■ **Learn to interpret your histogram.** Most advanced digital cameras offer a histogram feature that displays a graphic representation of the tonal range of your exposures, which is an extremely useful tool once you learn how to interpret the information. Learning to read a histogram isn't difficult, but it is foreign to most non-photographers. The sooner you become familiar with what it looks like and what its content means, the less abstract it will seem to you. At the very least, for now, learn where the control is to turn your histogram feature on and off.

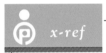

x-ref

I discuss the advantages — and the limitations — of the histogram feature in Chapter 8.

■ **Get to know an image-editing program.** If you're not already using an image-editing program, it's probably a good thing to learn concurrently with learning to use your digital camera. With some basic skills in editing, you can quickly remedy those (rare) exposure mistakes that you make with the camera, or simply enhance the good qualities of your exposures (converting images to black and white, for example — see figure 1-12). There's no point in hiding the fact that image-editing software is pretty much a photographic wizard when it comes not only to tweaking photographic exposure, but to unveiling a whole new universe of creative possibilities, as well. I'm an absolute Photoshop addict, and when I'm not shooting pictures, you can almost always find me

staring at my monitor working on files, to enhance them either technically or creatively. As I said earlier, however, I think it's far more important to spend your time learning to make good exposures in the camera than to learn how to fix bad ones in editing. Just as I learned the value of making better in-camera exposures by processing my own film and prints, your editing program can quickly teach you how to adjust your shooting methods to create better image files.

■ **Understand that technically correct isn't always the best exposure for the shot you're trying to take.** Even if every exposure you ever made was technically correct (again, meaning if the tonalities were recorded accurately), what are the chances that your camera would make the best aesthetic exposure choices? In figure 1-13, for example, I intentionally based my exposure on the brighter areas (the doorway) and let the interior of the barn I was standing in go black to create a more dramatic look.

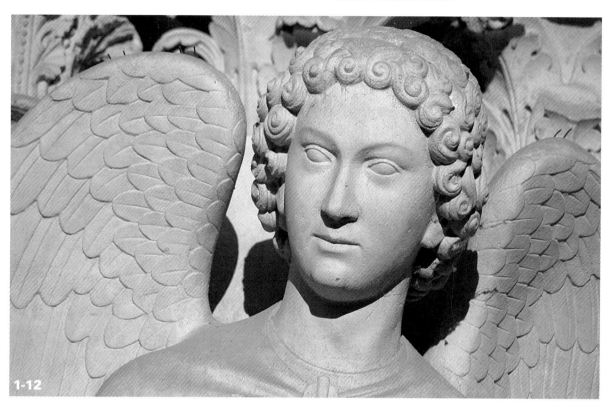

1-12

ABOUT THIS PHOTO *I converted this shot of a relief carving on the façade of Notre Dame in Paris to black and white using Photoshop — one of thousands of interesting effects available. Taken with a 70-300mm Nikkor zoom lens and exposed for 1/1000 at f/5.3, ISO 200, handheld.*

As you learn in the coming chapters, there is a vast gulf between creating a technically correct exposure and an inspired one. When it comes to capturing action subjects, for example, you can choose between using a faster shutter speed to freeze the motion, and using a slow shutter speed to transform it into an interpretive flow of color and light, depending on the feeling you are trying to create. Your camera could never make that distinction (at least not without help from you) because it has no idea what your intentions are or what you're photographing. That is why your camera will always need you to guide it in your quest for creative exposure perfection.

■ **Wean yourself off of the automatic scene modes.** There are numerous exposure modes, called *scene modes* on most cameras, which act as shortcuts for getting good exposures with subjects such as landscapes, sports, and night photos. While these modes can be useful when you're first learning to shoot a variety of challenging subjects, you still have to learn what the camera is doing behind the scenes when you're in those modes. There are better methods for controlling the exposure in virtually any of these situations, and the sooner you learn to use them, the more in control you are. Turning your picture-taking decisions over to automation is kind of like getting into woodworking and then buying a computer-driven lathe to turn the wood for you. Where is the artistic challenge and the fun of exploration? As precise as that lathe might be, it's going to give you the exact same predictable results every time you use it. (And what are you going to do with all of those identical candlesticks?)

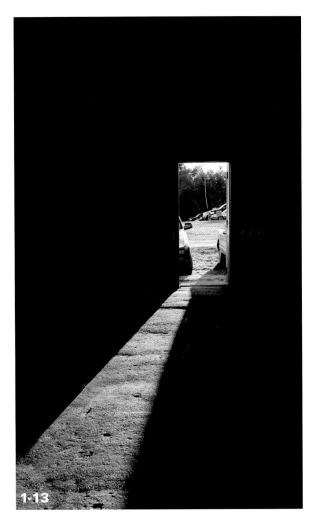

ABOUT THIS PHOTO *By intentionally metering and exposing for only the bright areas here, I was able to intensify the drama of this simple barn interior. Taken with a 12-24mm Nikkor zoom and exposed for 1/80 second at f/4.5, ISO 200, handheld.*

■ **Be patient — experience eventually pays off.** Digital cameras can't accumulate experience the way that your brain does (yet). With each photograph that you take, you are gaining experience that *will* translate into better and

more ambitious images. You are developing both technical and visual skills and learning how to finesse ordinary situations into great pictures. The charming portrait in 1-14 was taken by Jennica Reis, a former student of mine who went from hobbyist to running her own part-time portrait business while she was still taking classes. I could see in our class that she was applying the concepts she was learning and using her daughters as practice subjects almost daily.

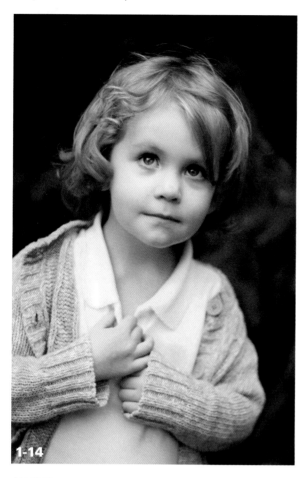

1-14

ABOUT THIS PHOTO *Learning to make gentle portraits like this is all about applying some basic exposure concepts to a subject that really touches you. Taken with a 50mm Canon lens and exposed for 1/250 second at f/1.8, ISO 200. ©Jennica Reis.*

x-ref Subject-specific exposure modes are found on many cameras and they can provide a shortcut to good exposures, provided you match the right mode to the right subject. In Chapter 6, I discuss some of the most common modes, when it's safe to use them, and when you're better off making your own decisions about exposure.

It's up to you to take charge of your exposures and all of your digital camera's controls so that you can use your camera as what it is meant to be: a tool. Think about all of the wonderful photographs that were made a hundred or more years ago and that have survived to inspire us today. Those pioneering photographers didn't even have film (let alone Wi-Fi enabled phones that transmit images across the room at the speed of light), and yet their photos created a new visual medium that forever changed the world. And now you are the pioneer of a new medium. Be humble (or at least pretend to be).

THE MYTH OF THE CORRECT EXPOSURE

Although throughout this book I may use the terms "good" or "bad" to describe the success or failure of a particular exposure, one of the myths that I hope to dispel early on is that there is only one correct exposure for any given scene or subject. Not to use a terrible photographic pun, but there is nothing black and white about good exposure — at least not when it comes to serious creative picture taking. As my high school art teacher used to tell me years ago (every time I would become frustrated with a new assignment), there are no mistakes in art, only personal choices and new opportunities. She was being kind, I know, but I got the point anyway.

VISUALIZING THE EXPOSURE YOU WANT

You're probably starting to become aware that the gist of what I'm saying so far is that exposure is a very subjective aspect of photography. Like choosing a subject or composing a scene, no two people see exposure the same way. The exposure that you think is correct for a particular subject and the exposure that someone else thinks is correct could be (not always, but often) entirely different — and yet each of you might be very

happy with your results. The key to getting the exposure that satisfies you the most is imagining what you want the picture to look like before you even begin to meter the subject (see 1-15 and 1-16). In the shot of New Hampshire's famed stone profile of the Old Man of the Mountain (see 1-17), I turned his classic profile into a silhouette by exposing for the sky. Sad to say, the Old Man crumbled to the valley floor during a hard winter — after 12,000 years of looking down on New Hampshire.

ABOUT THESE PHOTOS *Sunsets offer a great example of how a slight shift in exposure can radically alter the final results. In 1-15, I wanted to see how this Florida scene would look with more saturated colors, and so I underexposed from a meter reading of the sky (I metered the sky just to the left of the sun) by two stops. Shot using a 105mm Nikkor lens at 1/60 sec., f/18 at ISO 200, on a tripod. Figure 1-16 was shot only seconds later, and I shot at the actual metered exposure of 1/15 sec., at f/18.*

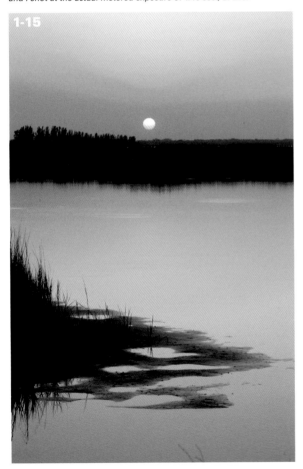

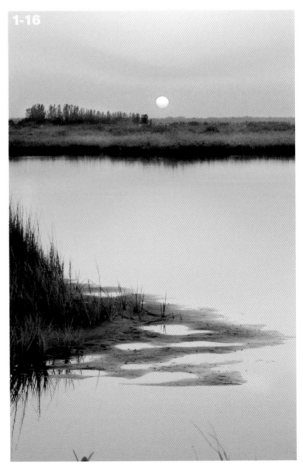

ABOUT THIS PHOTO
How you expose a scene is entirely up to you. I decided that it was the power of the profile that I was after. So, I exposed for the sky to create this silhouette. Shot using a 300mm Nikkor lens at 1/125 sec., f/16 at ISO 100, on a tripod.

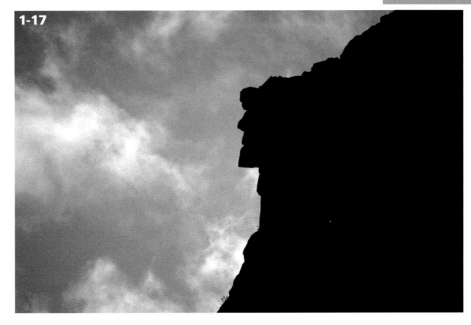

1-17

The great master photographer Ansel Adams, who probably did more to advance both the art and science of exposure than any other photographer, used the term *visualization* to describe the process of consciously trying to imagine the final picture *before* you make the exposure. In his landmark book, *The Negative*, Adams writes, "Visualization is a conscious process of projecting the final photographic image in the mind before taking the first steps in actually photographing the subject."

The goal of visualizing is, of course, to know where it is you're trying to get to creatively so that you can get on the right technical bus to get you there. If you've ever sat in a room that you were thinking about repainting and just stared at the blank walls and tried to imagine what the finished room was going to look like in a different color, you've already done some visualizing (or previsualizing, as a lot of photographers refer to it). In fact, every time you look through your closet in the morning and decide that your green shirt goes just perfectly with your purple shoes, you're previsualizing what your appearance will be once you're dressed (those do go together, don't they?).

HUMAN VISION VERSUS CAMERA VISION

For some people, the concept of visualization comes naturally, but for most of us, it takes quite a bit of conscious practice. I don't think it's an inherent skill for anyone, though, so don't be frustrated if your photos don't automatically mirror the images in your head. Even Adams thought it was an acquired skill that photographers — including himself — had to learn.

The more photographs that you shoot and the more often you fail (and succeed), the better you become at knowing your subjects and getting that great shot. Of course, not getting the picture only

works as a learning tool if you take the time to analyze exactly where you went wrong. For that reason, it's very important that you take the time to study the exposures that you think failed and try to figure out what went wrong. I've always found that to be a terribly painful process, especially if you've traveled thousands of miles to take the pictures, but it helps me improve my photography.

One of the inherent problems that all photographers face (and even the masters of the medium grapple with this issue) is that the scene that you see in your imagination and the image that the camera sees are two radically different things — for quite a number of reasons. For one, when you are standing in front of a pretty landscape, *all* of your senses are taking in the scene. As you walk through a rural landscape (see 1-18), you are awash in a symphony of sensory overload: You're hearing the wind rustle through the corn fields, you're smelling the fresh-mown hay in the nearby fields, you're hearing the bellowing cows as they wait to be fed, and you're feeling the warm morning sun on your skin (wow, sounds like a great place!). All of these things profoundly affect the beauty and intensity of the scene for you.

By comparison, your camera isn't having nearly as much fun. Tragically, the sounds, the scents, and the warm sun are completely lost on that expensive bit of technology. Also, while your eyes and brain are capable of admiring and absorbing a vast and subtle range of highlights, shadows, and colors, your camera is somewhat handicapped. No digital sensor can record all of the tones or gradations of color that you can see, because the contrast range that your eyes and brain see and the contrast range that the camera records are extremely different.

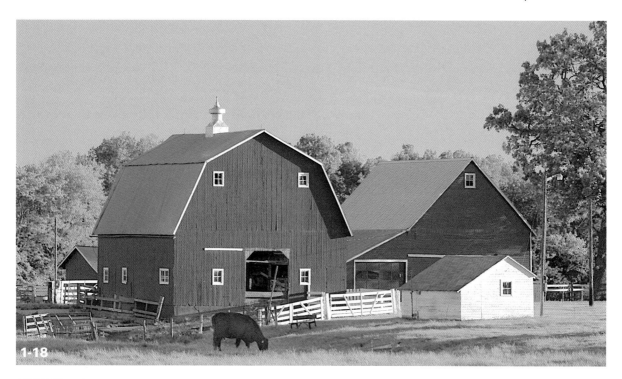

ABOUT THIS PHOTO *I like to drive the back roads looking for farm scenes to photograph, like this one in Iowa. However, you have to divorce yourself from the sensory overload and concentrate on the subject, the light, and the exposure. Taken with an 18-70mm Nikkor lens; shot at 1/250 sec., f/9 at ISO 200, on a tripod.*

Therein lies the rub and that is exactly where the power of visualization comes into play. Because your camera can't record every tone and color that your eyes see, you have to make a conscious effort to decide how you want those tones and colors recorded, and you have to know the limits of your camera's capabilities. You also have to accept the cold, cruel realization that in many scenes, particularly in high-contrast scenes, decisions have to be made and often certain aspects of a scene have to be sacrificed. The goal, of course, is not to throw the baby out with the bathwater. I photographed the treasure hunter (1-19) on a beach with very bright sun reflecting

p x-ref Contrast is one of the most vexing problems that all photographers face, but there are a lot of simple solutions. In Chapter 8, I show you several simple methods for dealing with excessive contrast.

off of the sea behind him. Had I tried to expose to get detail in his face or clothes, the sea behind him would have looked completely bleached out. Instead I chose to expose for that brightness and turn the man into a silhouette.

Here are a couple of tips that I found useful when honing my visualization skills

- **Keep a small notebook with you and take notes.** Each time you take a photograph; jot down a few notes about what it was you were trying to capture and why you exposed it the way you did. Even if you never look at those notes again, the act of analyzing the scene and writing down your thoughts and goals forces you to focus more on what it was you saw and wanted to record. Let's face it, most of us never looked twice at our high school geometry notes, but in the act of taking them, we paid far more attention to what was being taught.

- **Try to picture the finished photograph in a frame hanging in your living room.** What is it that you want to see in that frame each time you walk into the room, and what is it that you want your friends to notice or comment on first? Is it the stark shapes of the mountain peaks? The contrast of the yellow of the autumn leaves against the rich blue sky? And what about the water in the stream: Do you want it frozen as it surges along, or do you want a smooth satin ribbon of water flowing over the rocks? Each element of the subject has to be considered, and you have to decide how you want each to be represented in the finished image.

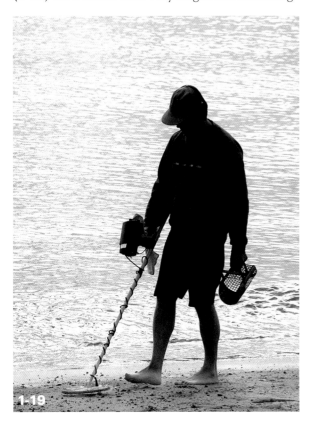

1-19

ABOUT THIS PHOTO *I used contrast to my advantage here by turning the man and his metal detector into a stark but interesting silhouette. Taken with a 70-300mm Nikkor zoom lens and exposed for 1/2000 second at f/5.6, ISO 400, handheld.*

Often all it takes to turn a mundane photograph into a memorable one is a simple adjustment in the exposure, but first you need to try to visualize what you want in the final image. In the photograph of a red tulip in figure 1-20, I really wanted that rich red color to contrast with the green of the foliage, and so I took an overall meter reading using my built-in matrix-metering mode and then underexposed one stop to increase saturation. You don't have to have exotic locales to test many of

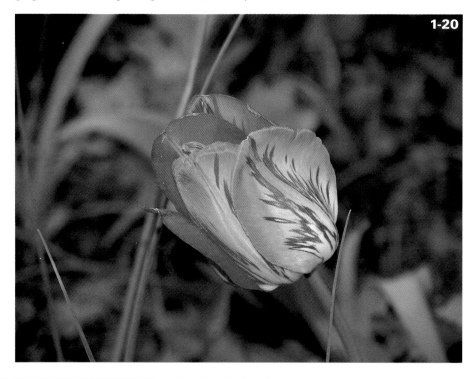

1-20

ABOUT THIS PHOTO
A simple one-stop adjustment in the exposure of this tulip was enough to make the red color really pop out from its deep green surroundings. Taken with a compact digital camera and exposed for 1/60 at f/3.5, ISO 100, handheld.

METADATA Although I have always carried small notebooks with me when photographing, digital cameras have eliminated the need to write down exposure data because all digital cameras record the *metadata* (also called EXIF data) for every exposure that you make as a part of the image file. You can access this data through most image-editing or image-management programs, or with the software that came with your camera. The metadata records an extraordinary amount of data about each image, including the type of camera used, the lens focal length, exposure information, ISO, white balance, and even whether or not you had the flash on. Learn to access your data, and you can learn a tremendous amount about your images. Where was this gem of technological wizardry when *I* was learning photography?

these techniques; your backyard, a small patio garden or a local park will do fine. The time to start thinking about how an image will look is not after you've pressed the shutter button, but before. That theory is just as true if you're using the simple point-and-shoot camera as it is if you're using a dSLR (digital single-lens-reflex) camera.

EXPOSURE AND MOOD

In addition to revealing a subject or setting in an interesting light and from an interesting angle, a good photograph should capture some of the emotional climate or mood of the moment — the mystery of a woodland scene shrouded in mist, the foreboding of a storm brewing over a harbor, or even the melancholy of a child sitting by himself on the backyard swings. In landscapes, for example, weather often establishes the mood of a scene. After enduring a frustrating week of bad weather along coastal Texas, I decided that getting shots of the weather, as in 1-21, was more productive than cursing the weather channel. Without mood, even some of the most stunning scenes in the world just fall flat because they carry no emotional weight. Mood captures the way a moment felt, not just the way that it looked.

If you've ever taken a snapshot of mountain scenery and had the photos come out much darker than you expected, but it turned out that you liked the moody look of the shot, that's an example of how a slight shift in exposure can enhance the emotional charge of a picture. In that particular case, your camera was fooled by the bright light bouncing off of the clouds and was tricked into underexposing the image. The exposure

may have been technically "wrong," but that dark exposure really helped to elicit the mood of the scene — a happy and creative mistake.

x-ref Mist and fog add a lot of atmosphere to landscape shots, but they can fool your camera's meter into thinking there is more light in a scene than there really is. In Chapter 10, I discuss techniques that provide accurate readings in a variety of weather situations.

How important is mood? The next time you're in a big tourist destination, check out the pictures on the postcard rack. Postcard publishers go to great lengths to make scenes as exciting and romantic as they can because that's what sells cards. Face it, if you're given a choice between a postcard of Miami Beach at high noon and one bathed in a radiant sunset, which one are you going to buy? Okay, if you're a young male on spring break, you're probably going to buy the card that's filled with the most females in bikinis, but even that is based on an emotional reaction to the scene. Take the bathing beauties off the beach, and chances are you'll move on to the cards with the most dramatic sunsets (and those are the ones you can send to mom).

Many factors can enhance the emotional charge in a scene, and exposure itself isn't always a dominating factor, but it can play a big role in intensifying mood with certain subjects. Knowing how and when to tweak the exposure to help convey mood is very important, though, and it's something to keep in mind when you're shooting potentially dramatic scenes. For example, sometimes you just get lucky when it comes to finding moody scenes,

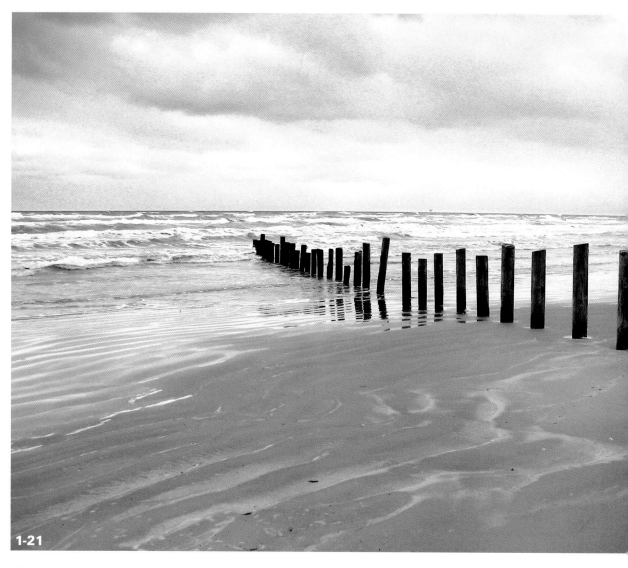

1-21

ABOUT THIS PHOTO *A storm brewing over the Gulf of Mexico in the Padre Island National Seashore. Photographed with a compact digital camera and exposed for 1/60 at f/2.8, ISO 800, handheld.*

but tweaking the exposure still helps you exaggerate the drama of the moment as shown in 1-22.

Bright and airy scenes tend to create happier moods, and you can often enhance that mood by making your exposure just a tad lighter than the camera's meter indicates is a good exposure. In the shot of this little girl blowing bubbles in figure 1-23, I intentionally made the exposure lighter by about one f-stop using exposure compensation to create a more summery, carefree mood. You have to be careful in lightening portraits though, if you start to lose detail in the skin, you've gone too far.

The key thing to remember in shooting moody scenes is not to be afraid of losing the shot by straying too far from the (here's that word again) *correct* exposure. Mood and emotional response are based largely on the exaggeration of normal factors, and photos are rarely as dramatic as they could be if shot at a safe exposure. Experiment with both moderate under- and overexposure to see if the changes enhance mood. If the first thing someone says when looking at one of your moody photographs is "Wow!" then you know you're on the right path.

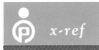
x-ref

Exposure compensation is a quick way to add or subtract light from an exposure. I talk more about this feature in Chapter 3.

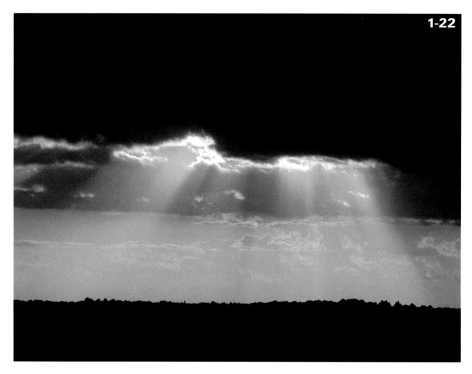

1-22

ABOUT THIS PHOTO
I shot this wild sunset after a storm at a beach on Long Island Sound in Connecticut, and all that I did to get the clouds so dark was to set a meter reading for the bright area of the sky. This shot looks exactly as it did coming out of my camera — I did no editing. Shot with a 70-300mm Nikkor lens at 1/500 sec., f/5.9 at ISO 100, handheld.

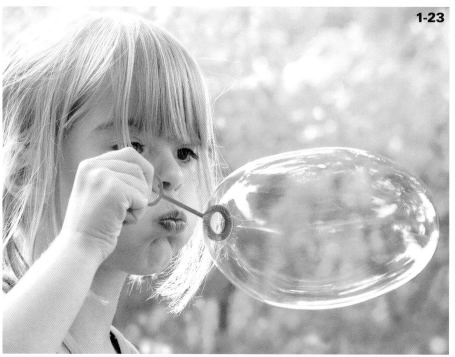

1-23

ABOUT THIS PHOTO
When it comes to portraits, I like to try and match the exposure to the mood — in this case, going slightly on the lighter side to enhance the happy mood. Shot with a compact digital camera and exposed for 1/160 at f/2.8, ISO 100.

Assignment

Practice Your Exposure Skills on a Piece of Architecture

For your first assignment, I'd like you to photograph a piece of architecture — either in whole, or a piece of architectural detail. This is the first assignment I've been giving my students for years and one of the main reasons is that buildings are stationary — you can return to them as often as you like at different times of day and in different weather. Your "building" can be anything you like: the dog house in your backyard, your local city hall, or perhaps your favorite hot dog stand. Visit it several times and see if you can't find the true personality of the building. Don't worry about creative exposure yet — just get a good basic exposure in the automatic mode.

I photographed this detail of the Vanderbilt Mansion in Hyde Park, New York. I'd been trying to get a good shot of the entire building all day and then just as the sun hit the horizon, its last rays ignited this bit of detail and I knew I had found an interesting shot. I quickly shot several exposures, but this was one of two or three that I really liked. Taken with a compact digital camera at 1/57 second, f/6.5, and ISO 100.

Remember to visit www.pwassignments.com after you complete this assignment and share your favorite photo! It's a community of enthusiastic photographers and a great place to view what other readers have created. You can also post comments, and read encouraging suggestions and feedback.

The degree to which you can manipulate your exposures depends, of course, on the range of exposure controls that your camera provides. All digital cameras, from the most inexpensive point-and-shoot cameras (see 2-1) to the most sophisticated professional DSLRs, are capable of creating consistently high-quality exposures. The difference between what more advanced cameras and simpler cameras can do is found not in the quality of their exposures, but in the range of flexibility the cameras offer for metering light and selectively manipulating fundamental exposure controls.

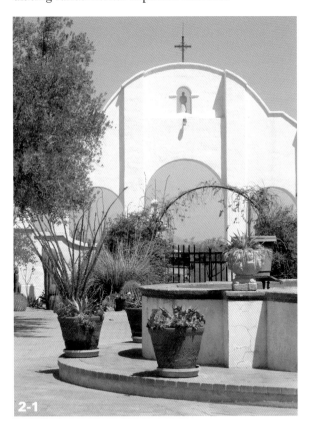

ABOUT THIS PHOTO *I photographed the ancient San Xavier del Bac mission church in Tucson, Arizona, using a very simple compact digital camera, and I was very pleased with the results. Exposure was 1/1250 second at f/7.1, ISO 100, handheld.*

In this chapter, I introduce you to these basic exposure controls so that you are familiar with most of the terms that you encounter later in the book. While digital cameras tend to look somewhat daunting when you first pull them out of the box, they usually have a very logical and methodical design to them (remember, they were designed by engineers to whom logic is everything) and are simpler to operate than you might think. Yes, at times it seems that engineers delight in packing in every possible option that technology and miniaturization of electronics allows, but usually this means more options and more features for creatively controlling your images. In fact, particularly when I'm using a camera that I happen to like a lot, I think that the people who design cameras must be operating at the genius level just to make it all work so harmoniously.

Because they pack so many features into digital cameras, however, it's important that you take the time to patiently study your camera's manual. In fact, the very first assignment that I give all of my students is to spend an hour or two sitting quietly with their camera and manual, identifying the various camera controls and navigating through the menu system. Despite their occasional complexity most digital cameras are entirely simple to operate if you take them one control at a time. While you may not understand the deeper meaning of some of the controls at the start, being familiar with their names and where they are located on the camera will save you lots of future frustration. Most importantly, don't be afraid to play with various controls since there's little that you can do (other than dropping it off your lap) to your digital camera that you can't quickly and painlessly undo. And even if it takes you a few evenings to feel really comfortable navigating the controls and settings, in time you begin to

appreciate the clever logic that the engineers who created your camera have devised — because if there is one thing engineers are good at it's making everything as logical as possible

GOOD EXPOSURES WITH ANY CAMERA

I frequently teach digital photography classes at adult community educational programs, and one of the first questions I get after my standard exposure lecture is, "Can I do all of that cool stuff with my camera?" My classes are generally made up of a mix of students who own all different types of digital cameras, from very basic to very advanced (including a lot that are more sophisticated and expensive than the cameras that I own), and the answer that I give them is, "Yes, no, and maybe."

Yes, regardless of what type of digital camera you own, you can capture good exposures in almost any situation. And yes, if you have a DSLR, you can manipulate the exposure settings with an incredible assortment of controls. But *no*, if you have a point-and-shoot camera with limited exposure controls, you may not be able to do some advanced things like exposure bracketing (a feature that lets you shoot several successive exposures of the same subject while varying the actual exposure settings by a range of stops; I discuss this in Chapter 3) or give preference to setting a particular aperture or shutter speed. The *maybe* response is because sometimes there are

note If you want to know what features a camera offers, just go to the manufacturer's Web site and look for the "specifications" page for the particular model; it should list virtually every technical feature in great detail.

roundabout methods of getting the exposure settings that you want, even if your camera doesn't have all of the exposure features. For example, while your point-and-shoot camera may not let you select a fast shutter speed manually because it has no shutter-priority or manual-exposure mode, it may have a "sports" scene mode that sets a high shutter speed for you. Your point-and-shoot camera will never offer the exposure flexibility that a DSLR boasts, but it may still provide all of the controls that you really need to get good pictures.

x-ref All DSLR and advanced cameras, and some (but not all) point-and-shoot models, offer a variety of exposure modes, including a shutter-priority mode (where you select the shutter speed) and an aperture-priority mode (where you choose the aperture). There are also a number of scene modes for specific subjects, such as sports, landscapes, and portraits. I talk about these at length in Chapter 6.

The one thing I try to make clear to my students is to not spend too much time on camera controls at the start — you will know when you need more controls, and there is never a shortage of better (and usually bigger) cameras to upgrade to. I find myself in the reverse position, when lugging 30 or 40 pounds of cameras and other photo gear through an airport security line, of envying those smiling faces peering into the LCD of their tiny compact cameras as they shoot photos of their friends in line.

Most digital cameras can be put into one of three general categories: point-and-shoot, advanced zoom (or advanced compacts, as some manufacturers call them), and digital single-lens-reflex cameras, or dSLRs. In terms of what exposure controls they offer, there are no hard and fast lines between these categories because, as new

digital cameras come along, manufacturers are squeezing more and more technology into even the tiniest and simplest of cameras. The following sections offer a breakdown of the three categories of cameras and a quick look at the exposure features they typically have.

POINT-AND-SHOOT CAMERAS

This category includes everything from the most basic shirt-pocket cameras to much more sophisticated compact cameras. Typically, you can expect to find a good light meter and a choice of basic but full-automatic exposure modes. A growing number of the more advanced (that is, expensive) point-and-shoot cameras also offer more advanced camera controls such as exposure compensation and aperture- and shutter-priority exposure modes. The great thing about compact cameras is that they're ready when you are and they can travel with you anywhere. I shot this sunset (see 2-2) using a fairly basic point-and-shoot camera while running errands and driving past my favorite beach. It was a bitter cold day and I probably would never have made the shot if I hadn't had my compact in my coat pocket. Would I sacrifice some exposure controls in order to have the fun of getting shots like this on the fly? You bet.

ADVANCED ZOOM CAMERAS

While they lack the lens interchangeability of dSLR cameras, advanced zoom cameras (some manufacturers refer to them as full-featured zoom cameras) usually provide a complete range of exposure options. I illustrated more than half of one of my previous books (*The Joy of Digital Photography*, Lark Books, 2006) with an advanced zoom camera, and even though that was a few

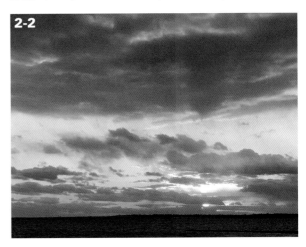

ABOUT THIS PHOTO *I pulled into the parking lot of a local beach and shot this sunset from the car window. The beauty of compact cameras is that they take great photos without being a burden to carry everywhere. Exposure was 1/640 sec., f/4.1 at ISO 100, handheld.*

years ago and cameras were considerably less sophisticated, the camera produced excellent exposures in some tough situations. I photographed the very colorful water lilies (see 2-3 and 2-4) against jet-black water — not an easy thing for any exposure/metering system — and the advanced compact camera that I was using exposed them perfectly. Again, the quality and reliability of exposure accuracy is very good in all digital cameras.

The one issue that I have with zoom cameras is that they generally use an electronic-type viewfinder (commonly called an EFT) that shows you a video-type projection of the viewfinder image in both the main viewfinder and on the LCD. These cameras have no optical or direct-viewing "peep-hole" viewfinder. You can get used to composing with an EFT (they're actually quite accurate because you're seeing almost exactly what the lens sees), but I find that making good exposure decisions means constantly pulling my eye away from the viewfinder to view the subject directly. If you're photographing action subjects and trying to make quick exposure decisions, it's even more difficult. Try it before you buy it.

ABOUT THESE
PHOTOS *I intentionally
underexposed these shots of
water lilies at Philadelphia's
Longwood Gardens by one stop
using the exposure compensa-
tion feature, which is found on
most zoom cameras. Both were
exposed using a 280mm Nikkor
lens at 1/100 sec., f/4.7 at ISO
100, on a monopod.*

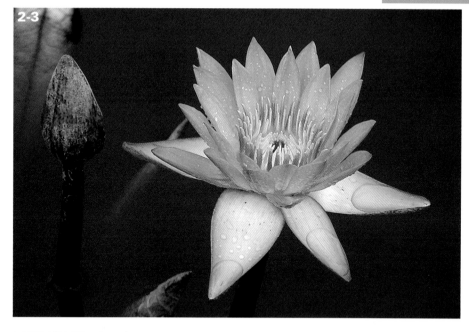

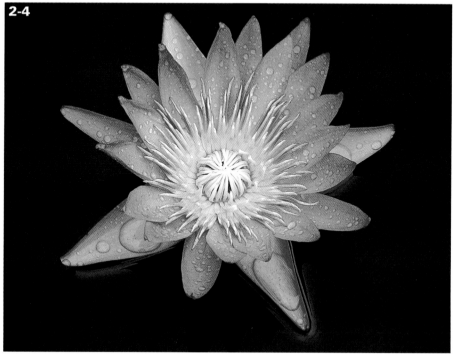

DSLR CAMERAS

Digital single-lens-reflex cameras (including all of those aimed at the consumer market) provide a very broad and sophisticated group of exposure tools that go beyond any other type of digital camera. While zoom cameras, for example, usually offer all of the standard exposure modes, some lack the ability to use exposure bracketing, to set exposure manually or to set a custom white balance. To expose the photo of the white egret (see 2-5), for example, I knew that the white bird and bright yellow background would probably fool the meter into underexposing the scene, and so I used the camera's spot meter to read the bird,

calculated the correct exposure, and set that exposure using the manual-exposure mode. All dSLR cameras provide all of those options, and because these tools are essential for complete exposure control, the dSLR is the preferred camera for serious photography.

One of the other primary advantages of using a dSLR, of course, is the ability to change lenses at will giving you complete access (or as much access as your wallet will allow) to a manufacturer's complete line of interchangeable lenses. Accessory lenses are available that range from ultra-wide-angle lenses for taking in sweeping views, to macro lenses for close-up photography

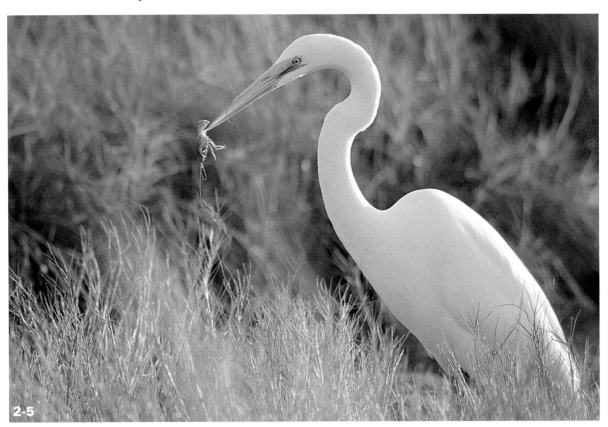

2-5

ABOUT THIS PHOTO *Using the sophisticated exposure controls of a dSLR helped me expose correctly for this great white egret at the Merritt Island National Wildlife Refuge in Florida. Exposed using a 400mm Nikkor telephoto lens for 1/1000 second at f/5.6 at ISO 200, on a Rue Groofwin Pod.*

to super-telephoto lenses for sports or wildlife shooting. While on a shooting trip in Iowa, for example, I was able to use a very wide 24mm wide-angle lens to photograph the façade of the state capitol building in Des Moines in 2-6 and later the same day switch to a 300mm telephoto to photograph bison at a wildlife refuge near Prairie City in 2-7.

Another advantage that may be significant to you if you do most of your own image processing is the ability of virtually all dSLR cameras to capture RAW file images. In the RAW format images are recorded with little or no in-camera processing so that the file you download to your computer is in

an untouched state — it is essentially just a capture of the light image. Virtually all other file formats modify or process images in various ways in the camera (enhancing color saturation, contrast, or sharpness, for example). RAW files are downloaded exactly as they were captured, but they do require editing software capable of opening the images.

Among the big advantages of RAW format images is that you can alter many key settings such as white balance and exposure *after the fact* (as in 2-8 and 2-9). If you are having trouble resolving or setting the white balance, for example, you can set adjust it during the editing process — a real plus if you're frequently working with unusual light sources (at

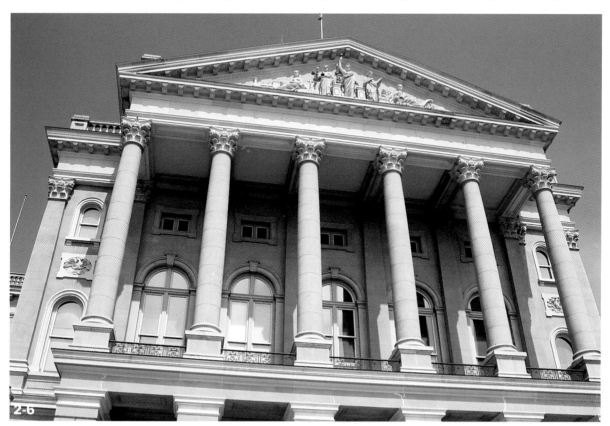

2-6

ABOUT THIS PHOTO *A dSLR camera provides an unmatched optical flexibility. Here I used a 24mm Nikkor zoom lens to capture a wide view of the Iowa capitol building. Exposed for 1/400 sec. at f/10, ISO 200, handheld.*

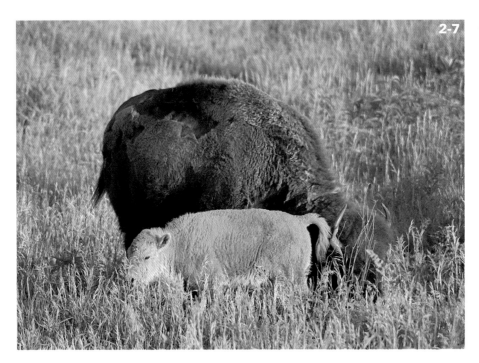

2-7

ABOUT THIS PHOTO
When it comes to photograph-
ing wildlife, nothing beats a
dSLR's ability to mount long
telephoto lenses. I used a
300mm Nikkor telephoto lens
for this shot of bison; exposed
for 1/160 second at f/5.6, ISO
200, handheld.

indoor sporting events, for example). You can also change the effective ISO setting after the fact, which enables you to essentially add or subtract several stops of exposure during editing as if you had actually changed the ISO speed of the sensor during shooting — quite an advantage in complex situations.

There is one drawback, though (although I don't really miss it much): With many (not all) dSLR cameras you can't view your compositions live on the LCD panel as you can with other cameras (although some high-end models do allow this now). This is because the reflex mirror that sends the lens image to the viewfinder so that you can see it is also blocking the sensor (until you expose the image, when it flips up out of the way). Because compact and zoom cameras don't have a reflex mirror, their LCD provides a live image during composition.

One question that I'm frequently asked is when it's time to move from a compact or zoom camera to a dSLR. The answer I think lies in the frustration factor. If you regularly find that you want to do things with your camera (like raise the ISO to a setting higher than your camera provides, or use exposure bracketing), then it might be time to consider the advantages of a more sophisticated camera. Make a list of the features that your camera doesn't have, or has in limited fashion, and see if a more advanced camera has those features. Once the "frustration list" gets long enough, you'll know that it's time to make the leap. Also, as prices for dSLR cameras continue to fall, owning one is more affordable than ever.

ABOUT THESE PHOTOS *This image was shot using the RAW format, which allows you to adjust a number of key settings after the fact — including exposure and white balance. Shot using a 105mm Nikkor lens and exposed for 1/640 sec. at f/11, ISO 200, on a tripod.*

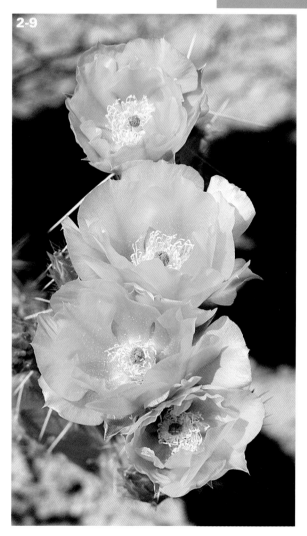

ESSENTIAL EXPOSURE CONTROLS

Regardless of the type of camera that you're using, all cameras set exposure using three basic controls: ISO speed, lens apertures, and shutter speeds. These are essentially the same three controls that photographers have been using since the very first cameras were invented. In upcoming chapters, I take a much closer look at each of these controls, but for now, here are the basic concepts of how your camera sets exposure and captures a light image.

ISO SPEED

ISO speed is a fundamental aspect of setting exposure because it establishes the relative light sensitivity of your digital camera's sensor. In all digital cameras, this is an adjustable setting, although it also has an "auto" option so that the ISO is chosen for you, based on the amount of light existing in the scene. Typically, the ISO (which stands for International Organization for Standardization in case anyone asks you on a bar bet) ranges from a low of about ISO 50 to a high of about 800 or

1600 (and up to 6400 or higher in some professional cameras). The lower the ISO number, the less sensitive it is to light; the higher the number, the more sensitive it is to light.

The most important thing to remember about ISO speed numbers is that each time you double the number (from 100 to 200, for example), you are doubling the effective sensitivity of the sensor. Similarly, of course, each time you halve the ISO (from 100 to 50, for example), you are cutting the sensitivity in half. This bit of math (and the concept behind it) becomes even more significant to you as you read about lens apertures and shutter speeds in the following sections.

Some of you who have owned film cameras know that when you bought film, you had to specify the film speed that you wanted because you had to select film to match the amount of light that you were expecting to encounter. If you were shooting in bright light, for example, an ISO 100 (or even slower) film provided enough sensitivity for good

exposure. If you were shooting indoors — in a concert setting or in a museum, for example — you needed a much faster ISO of 400 or even higher.

x-ref The ISO sensitivity that you select plays an important role in the range of shutter speed and aperture combinations that you have available to you. This relationship is discussed more in Chapters 4 and 5.

One of the extraordinary benefits of shooting digitally is that you can set the ISO differently for each individual frame. This can be a tremendous advantage when you are moving quickly from bright sunlight to dim interiors because with a quick change of the ISO setting you can optimize the camera's sensitivity to the amount of light available. While on vacation in Peru and photographing local faces, for example, photographer Derek Doeffinger was working in hazy bright sunlight and was able to use a relatively low ISO of 250 (see 2-10). On the other hand, when I photographed the series of

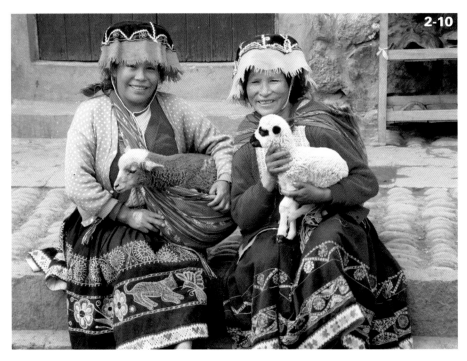

2-10

ABOUT THIS PHOTO
A wonderful travel portrait shot outdoors in bright existing light was taken using a relatively low ISO 250, providing maximum image quality. Shot with a 52mm Nikkor lens and exposed for 1/100 sec. at f/10. ©Derek Doeffinger.

shots of blues singer Miss Marie from the Crowmatix in concert (2-11, 2-12, and 2-13), I had to crank the ISO to 1600 to have any hope of stopping her animated stage performance under the relatively dim stage lighting.

There is a price to pay for using a higher ISO setting, however, namely *digital noise*. Digital noise is a grain-like pattern that occurs in images shot at high ISO speeds and it increases as ISO speed increases. The higher the speed you use, the more apparent the noise becomes. At a certain point when existing light gets very low, however, you just have to suffer some minor loss in image quality if you want to keep on shooting. Personally I don't object to the presence of moderate noise — it reminds me a lot of the look of fast films.

Noise varies not only by type of camera, but also by specific model and cameras that have larger sensors (like dSLRs) typically have less noise. Noise also increases as the pixel count grows — specifically with simpler cameras. In general, you get more noise from an 8-megapixel compact digital camera than an 8-megapixel dSLR because compact digital cameras typically have smaller sensors. And, of course, noise becomes obvious with bigger prints and enlargements, so if you have a shot with a lot of noise you can often make a smaller print and get a totally adequate image.

How much noise is acceptable is totally subjective and up to you. In order to shoot a mass in Notre Dame Cathedral in Paris shown in 2-14, for example, I knew that by raising the ISO to 1600 I was risking some digital noise, but I also knew that my Nikon dSLR has very low noise even at the top ISO speeds. There is some noise in the shot, but (for me, at least) not enough to worry about. Shooting candles in Notre Dame provided a bit more light, but still required shooting at ISO 1600 as shown in 2-15, but again, the noise seems minimal to me. The question you

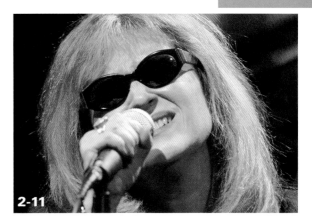

2-11

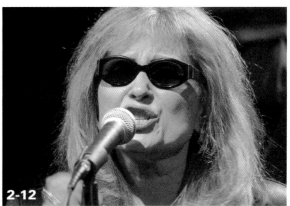

2-12

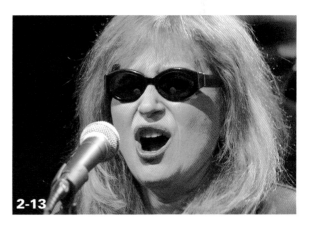

2-13

ABOUT THESE PHOTOS *Because I do a lot of concert photography where light levels are typically very low, the ability to have high ISO speeds available is extremely important — and even then I have to accept a certain amount of subject motion due to slow shutter speeds. To shoot this series, I had to set the ISO on my dSLR to ISO 1600 and was still shooting at 1/50 second. All three images photographed with a 70-300mm Nikkor zoom lens and exposed identically at 1/50 second at f/5.6, on a monopod.*

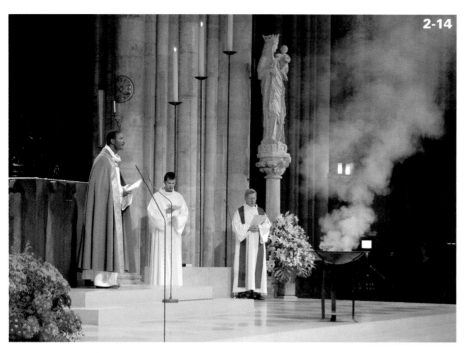

ABOUT THIS PHOTO
Church interiors, even the great cathedrals, are notoriously dim inside; and even at a high ISO 1600, I had to lean on a column to steady the camera. Exposure using a 18-70mm Nikkor zoom lens was at 1/13 second at f/4.5, handheld.

2-15

ABOUT THIS PHOTO
Shooting a close-up of candles in Notre Dame was easier than shooting a mass, but still required using ISO 1600 in order to work at a safe hand-held speed. Exposed at 1/160 second at f/6.3 using a 18-70mm Nikkor zoom lens, handheld.

have to ask yourself is: "Is the noise enough of a flaw to make me stop shooting?" Rarely would I let the prospect of some digital noise stop me from shooting.

There are some camera sensors that have notoriously high amounts of noise even at relatively low ISO speeds and that can be a bothersome problem. I photographed the two sisters in 2-16 using a good quality compact digital camera that, while a great camera in all other respects, has

quite a distracting noise problem. If noise is a concern, be sure to read camera reviews online or in photo magazines such as *Popular Photography* before buying a camera — digital noise is a hot topic in most reviews.

x-ref | For an in-depth look at flash and flash techniques, see Chapter 11.

Most digital cameras have three ISO options:

- **Default mode.** Cameras have a *default* ISO setting (usually ISO 100 for simple point-and-shoot cameras and ISO 200 for dSLRs) that the manufacturer believes is the best sensitivity setting in ordinary outdoor situations.

- **Auto ISO mode.** In the Automatic ISO mode, your camera measures the light and sets an ISO speed based on how much light there is — a higher ISO when the light is low and a lower ISO when there is an abundance of light. The nice part of the Auto ISO mode setting is that the camera is constantly adjusting the ISO and you don't have to think about it. The downside is that you're giving up control over the speed that the camera is setting, which may or may not matter to you.

- **Manual ISO mode.** In this mode, you can set the ISO speed manually, based on the amount of existing light and your personal experience.

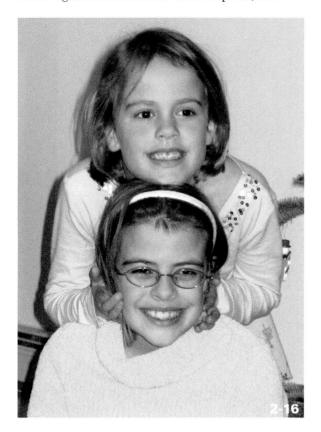

2-16

ABOUT THIS PHOTO *The digital noise in this cute image is very apparent and I find it quite distracting. It's the only flaw in an otherwise great compact camera that I own. Exposed for 1/60 second at f/4.1, ISO 800, handheld.*

tip | If you are setting the ISO speed manually, be sure to reset to the default setting when you're done with a particular subject. If you're shooting indoors and bump the ISO up to 800, for example, be sure that you return it to the default setting when you return outdoors or you will add needless noise to your images. I can't tell you the dozens of times I've found myself shooting flowers in bright sunlight at ISO 800 or 1600 simply because I had been shooting indoors the night before. Not a devastating mistake, but an annoying one.

DIGITAL NOISE *Digital noise* is a grainy cast that images get when you shoot at higher-than-normal ISO speeds. If you've ever shot with high-speed films, you already know what film grain is, and noise is the digital equivalent of grain. Noise is caused by electronic interference on your camera's sensor, and that interference is magnified at higher speeds. While noise isn't the monster it's made out to be in some photo magazines, your images will probably look better without it, and so it's best to shoot at the lowest ISO that the light allows. I think being able to shoot indoors in very low light is worth the price of some noise, and there are some noise reduction filters in most image-editing programs that work quite well.

Most simple point-and-shoot cameras and zoom cameras are more susceptible to noise, and at substantially lower ISO speeds than dSLRs. I own a Canon A-630, for example, that shoots brilliant images at ISO 100 but gets substantially noisy at ISO 400 or 800. However, using my Nikon D70s dSLR, I commonly boost the ISO up to 1600 in dimly lit or interior situations and I rarely see any substantial noise. I even bump up the ISO in sunset or sunrise situations when I need a faster shutter speed or more depth of field. In situations where there is a lot of shadow area, the noise becomes more obvious.

LENS APERTURE

Lens aperture is one of the two primary controls that are used to adjust exposure by controlling how much light reaches the sensor. In Chapter 4, I plunge you deeper into the world of lens apertures and all of their technical and artistic glory, but for now I just define what they are and why they are important. I also introduce the basic aperture math (but don't panic — it's a much simpler concept than you may have been led to believe).

In its simplest terms, the lens aperture is the physical opening in your lens that lets light reach the sensor. If your lens didn't have an aperture, all of your photos would be very dark indeed, because no light would ever reach the sensor. The size of the opening is adjustable so that you can moderate the flow of light — the smaller the lens opening, the less light that reaches the sensor in the same time period. Simple, right? Actually, it is a very simple concept and one that hasn't

changed since Joseph Nicéphore Niépce snapped the world's first permanent photograph at his family's home in France in 1827 (the photograph still exists today, incidentally, and is held at the University of Texas at Austin). And just in case you happen to be a trivia fan, the Niépce crater on the moon was named after this pioneering French photographer.

Today, of course, cameras have a glass lens that helps focus the light, but inside that lens there is still a small, adjustable aperture that controls how much light gets into the camera. If you own a DSLR, you can see the lens aperture by removing the lens and aiming it at a brightly lit area. If your lens has an aperture-adjustment ring (not all lenses do these days), take the lens off the camera and turn the ring; you can see the aperture as it changes size.

Aperture sizes are described by a numerical sequence called *f-stops*. This series of progressively larger opening sizes follows a pretty

standardized numbering system that I describe in Chapter 4. For now, there are just two essential things for you to remember about f-stops:

■ **The smaller the aperture number or f-stop is, the larger the opening is and the more light it lets into the sensor.** For example, an aperture described as f/4 lets in a lot of light, while an aperture of f/22 lets in far less light. Got that? Trust me, you won't be alone if you find this concept a bit confusing at first. The first time I run this idea past my students, I find myself looking at a roomful of somewhat confused faces. Looking at the diagram in 2-17 might be helpful. Also, an easy way to help remember this concept is to think of the f-stops as fractions of a whole. If you have 1/4 of a pie, for example, you have a much larger piece than someone who only has 1/22 of a pie.

■ **Each time you move from one whole f-stop to the next f-stop, you either *halve* or *double* the light reaching the sensor.** If you move to a larger aperture (from f/4 to f/2.8, for example, which is a whole stop larger), you double the light reaching the sensor. I shot the photos of the Mexican pottery in Tubac, Arizona, near the Mexican border late on a brutally bright day. The light was so intense,

it was confounding my meter readings, and so in order to be sure that I got a good exposure, I shot the same scene at several different settings using my auto-bracketing exposure feature. Figure 2-18 is the frame I liked the most; it seems to have richer and more saturated colors. In the second shot (see 2-19), the camera added one-and-one-half f-stops of exposure (therefore it received more light), and the colors seem washed out.

Conversely, if you move from f/4 to f/5.6 (a lens opening that is one whole stop smaller), you halve the amount of light reaching the sensor. This concept of halving or doubling the light that enters the camera is one of the most significant aspects of exposure, and it permeates every other area of exposure theory. Your resistance to understanding this topic is futile, as they say in a certain science fiction series, so try to embrace it joyfully.

> *tip* It may help you to remember all of this f-stop math if you keep in mind the fact that setting a larger lens aperture is referred to as "opening up" the lens, while moving to a smaller aperture is referred to as "stopping down" the lens.

ABOUT THIS FIGURE
The opening for an aperture of f/2.8 is much larger than the opening when the aperture is set to f/8, for example. So, much more light hits your camera's sensor at f/2.8 than f/8.

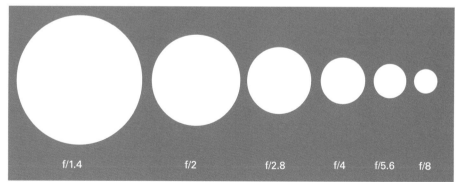

f/1.4 f/2 f/2.8 f/4 f/5.6 f/8

2-17

ABOUT THESE PHOTOS *Both of these shots were taken from the exact same position on a tripod using a 24-120mm Nikkor zoom lens. In 2-18 (the better of the two), the exposure was set at 1/400 sec. at f/11; in figure 2-19, the lighter one, the exposure was 1/400 sec. at f/7.1. While the aperture was only increased by 1.5 stops roughly, it more than doubled the light reaching the sensor. Both shots were taken at ISO 200, on a tripod.*

x-ref There is much more detailed information about f-stops in Chapter 4.

Here is a recap of the key points that should help you grasp the lens aperture concept:

- The lens aperture lets light into the camera.

- Lens openings are referred to as f-stops in photographic terms.

- The smaller the f-stop number, the larger the lens opening.

- The larger the f-stop number, the smaller the lens opening.

- Think of f-stops as fractions and you can visualize their size: For example, think of f/4 as 1/4 of a pie and f/22 as 1/22 of a pie. Which is the larger slice?

- Each time you move from one whole f-stop to the next smaller or larger f-stop, you either halve or double the light entering through the lens.

Piece of cake, right? Oops, sorry, pie.

SHUTTER SPEED

Because the aperture only regulates how much light comes through your lens, you still need some method to regulate how long the sensor is exposed to that light. That's where your camera's shutter speed comes into play.

The shutter is the other primary control that sets exposure. Using a sequence of precisely timed *shutter speeds*, the shutter controls the duration of the exposure — it determines how long the sensor is exposed to light. The longer the shutter remains open, of course, the more light that enters the camera; the shorter the exposure time, the less light that enters the camera. Typically, shutter speeds range from tiny fractions of a second (1/2000 second, for example) to much longer time exposures (a minute or more) for nighttime scenes (see 2-20 and 2-21).

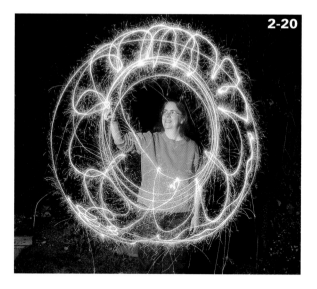

2-20

ABOUT THIS PHOTO *Using very long shutter speeds can lead to some very creative ideas. Here I photographed my friend Lynne drawing a flower in mid-air with sparklers. Taken with a 24-120mm Nikkor zoom lens and exposed for 24 seconds at f/18, ISO 200, on a tripod.*

 x-ref

For more on the technique of using sparklers and long exposures, see Chapter 9.

Depending on the type of camera you have, the shutter can take one of two forms. Most point-and-shoot and zoom cameras use an *in-lens* shutter that is made up of a series of iris-like blades (it actually looks like a second lens aperture, and in a few cases doubles as the aperture) built into the lens. When you press the shutter release button,

ABOUT THIS PHOTO *Here's my friend Sarah writing her name with sparklers during a 16 second exposure. Taken with a 24-120mm Nikkor zoom lens and exposed at f/18, ISO 200, on a tripod.*

2-21

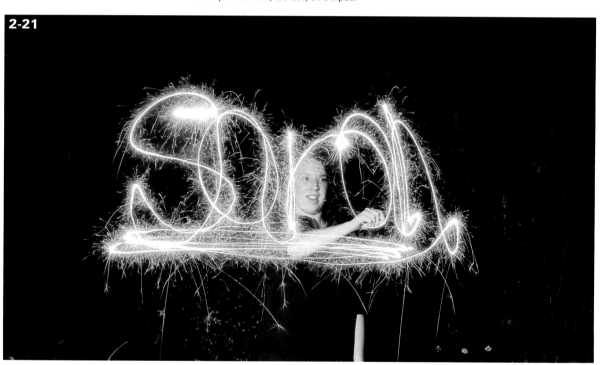

these blades open and close to let light into the camera for precise amounts of time. DSLR-type cameras, on the other hand, use a *focal-plane shutter* that acts like a curtain in front of the camera's sensor; you press the shutter release button and the curtain opens and closes, exposing the sensor.

For most people, the concept of shutter speeds is simpler to understand than that of lens aperture because the settings are described by the exact amount of time that the shutter remains open. A shutter speed of 1/60 second, for example, enables the sensor to receive light for exactly 1/60 of a second. Simple. And here's an interesting fact: Each time that you double or halve the exposure time, you either double or halve the amount of light entering the camera. (Sound familiar?) If you change the shutter speed from 1/60 second to 1/30 second (the next full stop slower), you double the amount of light reaching the sensor. If you switch the shutter speed from 1/60 second to 1/125 second (the next faster shutter speed), you cut the duration of the exposure in half. Because the shutter speed is a time-based function, it, of course, treats moving subjects much differently, depending on the speed of the subject and the length of the exposure. I discuss the relationship between action and shutter speed more extensively in Chapter 5, but for now just remember this: When you are shooting a moving subject, the faster the shutter speed you're using, the more you can stop action, and vice versa. Fast shutter speeds are fun with action subjects because they allow you to completely stop even the fastest motion. In the photograph of the speedboat (see 2-22), for example, I used a very fast shutter

ABOUT THIS PHOTO *I photographed this speedboat racing past in a canal in Fort Lauderdale, Florida, using a shutter speed of 1/800 sec. at f/7.1. The shot was made with a 300mm Nikkor lens, ISO 200, on a tripod.*

speed of 1/800 second and it stopped the motion of the boat entirely. Conversely, in the somewhat abstract photograph of rock musician "Professor Louie" (see 2-23), I used a very long shutter speed to capture the energy and motion of the moment.

Although shutter speed settings are typically displayed as whole numbers (30, 60, 125, 250, and so on), they actually represent fractions of a second. If your camera's viewfinder displays an exposure

setting of 60 at f/8, for example, it's actually exposing the sensor to light for 1/60 second at f/8. Similarly, if the display says 1000 at f/8, it's exposing the image for 1/1000 second at f/8. The exception to this is when your shutter enters the range of full seconds, which are usually followed by a pair of quote or "full second" marks. For example, a shutter speed of 4" means the exposure time is four seconds long.

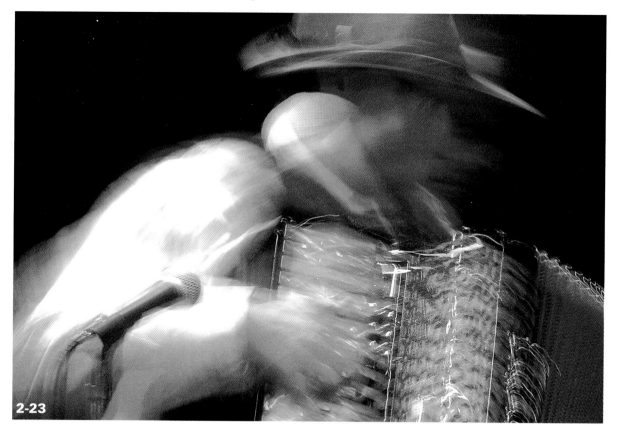

2-23

ABOUT THIS PHOTO *After shooting "straight" shots for most of the night, I decided to experiment with long exposures toward the end of the show. Exposure was for a full second, f/22 at ISO 800 using a 70-300mm Nikkor zoom lens, on a monopod.*

> *note* Here's a bit of photography slang that will come in useful when you're reading about exposure: Each time you switch to a shutter speed that keeps the shutter open longer, you're said to be switching to a "slower" shutter speed — because the shutter is taking longer to close. Each time you switch to a shutter speed that is briefer in duration, photographers describe it as moving to a "faster" shutter speed, because the shutter closes faster. Photographers tend to use the terms "longer" and "slower" interchangeably, just as they mean the same thing whether they say "faster" or "shorter."

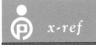

x-ref Shutter speeds follow a precise and standardized series of exposure times, and I explain those settings in more detail in Chapter 5.

EQUIVALENT EXPOSURE SETTINGS

Some of you have probably arrived at this fact already (you were the annoying ones that always had their hands up first in physics class), but there is a beautiful and perfectly reciprocal relationship between aperture and shutter speed in terms of how much light enters the cameras. In fact, it's one of the most useful and symbiotic relationships in all of photography. It's at the core of all creative exposure techniques, and when you come to appreciate the full glory of it, it makes your heart sing and swell with pride (well, hopefully it at least makes you smile).

As I explained earlier in this chapter, each time you move to the next larger or smaller aperture, you either double or halve the amount of light entering the lens, respectively. If you open the aperture from, say, f/11 to f/8, you double the light entering the lens. If you close the lens down from f/11 to f/16, you cut the light in half. And, as I also just explained, each time you change the shutter speed to the next slower or next faster shutter speed setting, you either double (if you're going to the next slower speed) or halve (if you're moving to the next faster shutter speed) the light entering the camera. Voilà! A perfectly reciprocal relationship.

THE CAMERA OBSCURA Even before cameras were able to record images (that is, before the invention of photography), artists were able to study projected images of light using a device called the *camera obscura*. The camera obscura (see 2-11) was essentially a dark box that had an aperture at one end (early models didn't even have a lens — just a hole that was small enough so that it focused the light beams as they passed through the opening) and a surface at the other end upon which the image was projected.

Some camera obscuras were actually room-sized, and people would pay to sit around in chairs and watch live images float by on the rear wall. Think of the fun that must have been! Saturday nights, you buy your date a box of popcorn and take her to a dark room to watch images dancing on the wall. Sounds kind of familiar, actually.

Abu Ali al-Hasan ibn al-Haitham (965-1039) an Iranian Muslim scientist, is widely accepted as the first person to describe the invention in writing. Although his discovery pre-dated cameras by about 800 years, it had a direct impact on the invention of photography. Considering his other interests, we're lucky he ever got around to the camera obscura: In his lifetime, he made seminal contributions in the fields of anatomy, astronomy, engineering, mathematics, medicine, ophthalmology, philosophy, physics, psychology, and visual perception — not the kind of guy who was using a one-page resume.

Table 2-1

Reciprocal Exposure Options

Shutter Speed	Lens Aperture
1/1000	f/1.4
1/500	f/2
1/250	f/2.8
1/125	f/4
1/60	f/5.6
1/30	f/8
1/15	f/11
1/8	f/16
1/4	f/22
1/2	f/32

Because of this reciprocal relationship, there is not just one but many different combinations of aperture and shutter speeds that can provide the exact same exposure. For example, if your meter suggests that a setting of f/8 at 1/60 second provides an optimal exposure, you could still get a perfect exposure (in terms of light quantity) if you were to change the setting to 1/125 second (the next fastest shutter speed, which is halving the light) and open the lens one f-stop to f/5.6 (the next wider full f-stop setting). You could also go in the other direction, by setting the shutter speed to 1/30 second (doubling the light entering the lens) and closing down the aperture to f/11. Table 2-1 shows you all of the equivalent exposure settings possible for an arbitrary meter reading starting at 1/1000 second at f/1.4 and going to 1/2 second at f/32. Each of the readings provides *exactly* the same amount of light to the sensor

(although as you learn in Chapters 4 and 5, the creative results are different for each setting).

Photography instructors often use the analogy of the "faucet and the hose" to help students visualize the relationship between aperture and shutter speed. Imagine that you're trying to fill a bucket with water coming from a tap. If you use a narrow hose (that is, a smaller aperture), you have to leave the faucet open longer to fill the bucket. But if you use a wider hose (a larger aperture), you can fill the bucket in a much shorter time. This analogy never really worked for me when I was studying photography because, being the excessively literal kid I was, I couldn't picture different-sized hoses. Hoses are pretty much all the same diameter, aren't they? Regardless, I've found over the years that my students love the analogy, so I don't mess with what works.

The key thing to remember is that for every combination of aperture and shutter speed, there are many other settings that provide an identical amount of light and thus (in terms of light quantity) identical exposures. But as you learn in Chapters 4 and 5 on aperture and shutter speed, respectively, just because the correct amount of light reaches the sensor doesn't mean that the exposures produce identical results. In fact, each time you switch to an alternate-but-equal combination of shutter speed and aperture, you are altering — sometimes profoundly — the appearance of your subject. As you learn in Chapter 5, for example, using a slower shutter speed causes moving subjects to blur, while using a faster shutter speed freezes their motion. And changing from one aperture to another radically changes which parts of your image are in sharp focus.

Assignment

Experiment with ISO Speeds

It's relatively easy to get a good exposure on a clear day when the sun is high and there is a lot of bright light to go around, but now that you know you can shoot in very dim light by raising your ISO speed, it's time to experiment. For this assignment, try to think of some relatively (or very!) dim locations around your house or neighborhood — perhaps the interior of a church, Main Street after dark, or even a local carnival — and then crank up your ISO as far as it goes and see how creative you can get in dim light.

My assignment photo was shot at Mission San Xavier del Bac, a very old mission church (the current building was built between 1783 and 1797) just south of Tucson, Arizona. The interior of the church is very dim; the only light comes from a few incandescent lamps, a doorway, and a few small skylights. Taking pictures with a flash would destroy the atmosphere, and so the only solution was to raise my ISO up to 1600 (the highest setting on my Nikon D70s) and use the existing light. This photo of the Madonna (the religious one, not the rock star) was exposed for 1/20 second at f/4.2 using an 18-70mm Nikkor zoom lens. The camera was handheld, but I was using the back of a pew to steady my elbow and the camera. I would much prefer to use a tripod in this situation, but they're not allowed.

Remember to visit www.pwassignments.com after you complete this assignment and share your favorite photo! It's a community of enthusiastic photographers and a great place to view what other readers have created. You can also post comments, and read encouraging suggestions and feedback.

Regardless of what the subject is that you're photographing, what lens you're using, or what time of day it is — or for that matter, even if you're shooting on a dark street in the middle of a rainy night and can barely see the puddle you're standing in — there is one very important piece of information that you (and your camera) need to know in order to create a good exposure: You need to know precisely how much light is in a scene. After all, light is the basic element of exposure and until you know how much you're dealing with, everything else in the exposure sequence is in limbo. So the very first thing that you need to do in order to get a good exposure is to measure the light.

In order to measure the light, of course, your camera is equipped with a very sophisticated tool called a *light meter* that is designed to perform just that (and only that) task. The meter that is built into your digital camera is no run-of-the-mill technological gizmo, either: it's a modern miniature electronic marvel. If they ever vote for the "Seven Miniature Electronic Wonders of the World," your meter will be nominated. You can pretty much point your camera at any scene and, faster than your teenage kids can text message "Great sunset!", the meter has measured the light and shared the information with your camera's eagerly-waiting exposure chain of command. Also, while your camera has only one built-in meter, it probably has several different light-metering options available (and I explain each of them in the coming pages); learning how and when to use each one is crucial when it comes to accurately measuring the quantity of light in a scene.

HOW LIGHT METERS WORK

In most cases, the exposure information that your meter provides is extremely accurate. As with all things technological, however, putting too much blind trust in them often backfires. It's kind of like assuming that the automatic "popcorn" setting on your microwave oven knows how long to cook microwave popcorn, regardless of the brand. But as you've probably learned, unless you like burned (or un-popped) popcorn, you're better off standing by the oven, watching it pop. In order to get the best results from your light meter, you need to know just what it does, how it does it (within reason — I gave up faking my way through physics papers in high school), and when you, with your vastly superior human intellect, need to intervene. As you will see in the coming pages, some scenes are easier (see 3-1) to measure accurately than others (see 3-2).

> **ⓟ** *x-ref* White swans on black water, and black dogs napping on a white couch are two of the many situations that can fool even the best TTL light meters. In Chapter 8 I talk about a variety of these metering challenges and provide some reliable methods for outwitting the most difficult exposure subjects.

The way that your camera's built-in light meter works is fairly straightforward: Light coming from a source (usually the sun, although it could just as easily be a bank of artificial lights in Fenway Park, or even the lights of a carnival French-fry stand, as shown in 3-3) strikes your subject and bounces back toward your camera, and its intensity is measured by

ABOUT THIS PHOTO
Scenes that contain an equal mix of bright and dark tones are the simplest scenes to expose correctly. Taken with an advanced zoom digital camera with the zoom setting at 225mm at 1/220 sec., f/7.3 at ISO 200, on a tripod.

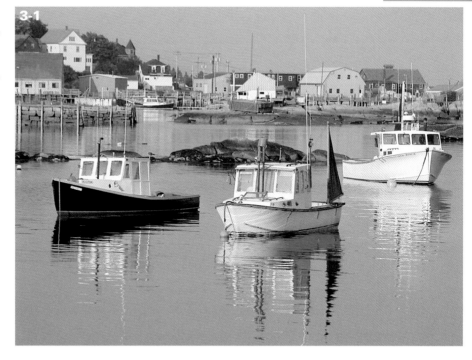

ABOUT THIS PHOTO
Metering becomes a significantly more human chore with contrasty subjects like these swan cygnets preening on a muddy riverbank. You must decide which is the important element. Exposed with a 70-300mm Nikkor lens at 1/220 sec., f/7.1, ISO 200 with camera steadied on a rock.

ABOUT THIS PHOTO *I am particularly fond of photographing carnivals, and so I tend to encounter a lot of different light sources. Photographed with an advanced compact digital camera at 1/30 sec., f/1.8 at ISO 100, handheld.*

a light-sensitive cell. This information is analyzed by your camera's onboard computer (if you can call thousands of electronic calculations being made in fractions of a second analyzing) and is displayed for you, in the form of apertures and shutter speeds, in your camera's viewfinder. What could be more convenient? You, of course, are free to accept or reject the camera's advice.

The meter that's built into your camera is called a TTL, or "through-the-lens," type meter. This means that it measures the light after it passes through the lens on its way to your camera's sensor; in fact, the light is typically measured at or very close to the plane of the sensor. The beauty of measuring the light *after* it passes through the lens, of course, is that the meter doesn't have to compensate for (or worse, ignore) any interference or light loss that is caused by the lens or lens accessories. Some of the light's intensity is diminished, for example, as it passes through a particularly long telephoto lens or a close-up extension tube, and some of the light is scattered by the internal glass surfaces of the lens (see 3-4).

Because the light has already cleared the camera's optics, it is being measured exactly as the sensor will see and record it. Your meter provides the same accurate results, regardless of what focal-length lens you're using or what type of filter you might put over the lens. Many early film cameras used "external" metering cells that were mounted to the front of the camera and measured light before it passed through the lens. The results were usually less than stellar. TTL meters, on the other hand, are extremely accurate.

note Incidentally, a German engineer named Karl Nüchterlein registered the first-ever patent for a through-the-lens light meter in 1939 — just in case anyone ever asks you. Tragically, Nüchterlein went missing in action in the waning days of WWII and never saw the fruition of his invention.

3-4

ABOUT THIS PHOTO *Close-up devices absorb a lot of the light entering the camera, and non-TTL meters typically underexpose close-ups. This photo was made using a camera with TTL metering, and so the meter compensated automatically. Exposure was 1/100 sec., at f/4, handheld.*

TTL METERS

In the early days of 35mm photography, before digital cameras stormed the photography world, a lot of cameras used simple "averaging" TTL meters, which basically look at a scene, add up all the brightness values, and find a comfortable middle ground — an average reading. The readings were a good starting point, but they rarely produced perfect exposures without a lot of fussing (and mumbling) from the photographer. Fortunately, things have changed a lot and the TTL meter in your digital camera is exceedingly sophisticated by comparison.

While all TTL light meters are reflected-light meters (that is, they measure the light after it reflects off of the subject), there are three different types of meters built into digital cameras. Some cameras, such as many point-and-shoot cameras, offer just a single type of meter, while other more advanced cameras (such as zoom cameras and dSLR cameras) have all three types. Essentially, the difference between the three types of meters is the amount of subject area that they look at to get their readings and what pattern or portion of the viewfinder they use. You can pretty much guess what areas of the viewfinder each type of meter uses just by their names:

- ■ Multi-segment (the entire viewfinder)
- ■ Center-weighted (the center)
- ■ Spot (a tinier part of the center)

Switching between the three types of meters (if you happen to have all three) is very simple and typically involves pressing a button and turning a dial simultaneously, or working with a menu. The toughest part (especially if, like me, you're over 40 years old) is just finding your reading glasses so that you can read the tiny hieroglyphic symbols that manufacturers use to identify things. Don't be afraid to experiment with the different types of metering patterns that your camera offers, because sooner rather than later, you're going to find a very good reason to use one of them in action. I'm constantly telling my students to sit on the couch with their camera manuals and their cameras and try *everything* they don't understand on their cameras so that when that big double rainbow soars up over the Grand Canyon, they aren't caught fumbling with controls and asking the person next to them (as several strangers have asked me), "Do you know how to work my camera?"

Not all light meters are built into cameras, by the way, and later in this chapter I talk about accessory or handheld light meters and why some photographers prefer (often passionately) to use them. For now, let's take a closer look at the three types of TTL meters.

MATRIX METERS

Technically these meters are called multi-segment meters, however I refer to them as matrix meters simply because that's how I've always thought of them. Regardless, they are easily the most sophisticated, accurate, and easy-to-use type of meter built into digital cameras. These meters are often referred to by their proprietary names — Nikon calls their system matrix metering and Canon calls theirs evaluative. Fortunately, whatever you call them, this type of meter is built into most digital cameras, from simple point-and-shoot cameras to high-end professional dSLR cameras (virtually all zoom and dSLR cameras have some form of matrix metering).

note Nikon introduced the first multi-segment-type meter in the early 1980s, and since then, virtually every manufacturer has adopted, adapted, and enhanced the technology.

As their name implies, matrix meters divide the entire frame in a mosaic of segments that can include anywhere from five large segments up to several hundred tiny segments. When you partially depress the shutter-release button to activate the camera, the meter measures the light in each of the individual areas. Then, through a complex series of algorithms, this information is shared with an onboard computer that has been programmed with the data from as many as 50,000 or more sample exposures (the Nikon D2x, for example, claims to have the data from 300,000 exposures programmed into its memory — yikes!). By comparing the scene you're about to shoot to the information from the saved exposures, the camera is able to analyze your subject and make

an educated guess about what type of subject it is — and which parts of the frame are important. And I'm not making any of this up.

The most impressive aspect of multi-segment metering is that by comparing the scene in your viewfinder to the data stored in the onboard computer chips, your camera is able to make a fairly accurate guess about what type of subject you're photographing — or at least what the main subject is. For example, in photographing this horse on the King Ranch in Kingsville, Texas (see 3-5), even though he was surrounded by bright foreground grasses and a fairly light background, the meter came to the conclusion that the horse was the important part of the scene and exposed him correctly. I've made some slight adjustments to the foreground grass brightness and color in Adobe Photoshop, but the horse was exposed extremely well; a lesser metering system would have been fooled into underexposing the horse by all the bright grass.

ABOUT THIS PHOTO
This horse appeared out of the blue while I was touring the million-acre King Ranch in Texas, and I had no time to fuss with the meter — it was matrix metering or nothing. Using a 70-300mm Nikkor zoom lens at 1/125 sec., f/5.6, ISO 200, handheld.

3-5

Depending on how sophisticated the meter is, it may also actually consider other factors than light intensity in making its calculations: Contrast, subject distance, focus, and scene contrast may all be taken into consideration. In the photograph of the bridge in 3-6, which was taken in late afternoon light, for example, the matrix meter in my dSLR was able to take into consideration the relatively dark water, the brightly illuminated bridge, and the bright blue sky and still come up with a good overall exposure.

Although, as you'll read later in this chapter, almost all light meters view the world as gray, some evaluative meters on high-end dSLR cameras take color into consideration (see 3-7). All of this knowledge combines to produce extraordinarily

precise exposure in an astounding variety of situations. If you feel that you'd like to choose just one type of TTL metering to use for all of your photography, choose matrix metering.

CENTER-WEIGHTED METERS

I learned photography at a time when TTL metering was still a relatively new thing and matrix metering was still a gleam in some electrical engineer's daydreaming eyes. Most of the meters that we used then were called "averaging" meters and, as I mentioned earlier, they did just that: They took into account all of the values in a scene, mixed them together like so much olive oil and vinegar in a jar of salad dressing, and created an

3-6

ABOUT THIS PHOTO *Matrix meters are extremely good at metering complex scenes. This shot was made using a 24-120mm Nikkor zoom lens and exposed at the metered exposure of 1/100 second at f/14, ISO 200, on a tripod.*

"average" reading (see 3-8). At most, it was a starting point. The problem was that shadows and light don't mix any better than oil and vinegar, and whenever you average light, something pays the price. When center-weighted meters were introduced during the mid 1960s, the accuracy of TTL metering bolted forward by a quantum leap.

ABOUT THIS PHOTO Averaging meters look at all of the tones of a scene and then find a one-size-fits-all reading. If you're lucky, the scene is relatively even in tones, like these carnival toys, and the reading works. I exposed this frame using an 80-200mm Nikkor lens at 1/1000 sec., f/5.6 at ISO 100.

Center-weighted meters don't divide the frame up in the way that matrix meters do, but instead concentrate their sensitivity on a small circle in the middle of the viewfinder; as a result, they typically bias their readings (usually about 70/30) for that area. In other words, while the meter looks at the entire area you're photographing, it gives extra emphasis to that central area. This is a great feature because it allows you to tell the camera exactly which part of the scene is important to you. This is particularly useful if your main subject is relatively small in the frame, or if it's dominated by particularly bright or dark surroundings.

I photographed my girlfriend (see 3-9) in a relatively dark wilderness setting with her face lit by a small area of open sky. I wanted to keep the background rich and woodsy-looking, and so I used center-weighted metering and took a reading of just her face so that the background would remain dark. Matrix metering might have done the job, but by choosing center-weighted metering, I took control of the exposure.

ABOUT THIS PHOTO
For outdoor portraits, use center-weighted metering, read directly from the skin tones, and, if necessary, add an extra stop of light using exposure compensation. Exposed using a 120mm zoom setting at 1/4 sec., f/5.3, ISO 200, on a tripod. Softened slightly with a Gaussian blur in Adobe Photoshop.

3-9

Center-weighted metering is also useful when your important subject matter is relatively small in the frame or when your main subject is in different light than the overall scene. If you were photographing your daughter sitting on a swing in the shade and surrounded by bright sand and sea at the beach, for example, you would aim the central circle at her face and ignore the larger environment. For those reasons, as much as I love matrix metering, I often find myself using the center-weighted feature.

Using a center-weighted meter requires a few more steps than using a matrix meter because it requires that you carefully aim the metering area (indicated in the viewfinder) only at the important subject area. In photographing the captive Caribbean flamingo in 3-10, for example, I put the metering circle over the wing of the bird to avoid metering any of the dark water in the background. I was able to meter just the bird and then use the exposure-lock feature to keep that reading while I re-framed the scene. The trick is to center your subject to take your reading, use your camera's exposure-lock feature to lock that reading,

and then recompose the photo and shoot. If your camera's features are well laid out, this should be an easy, one-handed operation.

With most cameras, the shutter-release button acts as an exposure lock feature: If you compose a scene and press the shutter release halfway down, the camera locks that exposure until you either press the button all the way to take the picture, or release it. The problem with this feature is that the exposure lock is tied in with a focus lock feature. At times you may want to lock the exposure after you take a center-weighted or spot-meter reading, but not lock the focus. Some cameras have a separate exposure-lock button that enables you to just lock the exposure (and some allow you to lock the focus independently, as well). If exposure and focus are tied together in your camera, take a center-weighted or spot reading normally in whatever exposure mode you are shooting in, and take note of the exposure setting; then switch to the manual exposure mode (if your camera has one) and dial in that setting. You're then free to recompose and focus without disturbing the meter reading.

3-10

ABOUT THIS PHOTO *Center-weighted meters are very accurate because they let you meter just the important areas. Exposed using a 400mm Nikkor lens at 1/60 sec., f/6.3 at ISO 200, on a tripod.*

SPOT METERING

Spot metering takes the idea of center-weighted metering and refines it to a precise level. These meters also read a small area in the center of the finder, but it is often limited to an area as small as three degrees — or (compared to a typical viewfinder) about the size of the head of a small nail. Such a tiny metering area can come in quite handy when the important subject area is a very small area of the frame, particularly when large areas of dark or light background would mislead a matrix or even a center-weighted meter. I used the spot-metering mode of my dSLR to take a reading from just the shoulder of the woman in the bottom of the frame in 3-11, for example,

because I knew that otherwise the dark of the water and the brightness of the sand might mislead the meter. Any time that you're confronted by a complex scene that contains a known tonal value (a known middle gray or a skin tone, for example), you can use a spot meter to meter only that area. That's a pretty small area to be reading, and using a spot meter effectively requires patience, experience, and practice.

> *caution* Because you're reading such a tiny area of the viewfinder, it's imperative that you are reading from the correct area — and that you know what to do with the information the meter provides.

3-11

ABOUT THIS PHOTO
Taking spot-meter readings from subjects of known reflectance, such as human skin, can be very useful in establishing a good overall exposure. Photographed with a 18-70mm Nikkor zoom and exposed for 1/400 second at f/10, ISO 200, handheld.

As you'll learn in the section on middle gray later in the chapter, all light meters are designed to record whatever you aim them at as a medium tone. The first problem this creates with spot metering is that if you want to take a reading from a mid-tone area, you must have a trained eye to know exactly what a middle-tone looks like in a complex visual world. You *can* learn to spot tones — and you will — but it does take practice.

The very minimal shot of Fort Lauderdale Beach (see 3-12) presented a real exposure challenge because there was a lot of tonal contrast and not much (other than the sky, perhaps) to meter from. With my spot meter I was able to meter from a tiny area of gray roof on the lifeguard booth, and it provided a dead-on exposure. I could have exposed for the white wall and adjusted the exposure accordingly, or chanced a sky reading, but I knew the gray would work perfectly, and it did.

Of course, you don't necessarily have to take a light reading from just a mid-tone. You could just as easily take a reading from a dark shadow or a bright highlight — but then you would need to know how to adjust that reading to "place" the values where you want them. In the section about the Zone System later in the chapter, I explain (briefly!) the concept of using exposure changes to adjust tonal relationships and how taking spot readings of known tonal values, and then altering exposure to "shift" or alter those values, opens the doors to exposure perfection.

The real benefit of a spot-meter, of course, is that it enables you to take light readings from tiny areas of the frame. Imagine you're photographing a lone mountain sheep standing in a small pool of sunlight on a dark mountain ridge; what you want to get a good reading from is the sheep. If you expose for the animal properly, you can let the dark ridge fall into shadow — you've correctly

exposed for your main subject and that is the key thing. With a spot meter, you can take a reading from just the sheep from quite a distance (which is why spot metering is a favorite technique of wildlife photographers).

HANDHELD METERS

In addition to the meters that are built into digital cameras, there are several types of accessory or "handheld" meters available (just what you needed — another accessory to daydream about

owning!). Handheld meters, some of which cost more than a good dSLR camera, were the mainstay of light metering before the TTL meter was invented, and most professionals and (I believe) a growing number of hobbyists still use them.

Why would anyone want to use a handheld light meter when it's so easy to meter using the camera? A lot of professional studio photographers use handheld meters for one very simple reason: Many of the cameras they use don't have meters built into them. Large-format studio and large-format field cameras, for example, have no means

3-12

ABOUT THIS PHOTO *In complex or contrasty scenes, look carefully to find a reliable middle tone to meter, as I did by using the gray paint on the lifeguard station. Exposed with an 18-70mm zoom at 1/1000 sec., f/7.1, ISO 200 on a tripod.*

of measuring light. Also, for many fine-art and landscape photographers — even those using cameras that have built-in meters — exact exposure is central to the quality of their work, and they simply have more confidence with a handheld meter. As with any craft, precision becomes an obsession, the more involved you become.

Another benefit of using handheld meters is that they typically have much more detailed (and easier-to-read) displays, often providing readouts in tenths of a stop, for example. You can take and store several readings and then average those readings, a useful option in contrasty situations. I've always found it comforting to be able to take a reading of a scene, sit on a rock, and scroll through and consider all of the exposure possibilities (while hoping the light didn't change during my deliberations).

I describe the three basic types of handheld meters in the following sections, but in reality most of the high-end meters (which is pretty much all of them) on the market today are modular meters that are a composite of all three types, which you can see an example of in figure 3-13. Most *reflected-light* meters, for example, can easily be converted to *ambient*-style meters, and most also have spot-metering attachments available as either standard gear or an accessory.

Using a handheld meter is actually quite simple: You set the same ISO that is set on your camera and then, according to the type of meter, you measure the light by pointing it either at the subject or at the camera (or in some cases, the light source). The readings are displayed in a digital format, and on many meters you have a choice of metering modes. In the shutter-speed mode, for example, you can set the shutter speed at 1/1000 second and the meter displays the correct corresponding aperture, and vice versa. Most meters also let you display readings as "Exposure Values," or EV, that are equivalent to whole-aperture or shutter-speed stops.

3-13

Accessory obsession aside, do you need a handheld meter? Probably not. At least not until you reach the fanatical side of photography, and perhaps not even then. Your in-camera meter always does a very good job at measuring light, and in some respects the matrix meter in your camera is the most sophisticated and accurate type of meter around. But for certain photographic specialties (macro work and portraiture come to mind), there are tangible advantages to handheld meters.

Read more about them or ask a professional friend if you can borrow one sometime, and you'll be able to decide if it's a worthwhile accessory.

To me, the value of handheld meters is proven by one other bit of empirical evidence: On eBay, the prices are consistently very strong — a lot of people are still willing to pay for this type of metering accuracy.

REFLECTED-LIGHT METERS

Reflected-light meters work just like the meter in your camera, except that they're self-contained. You take a reading by standing at the camera position and aiming the meter at your subject, or by walking up to your subject to take a close-up reading. Most handheld reflected-light meters take in a fairly wide-angle view (roughly 30 degrees), but many can also be fitted with adapters to reduce the angle of view. As with your TTL meter, the reading you get with a handheld reflected-light meter depends entirely on what part of a scene you aim the meter toward, and so you have to be careful to meter the most important areas.

Because they take in a relatively wide subject view, these meters are really averaging the light bouncing back from different areas of your scene in the same way that your TTL meter does. The difference is that with your TTL meter set in matrix mode, your camera is making educated guesses about what the subject might be and which are the important areas of a scene. When you're using a handheld meter, you have no help in that regard, and so it's up to you to know what to measure and how to interpret those readings. You can easily learn to use one, but in some respects it's kind of like shutting off the navigation system in your car and going back to reading paper maps (if you have young kids, someday you'll get to explain to them what a paper map was).

INCIDENT-LIGHT METERS

Unlike virtually all the other types and variations of meters I've discussed, incident-light meters have one monumental difference: They measure the light *falling onto* a particular subject or scene rather than reflecting from it. This offers a huge advantage for one very simple reason: Because ambient meters read the light before it strikes any subject matter, the meter is not misled by the brightness (or darkness) of your subject. It doesn't matter if your subject is black, white, gray, or a combination of thousands of shades of color; an incident meter just measures the existing light. In fact, to take an incident-meter reading, you point the meter at the camera (or in some cases the light source) rather than at the subject.

Why is this an advantage? Because by reading the ambient light, you're setting the middle tones of a scene exactly where they belong — as middle tones. The meter is designed and calibrated to provide a reading that renders *any* subject a medium tone, and that's exactly what it does. All of the other lighter and darker tones are then automatically placed where they belong. Blacks record as blacks, whites as whites, and all of the middle tones record as they're supposed to record. Among most professionals, incident metering is considered the most accurate method of light measuring, regardless of the subject or the light source.

To take an incident-light reading of a nearby subject like a still life or a flower blossom, you normally aim the meter back toward the lens from the subject position. If the subject is a landscape or another distant kind of scene, you simply meter from an area of similar lighting. Incident meters are particularly useful in low-light situations because there is always more light falling on a scene than reflecting back; this is because once light strikes any object or scene, much of the light is absorbed.

SPOT METERS

As with built-in spot meters, the handheld variety is designed to take exact readings from very tiny areas of a scene — usually about a one-degree angle. That is a *small* area. Again, the advantage of metering such a tiny area of the scene is that you can set your exposure for very specific parts of the scene. Another big advantage is that you can take several readings in succession and then average just those readings (most meters have an automatic averaging feature that is as simple as pressing a button once you've made the readings). Because you are only reading and averaging certain specific areas, you can control what you're averaging.

Most notably, you can also use a spot meter to measure the contrast range of a scene. Most digital cameras, for example, have a maximum contrast or dynamic range from total shadow to highlight of about five stops. If the tonalities in the scene extend beyond that right range, something has to give — either shadows block up and turn black, or highlights burn out (become white with no detail). By knowing that a scene exceeds the contrast range of your camera's sensor, you can make decisions about how to best handle the situation.

Because spot meters read such a tiny portion — often one degree — of the scene area, you not only have to be careful about what area you meter, but when you meter it. A small shadow drifting across your metering target may be impossible to detect with the naked eye, for example, but it does have an effect on the overall scene exposure. I typically meter an area when I first start to plan a shot and then meter again just before I expose the scene. If the readings are less than one-half

stop different, I usually ignore the difference, but I've had occasions when, unexpectedly, that reading changed by more than a stop. Follow the old carpenter's saying: measure twice, cut once.

> **⊕ x-ref** There will be many times when a scene simply exceeds the recordable contrast range of your camera, and when that happens you have to make decisions about which tones to keep and which to either sacrifice or save by altering your exposure settings. I talk more about how to deal with extreme contrast and how you can use simple exposure controls to save contrasty situations in Chapter 8.

A WORLD OF GRAYS

Although we live in a splendid world of many colors (the computer monitor I'm looking at right now can discern and display millions of them), your light meter sees the world as a single gray value. Tragic from the perspective of human imagination and vision perhaps, but a very efficient model when it comes to accurately measuring light. By assuming the world is a single tone of gray, your meter ignores the gaudy trappings and distractions of color, and measures just one thing: how much light is reflecting from the scene that you are pointing it at. And in reality, that is all the basic information you need to create a good exposure.

Regardless of the type of light meter you're using, all of them are calibrated on the following two premises: first, that everything in front of them is (and should be recorded as) 18-percent gray or medium gray, as it's often referred to, in tone; and second, that this is just fine with you (see 3-14

and 3-15). The reason that they are designed to see the world as 18-percent gray is because that gray represents a tonality that is exactly halfway between pure black and pure white. It doesn't matter what colors your subject contains or what

3-14

3-15

ABOUT THESE PHOTOS *If you were to see the world the way the meter sees it as in 3-15, rather than the way that you see it as in 3-14, everything would exist only in shades of gray. Your meter is only interested in the brightness range of a subject, not its color. Exposure for the original (color) scene of these horses was 1/320 sec., f/7.1 at ISO 200, using an 18-70mm zoom, and shot on a tripod. The black-and-white image was converted to grayscale in Adobe Photoshop.*

lighting is illuminating it; your meter is going to give you an exposure recommendation that records that subject as a medium tone.

As you learned in the previous section, you can meter large or small parts of a scene, but whatever part (or parts) of a scene you take your light reading from, your meter wants to record them (or an average of them if there are multiple tones) as medium gray. Black cat? Gray. Yellow cat? Gray. Your great grandmother's beautiful antique-white wedding dress? Gray.

If the world really were made up of just medium tones, this system would work perfectly all of the time, and all of your exposures would be technically perfect. Unfortunately, we would all end up bumping into buildings and tripping down stairs because everything would be exactly the same color as everything else. Fortunately, the world is made up of a lot of tonalities with a lot of subtle distinctions and gradations between them.

Here is the beauty of this system: By recording just one of those tones — a well-chosen middle-gray tone — correctly, you establish the exposure for all of the other tones. If you take a meter reading of a complex scene with a lot of bright, dark, and middle tones, as long as the middle tones are metered and recorded correctly, most of the remaining scene elements will record accurately (or, at least, acceptably). This is true whether you're using a matrix meter that is capable of metering scenes of complex tonal values, or a selective-area meter where you're just metering the middle tone directly.

In the shot of the oyster boat (see 3-16), I used the spot-metering mode of my camera to take a selective reading from the wooden piling in front of the boat, a subject I knew from experience to represent a solid middle gray. By establishing this area as the middle, the brighter areas recorded as whites and the darker areas recorded as dark grays and black.

The reason this system works, of course, is because the objects in any scene *are* of different values, and so they don't all expose on the sensor in the same way. The dark tones provide *less* light to the sensor and so, in effect, they are underexposing (compared to the middle tones). Similarly, the light tones in a scene are providing the sensor with *more* light and so they are overexposing compared to the middle tones. As long as all of the tones in the scene are within the acceptable contrast range of your camera's sensor, you end up with a correct exposure. You might still have to tweak the exposure a bit to put the values exactly where you want them, but the base exposure is very accurate.

3-16

ABOUT THIS PHOTO *By using a spot meter to precisely read an area I knew to be a middle gray, the exposure for the rest of the tones in this scene fell into place correctly. Shot with a 18-70mm Nikkor zoom lens and exposed for 1/800 second at f/7.1, ISO 200, on a tripod.*

SITUATIONS THAT FOOL METERS

Things get a little trickier when your predominant subject is either significantly lighter or darker than a middle tone. If you were photographing a pretty white rose in close-up, for example, and aimed your meter so that all it saw was the rose, you would end up with a gray rose — and there is nothing the world needs less than a gray rose. Similarly, if you were to take a meter reading of your shiny, new, black Corvette (perhaps you won the lottery that week), you would end up with a portrait of your very expensive, medium-gray sports car. (To which your friends would say, "You should have spent some of your money on a better camera.")

Another classic example of a meter-fooling subject is snow. If you simply take a meter reading at face value when photographing a snow scene, you end up with a photo of a nice gray winter's day. Remember, your meter doesn't care how Currier and Ives reproduced snow, it wants that snow to be medium gray. In order for the snow to return to pristine white, you have to add some additional exposure, either by adjusting the meter reading manually or by using your exposure compensation feature (I discuss both of these methods later in the chapter); or, you have to find something else in the scene to meter besides the snow — as I did in the shot of the headstone (see 3-17) in historic Deerfield, Massachusetts.

3-17

ABOUT THIS PHOTO *One safe way to meter snow scenes is to meter something besides the snow. Here I was able to meter the slate headstone — nearly a perfect medium gray. Exposed with a 105mm Nikkor lens at 1/320 sec., f/9, ISO 200, on a tripod.*

It's important, then, to learn to recognize when a particular subject is likely to fool your meter and, just as importantly, to know where to meter a scene to get the best results. Any time that your predominant subject area is significantly darker or lighter than a middle tone, the meter is in jeopardy of being fooled — or at least straying somewhat from a perfect exposure. Learning to recognize what a middle tone is, of course, takes some experience.

> **tip** One way to learn to recognize strong middle tones is by consciously eliminating the extreme tones. You know that snow and white sand are extreme tonalities, for example, as are dark shadows, black pavement, and almost anything in pure silhouette. The farther you get away from these tonal extremes, the more likely your subject is to be of average or middle tonality.

METERING SHORTCUTS

Theory, theory, theory. What we need here, you say, is some quick, practical advice — a shortcut through the tonal theory would be nice. I agree. The more photographs you take (and print) and the more time you spend with your camera, the faster you will begin to recognize the "good" areas to meter from — that is, middle tones. Fortunately, there are a lot of common subjects that are of a medium tone, and all you have to do to get a good exposure is to meter from one of them. The blue northern sky on a clear day, for example, is an ideal metering target if you're photographing front-lit landscapes. When I photographed the Chrysler Building in Manhattan (see 3-18), for example, I knew that the silvery surface of the building would mislead my meter no matter what mode I used, and so I simply pointed the lens to the right of the tower and took a meter reading directly from the blue sky.

3-18

ABOUT THIS PHOTO *Photographers have been lured to the Chrysler Building since it was first built. Metering it is tough because of the polished surface. I metered the sky and shot at that reading: 70-300mm Nikkor zoom lens at 1/500 sec., f/4, ISO 200, on a monopod.*

If green grass and green foliage are in the same light as your main subject, then metering off of them provides very good exposure results. In the formal garden at Chateau du Chenonceau in the Loire Valley region of France, I had no trouble finding something green to meter off of (see 3-19). I simply metered off of the grass in the foreground using a center-weighted meter, and the exposure was quite good. I did only minor tweaking of colors in Photoshop; the actual exposure remained unchanged.

ABOUT THIS PHOTO *Brightly lit scenes that contain a lot of green grass or foliage are simple to meter — just pick an evenly lit area of foliage and take a close-up meter reading. Exposure was 1/125 sec., f/11, ISO 200, on a mono-*

3-19

Gray subjects such as weathered wood or stormy skies can also be a good place to look for middle tones. The porch wall of this worker's shack on the estate of Marjorie Kinnan Rawlings (the author of *The Yearling*) in Cross Creek, Florida, is a great example of a "found" middle-gray subject (see 3-20). Because the wood dominated the frame, I knew that a matrix reading would provide a good overall exposure. If the wood hadn't dominated the frame, but had only been one small area, I would have switched to a center-weighted mode to take the reading.

The following list contains examples of good middle-tone subjects. If you take your meter reading from any of these subjects, you can get a good overall exposure. (Why didn't he say this five pages ago, you ask? Because unfortunately, not every scene will have one of these subjects in it — and so, sooner or later you're going to have to make your own list of good metering subjects.)

- Red-brick buildings
- Green grass in sunlight

- Average gray weathered buildings
- Gray stone (in average light)
- Clear, blue sky (particularly northern sky)
- Dark skin (or shadows on lighter skin)

Once you identify a good middle tone for metering, you can use several simple techniques to be sure that your meter is biasing its reading for that subject. If you're using matrix metering and the middle-tone subject is relatively large, you won't have any problems because the meter will favor that part of the scene. If the important middle tones are smaller, however, you have a few options for getting an accurate reading of just that area. One way to get a close-up reading, of course, is to simply move closer to the subject (or zoom in on it). You can then use your exposure-lock feature to hold that reading while you recompose the scene to take in a larger view. Or you can switch to either center-weighted or spot metering to take a reading directly from the area you want to meter. In any case, use your exposure-lock feature to hold that reading and then recompose the scene.

THE ZONE SYSTEM

By this time, you're probably waving your hand and dying to ask one simple question (which all of my students ask almost simultaneously whenever I talk about exposure): What happens if you're metering a subject that isn't a middle tone and you don't want it to reproduce as a middle tone — such as the infamous white rose? Ah, there's the rub. The answer is that you have to modify your exposure in order to place the tonal value of that particular subject where you want it. By adjusting your exposure, either toward underexposure or overexposure, you can alter the way that any tone within any subject reproduces. So how do you do that?

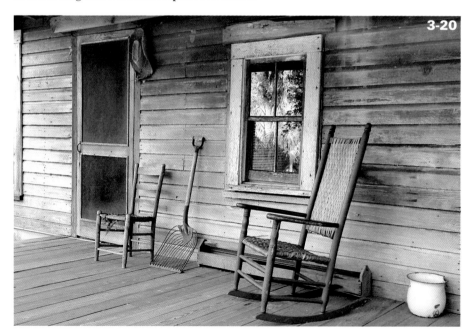

3-20

ABOUT THIS PHOTO
I took a matrix reading of the front porch and it provided an exposure that needed almost no post-production work (I did saturate the reflection a bit). Exposed with a 10-20mm Nikkor zoom lens at 1/30 sec., f/4, ISO 200, on a tripod.

There are actually several different ways that you can modify exposure, and they are all fast and easy to use. In order for you to understand how each of them works, let me first give you a very brief look at the Zone System.

Photographers Fred Archer and Ansel Adams developed the Zone System theory of exposure in 1941 so that photographers would have a consis-tent and universal means for measuring exposure and for creating negatives and prints that matched their personal interpretations of a scene. Many books have been written about the Zone System (including several by Adams) that explain all of the deeper complexities of the system, but Archer and Adams never meant for the system to become complicated. In fact, it was their intention that the system would simplify exposure. Unfortunately,

USING AN 18-PERCENT GRAY CARD Another technique that many professionals use to get accurate meter readings is to meter from an "18-percent gray card" rather than the actual subject. These cards (usually about 8½ x 11 inches, but you can buy pocket-sized versions) are carefully calibrated to reflect 18 percent of the light striking them. In other words, they are perfectly matched to your meter's calibration. Hallelujah, a system is born!

Using a gray card is incredibly simple: You place the card in the scene in an area that is lit similarly to your main subject and then meter the card. It's important when you take the meter reading to fill the frame with just the card and to be sure the card is aimed slightly toward the light source. Once you have a reading, you can either use your exposure-lock feature to hold it (provided your camera has an exposure-lock feature that doesn't automatically lock your focus — check your camera manual) while you recompose the scene, or you can switch to your manual exposure mode and set that reading manually.

Metering from a gray card provides near-flawless readings in almost any situation, and I consider it an invaluable tool when you're learning to expose things properly. The problem is that if you're photographing a landscape or other broad scene, it's not always easy to get the card into the same light as the overall scene. If you can, that's great. If not, I still recommend using the card as long as the lighting isn't radically different from the more distant scene, but you have to be aware that you may not be getting an ideal meter reading. Gray cards are especially useful for outdoor still-life subjects, formal portraits, and macro photography.

Although the concept of meters being calibrated for "18-percent" gray has been accepted as an industry standard since light meters and gray cards were first introduced, there has been a serious amount of debate on this issue among photographers and, of course, on the Internet. The truth is that light meters are probably calibrated to a figure closer to 13 and not 18 percent. What does this mean for the average photographer? Essentially, if this argument is true, it means that when you take a reading of an 18-percent gray card, your reading will be underexposed by about one-half stop of light (the difference between 18 and 13 percent is roughly one-half stop). Should you even care? If you're making fine-art prints of your digital images, or if you're involved in copying paintings or other flat art, a very precise reading could be important. You can find a lot of articles about this topic online.

probably because it works so perfectly, the Zone System has developed an almost cult-like status among some photographers — many who have imbued it with a near-spiritual dimension. I'll just give you the practical information.

Although the Zone System is usually associated with black-and-white film photography, the underlying theory works quite well in explaining how changes in exposure can affect the tonal range of a photograph — even with color digital photography. Essentially what Archer and Adams did was to divide the tonal scale — the complete range of tones between pure black and pure white — into 11 equal shades of gray or "zones" (you will also see it condensed to nine or ten tones in some books, but in practical terms it makes little difference). As figure 3-21 shows, in the 11-step version, Zone O represents pure black (black with no detail), while Zone X represents pure white (white with no detail). Zones I through IX are the main tones that contain some level of detail and texture. Zone V represents the exact middle of that scale.

Here's where the knowledge you gained in Chapter 2 comes into play. Each zone in the scale represents a tone that is either half as dark, or half as light, as the previous one. Sound familiar? In other words, *each zone is exactly one photographic stop away from the one next to it*. So if you take a meter reading of a Zone V subject and want it to be one stop darker, you simply underexpose one stop from your meter reading. If you want the tone to be one zone lighter, just add one stop of exposure.

There you have it: the essence of the Zone System. I'll venture forth with a few more paragraphs, but what you just read explains most of what you need to know.

It doesn't matter how you get there — you can adjust the shutter speed or the aperture — but each time you change the exposure by one stop in either direction, *every zone on the scale shifts in that direction by one stop*.

Here's a practical example: In looking at the scale, let's assume that my shot of a great white egret (see 3-22) should land on about a Zone VII tone — white with some gray detail and texture. If I had photographed the egret at the metered reading, the egret would actually record as a Zone V. But I wanted the egret to be closer to a Zone

0	I	II	III	IV	V	VI	VII	VIII	IX	X
0	026	051	077	102	128	153	179	204	230	255

3-21

ABOUT THIS FIGURE
A depiction of the Zone System scale where each separate zone is one f-stop from the next.

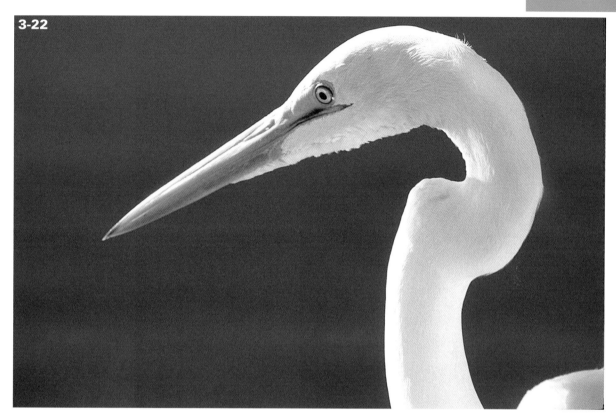

3-22

VII and I wanted its highlights to be almost pure white, with some minor detail. So instead of shooting at the metered reading, I opened the lens by two full stops.

I'll work it in the opposite direction: Suppose your black cat is sitting on the porch looking as cute as ever, and you decide to take a close-up portrait. If you read directly from his face, your black cat will be your Zone V gray cat. Your cat really belongs around Zone II (black that still shows detail), which is also three stops away, but in the opposite direction. By *underexposing* from your meter reading by three stops, your cat will be "zone shifted" down to Zone II. Voilà! Black cat. In reality, with a matrix meter you might not need three full stops — you might get the black

you're after by shifting just two zones — but experience is the best guide.

As I said earlier, it takes some practice to visualize color subjects as tonalities, but the system does work equally well with color. If you were photographing a yellow tulip, for example, you would probably want it to reproduce as approximately Zone VI or Zone VII. But again, if you meter just the yellow tulip, you end up with a Zone V tulip. By opening the lens one or two stops and *overexposing* from the metered tone, you have a much more natural-looking flower.

Do you have to memorize all of this zone theory to get good photos? Absolutely not. But understanding the basic premise of the Zone System provides a practical and visual guide for tweaking your

exposures when the meter is making them either too dark or too light in the final print. There are a number of simple ways to adjust your exposure, and once you become comfortable with the concept of altering exposure to shift tones, you'll find yourself using the tools outlined in the following sections without thinking much about them.

EXPOSURE COMPENSATION

Your camera's exposure-compensation feature (usually a button or a dial near the top of the camera) lets you add or subtract exposure from the metered exposure. Typically you can add or subtract exposure in one-third-stop increments up to a maximum of two or three stops in either direction. Once the compensation is set, it is applied to each frame until you set it back to zero. (Shall I tell you of all the hundreds of times I've found myself shooting with compensation from a

previous shot when I no longer wanted it but forgot to reset it? Do what I say, not what I do — reset it as soon as you're done.) This is a great feature if you happen to be shooting in a situation like the foggy Cape Cod lighthouse in 3-23, where you know you're going to want to add an extra stop or two of light to every frame you shoot. Knowing how much compensation to use is purely a matter of experience. With sunlit snow, for example, I've found that two extra stops of light usually provide a clean, white snow with good detail, but with fog I often find that one additional stop is enough.

tip I recommend that you make yourself a little crib sheet on a 3 × 5 index card with notes on how much compensation certain common subjects (for example, fog, snow, ice, and dark skin) use so that you have a handy reference tool.

3-23

ABOUT THIS PHOTO
Exposure compensation is a quick and convenient way to boost (or reduce) exposure. I used +1 stop of compensation for this shot. Taken with a compact digital camera and exposed for 1/400 second at f/7, ISO 200, on a tripod.

EXPOSURE LOCK

Your camera's exposure-lock feature lets you meter one part of a scene (a recognizable Zone V area, for example) and then lock that reading in while you recompose the scene. I often use this method when I'm using center-weighted or spot metering, because I can do it quickly and do not have to stop what I'm doing and take my hands off of the controls to set exposure compensation or switch to the manual exposure mode.

MANUAL EXPOSURE

If you're using a dSLR or a more feature-laden zoom camera that has a manual-exposure mode, you have ultimate control over adjusting the metered exposure. In the manual mode, you are free to set whatever aperture and shutter-speed combination you like, based on your meter reading. In my film days, I used the manual mode almost exclusively because I knew precisely how different films would react to different lighting situations. Because I'm obviously not switching films with digital, I find that I use the manual mode far less often (the one exception would be long-time exposures where I am often experimenting — using the manual mode is a much faster way to set long exposures). In the manual mode, your camera's meter still recommends the correct exposure, which you are then free to completely ignore.

x-ref

In Chapter 6, I discuss all of the available exposure modes, including the manual-exposure mode.

BRACKETING

The exposure-bracketing feature lets you program in a series of exposures that you can shoot in rapid succession while automatically altering the exposure for each frame you shoot. Typically you would program the bracketing feature to give you one exposure at the metered setting, and then one frame that is underexposed from that setting and one that is overexposed — although some cameras let you program up to seven or more successive frames. On most cameras, the bracketed exposures can be made in a quick burst by just holding down the shutter-release button (although on some cameras, you also have to reset the camera for continuous shooting).

To program the bracketing, you simply tell the camera how many frames you want to shoot and how many stops (or fractions of a stop) difference you want between each frame. In the foggy early morning scene (see 3-24, 3-25, and 3-26), for example, I wanted to see some variations of exposure with the fog, and so I programmed the camera to shoot one frame at a full stop overexposed, one frame at the meter reading, and one frame at a full stop underexposed. With more sophisticated cameras, you can also decide whether you want to stick with the traditional "one-frame-under/one-frame-over" arrangement or to set all of the frames to either under- or overexposure. In this instance, I could just as easily have told the camera to shoot one frame at the metered exposure, then one frame overexposed by one stop, and then another frame overexposed by two stops.

Exposure bracketing is a wonderful tool when it comes to learning how variations of exposure affect your subjects, and even when you're very

experienced, you'll find yourself using it to deal with unusual or very demanding situations. Using this feature is kind of like playing the show and place horses while still betting on the horse you want to win the race. If you bet on enough horses, you're bound to pick a winner.

3-25

3-24

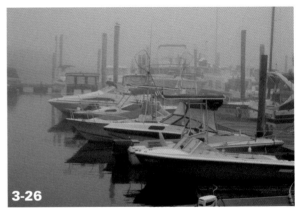

3-26

ABOUT THESE PHOTOS *This series shows the bracketing sequence that I used one foggy morning to give myself a choice of three exposures. Fog tends to underexpose shots (as it did here in two out of the three frames) because it fools the meter into thinking there is more light than actually exists. The shot I like best is 3-24, taken at 1/6 second, which was overexposed from the meter reading by one stop. Exposures were as follows: 3-24, 1/6 sec.; 3-25, 1/13 sec.; and 3-26, 1/25 sec. All f/14 at ISO 200, using an 18-70mm Nikkor zoom lens, on a tripod.*

Assignment

Search for the Middle Tones

Learning to identify middle tones in any scene is like having a steady anchor in a visual light storm. If you can find a good middle tone in a complex scene, you always have a trusted subject you can use as a metering target. For this assignment, search out a subject that you think is a good middle tone — whether it's gray or a particular color — and either walk close enough to meter just that tone or use your center-weighted or spot-metering function to meter only that tone. Remember, middle tones aren't just gray, they can also be green grass, weathered wood, or even a red-brick building.

I found the scene here quite by accident while looking for a bakery in the small French town of Amboise. I almost laughed when I saw the scene because it looked like it was designed for an exposure lesson — almost every building in the town was a nice, solid middle-gray tone. I took both matrix readings and center-weighted readings (mostly of the tall building on the right), and they were nearly identical. I tweaked the saturation of the colors a bit when editing this shot, but the exposure was ideal right out of the camera. Taken at 1/200 second at f/8.0, ISO 200.

Remember to visit www.pwassignments.com after you complete this assignment and share your favorite photo! It's a community of enthusiastic photographers and a great place to view what other readers have created. You can also post comments, and read encouraging suggestions and feedback.

79

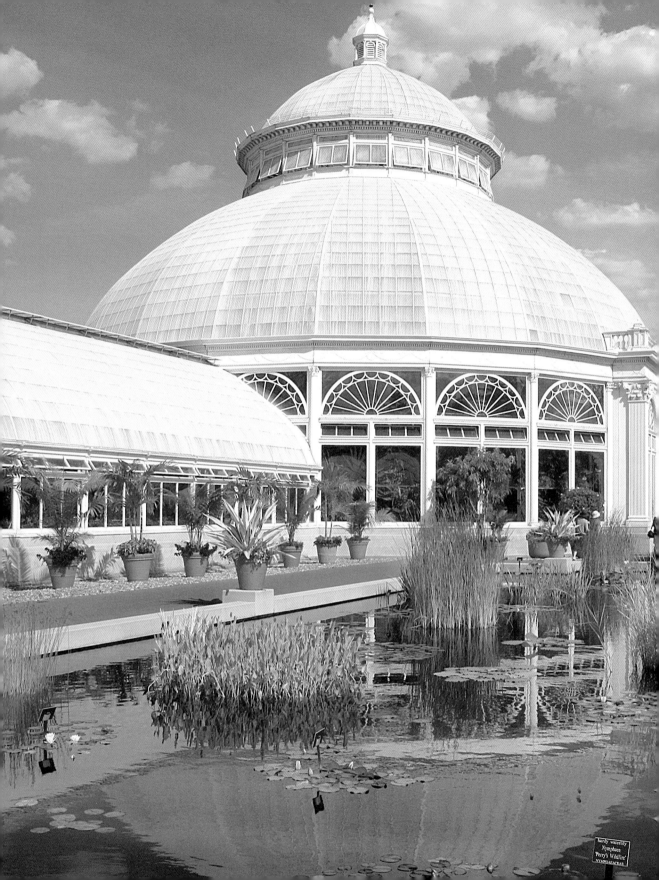

LENS APERTURES AND DEPTH OF FIELD

The primary function of the lens aperture, as you now know, is to let light into your camera. No aperture, no light. The ability to adjust aperture size gives you profound and precise control over exactly how much light reaches your camera's sensor. If that were all there was to the aperture story, of course, this would be a very short chapter. But, there is more to the story and this chapter is where the fun and sexy part of apertures comes to life.

One of the by-products of having an adjustable aperture is that, because of the physics of optics, a very interesting thing happens as you change the aperture size: the amount of near-to-far focus (also called *depth of field*) changes. That small feature is one of the most creative and interesting tools that you have access to as a photographer. The ability to shift what is and what isn't in focus, beyond the actual point of sharp focus, gives you extraordinary control over how viewers interpret your subjects. You can, for example, render backgrounds totally out of focus (fun to use in portraits; see 4-1) or pull everything in a scene into sharp focus (something you'll use often in landscapes; see 4-2).

Before I explain the fun and magic of depth of field, though, I'm going to present a collection of technical concepts and definitions that are closely related to apertures. There really aren't that many technical things to remember about apertures, but understanding the concepts and being familiar with the lingo is quite useful. One of the great things about learning how apertures work and understanding the terminology, especially if you own a dSLR, is that this information can help you when it comes to shopping for lenses. Much of what makes lenses expensive (or inexpensive) is related to their aperture system.

4-1

Here's something else you might find interesting: Lighting and subject aside, the thing I think about most when I'm taking pictures is aperture. Knowing what is or isn't in focus is *very* important to me when I'm shooting, and so are things like the brightness of the viewfinder (which you'll see shortly is related to aperture size). In fact, if you were to tap me on the shoulder when I was about to shoot a picture (and I discourage that idea right here and now), you would likely interrupt just one thought: *Am I using the right aperture?*

4-2

ABOUT THIS PHOTO *A small aperture combined with a wide-angle zoom setting on my 18-70mm Nikkor zoom lens provided extensive near-to-far sharpness for this Iowa farm scene. Exposure was 1/50 sec., f/16 at ISO 200, on a tripod.*

A REALLY EASY LESSON IN APERTURE TERMINOLOGY

A number of years ago, I brought a friend with me to the camera shop one Saturday afternoon and, as usual, I got into a discussion about lenses and f-stops and the glory of "fast glass" (I'll explain that in a minute) with the clutch of photographers who were hanging around in the shop. (Yes, this really is the stuff that photographers talk about.) The conversation went on for an hour or so, and when my friend and I left, she turned to me and said, "I didn't know you spoke another language." To her, the names, numbers, and descriptions of lenses that the photographers were using might as well have been spoken in a completely different language.

It was then that I realized that the terminology that had become such a part of my consciousness was, well, Greek to most non-photographers. It was a good lesson to learn because as I began writing and teaching more, I was always careful to explain all the terms I was using so that no one was left needing a translator. On the next few pages, I define some basic terms and unravel the last tidbits of math that you need to know to better understand your camera's aperture system. Just think, after you've read this chapter, you'll be able to eavesdrop on the local photography aficionados and understand every word.

THE F-STOP NUMBERING SYSTEM

All lenses, regardless of the brand, the focal length of the lens, or the type of camera that they are used on, use the exact same f-stop numbering system. Some lenses may have more f-stop choices than others, but the sequencing of the *whole* numbers that they share in common is exactly the same. In the pre-digital days, these numbers were always inscribed on the lens barrel on what was known as the "aperture ring," and in order to set a particular aperture, you simply twisted that ring until the aperture you wanted was adjacent to a mark on the lens. Many dSLR lenses still have an aperture ring, but today, of course, apertures are typically set electronically.

As I discussed in Chapter 2, each number in the traditional f-stop sequence represents a *whole stop difference* in light gathering from the adjacent number. If you move to a larger f-stop (a smaller number), you double the light entering the lens; if you move to a smaller f-stop (a larger number), you halve the light. The standard f-stop numbering pattern looks like this: f/1.8, f/2.8, f/4, f/5.6, f/8, f/11, f/16, f/22, and f/32. There are some lenses that have larger maximum apertures (such as f/1.4) or smaller apertures (such as f/45), but they still represent full-aperture stops. The important thing to remember is that among the apertures they do share, the sequencing is always exactly the same.

One difference that you'll encounter between older lens aperture rings and f-stops set electronically on digital cameras is that, in addition to the whole number stops, you can set precise intermediate f-stops, typically in one-third stop increments. On an older lens, for example, while you won't see any intermediary stops between f/4 and f/5.6 (a whole stop), on some lenses you would see two tiny dots indicating third-stop increments. With digital cameras, however, there are almost always incremental f-stop choices between

the whole-stop apertures. On my Nikon dSLR, for example, between f/4 and f/5.6 (one whole stop), there are two incremental stops — f/4.5 and f/5 — and these represent one-third stop increments. Look in your manual and you'll find the exact sequence that your camera uses.

Do you really need the minimal exposure shifts offered by third-stop increments? Actually, sometimes an extra third (or a third less) of a stop is exactly what you need. As you gain experience at working with different subjects (especially difficult or contrasty subjects), you will find that the ability to "tweak" an exposure by a third of a stop (or, more frequently, two-thirds of a stop) provides a very important bit of flexibility, or what I call the "nudge" factor. I'll often bracket an exposure in one-third stop increments, for example, just to be sure I have the exposure I want — particularly with tricky subjects like the old New England clock tower shown in figure 4-3.

WHERE THE NUMBERS COME FROM

Until you understand its meaning, the sequence of aperture numbers might look somewhat random or even arbitrary but, of course, there is always the persistent hand of science lurking just under the surface, and the numbers actually do mean something. Why should you care? Simple: Once you understand the basic principle of what the f-numbers mean, it becomes much easier to visualize the size (and comparative relationship) of different f-stops.

The math is elegant and simple: The f-numbers represent the ratio of the physical aperture diameter to the focal length of the lens. In other words, if you're using a 100mm lens and you're using an aperture of f/4, the physical size of the aperture is 25mm, or one-fourth of 100mm. If you moved to a *larger* aperture (that is, a smaller

4-3

ABOUT THIS PHOTO *I photographed this clock tower late in the afternoon under a clear sky. I added extra exposure from my meter reading to keep the tower white, but also bracketed in one-third stops. Taken with an 18-70mm Nikkor zoom lens, exposed at 1/320 sec., f/9 at ISO 200, handheld.*

f-number) such as f/2, the size of the lens aperture would be 50mm (because 50mm is one-half of 100mm).

You can always figure the diameter of the lens opening by simply dividing the f-stop number into the focal length of the lens. If you're using a 400mm lens set at f/8, for example, the diameter of that f-stop is 50mm. If you switch to f/2, the diameter is 200mm. Which is larger? Which will let in more light?

Will you ever need to know the physical diameter of the aperture? Never. It will *never* come up. But

again, knowing how to figure it out can always help you to know which f-stops are bigger and which are smaller — *and that is the only reason to do the math*.

It might help you to visualize this if you imagine flipping the lens opening sideways: If you were using a setting of f/2, it would fit exactly twice from the center of the front lens element to the sensor plane of the camera. By the same token, an aperture of f/16 would fit 16 times from the center of the front element to the sensor plane. It's easy now to visualize that an f-number of f/16 represents a much smaller aperture than f/2 — after all, you can fit 16 f/16 openings from the front of the lens to the sensor, but you can only fit two of the f/2 openings.

If you're a math person, the beauty of this logic is the kind of thing that makes your morning coffee taste better. If you're not a math person, it's the kind of thing that makes you a little bit suspicious of people who say they *do* understand it. Not to worry, though; if understanding the relationship between f-numbers and lens focal length leaves you cold, then ignore it. At no point when you're out photographing a deer in a meadow at dawn will anyone (including the deer) ask you to explain the size of various apertures.

LENS SPEED

One term you often hear photographers use when they're talking about lenses is *lens speed*. The speed of a lens is described by its maximum aperture size. If you have a 100mm lens with a maximum aperture (largest lens opening) of f/4, for example, the speed of the lens is f/4. The larger the maximum aperture is, the faster the lens is considered to be. This is because the wider the maximum aperture, the faster light can get to the sensor because more of it enters though a larger opening (and also the faster the shutter speed you can use when the lens aperture is wide open).

Lenses that offer a large maximum aperture are commonly referred to as "fast" lenses (or "fast glass" in photographer-speak), and lenses with smaller maximum apertures are regarded as "slow." As with sports cars and racehorses, faster is generally considered better — at least among equipment enthusiasts.

Lens speed is important for two reasons: First, the faster a lens is, the brighter the viewfinder is when you're focusing (again, because more light is coming into the camera), and that can be particularly useful in low-light situations. I've done a lot of concert photography over the years, and when I'm photographing performers like guitarist Artie Traum (see 4-4), the venues are typically very dark, even with stage lighting, and so having a bright viewfinder really helps me compose these tight shots.

Second, in low-light situations, having a wider maximum aperture means that you can shoot at a faster shutter speed (or work at a lower ISO, or both). Personally, I am only concerned with the first advantage because I almost always use a tripod and so, unless I am trying to restrict depth of field, I would rarely use the widest aperture. In fact, if I were to quickly scan the metadata for 1,000 recent photos, I doubt that you would find 25 pictures shot at the maximum aperture.

As a rule, the faster a lens is, the more expensive it is and the heavier and larger it is. In order to

4-4

ABOUT THIS PHOTO *Lens speed plays a very important role in providing a bright viewfinder image in dimly lit situations, like this live performance shot. Exposed using an 80-200mm f/2.8 Nikkor zoom lens at 1/100 sec., f/5 at ISO 1600, on a monopod.*

get more light into a lens, manufacturers have to use larger elements and more refined types of glass, both of which add to the cost of manufacturing. Also, single-focal-length lenses (also called prime lenses) are faster than zoom lenses — usually by a stop or two. Some manufacturers make the same-focal-length lens in several different speeds. For example, a 135mm *prime*-focal-length lens might be available with a lens speed of f/2 and f/3.5. You can guess which one is more expensive.

Zoom lenses (with the exception of very expensive professional lenses) are usually a stop or two slower than prime lenses within their focal-length range. A 50mm lens might have a speed of f/2, for example, while a 50-135mm zoom might have a maximum aperture of only f/4.5 or even f/5.6. The loss of two stops of light makes the viewfinder image significantly dimmer.

Lens speed is really only an important issue with dSLR lenses and some advanced zoom cameras, because compact cameras typically have smaller zoom ranges and larger maximum apertures. Still, if you're in the buying mode, it's worth reading the camera's specifications to see what the maximum aperture is, because it will tell you something about the quality of the lens and the brightness of your viewfinder (including your LCD panel).

 note Single-focal-length or prime lenses typically have a faster maximum aperture and are lighter and more compact than zoom lenses (although that's not always the case). Many photographers find that prime lenses are optically superior to zooms, although in recent years the quality of zoom lenses has increased significantly.

CONSTANT VERSUS VARIABLE-MAXIMUM APERTURES

On all single-focal-length (non-zoom) lenses, the maximum aperture remains constant. If you have a 135mm f/2.8 lens on your dSLR, for example, the maximum aperture is always the same. This is not true of many zoom lenses, though — most zoom lenses (especially those in the consumer price range) have a variable maximum aperture that gets smaller (gathers less light) as you extend the focal length of the zoom. You might notice, for example, that your 70-300mm zoom lens has two maximum apertures marked on the lens: f/3.5-f/5.6 is common for a lens in that zoom range.

When you are using the lens at its shortest focal length (70mm), the aperture is indeed f/3.5 — a fairly fast lens. But as you zoom out toward 300mm the lens speed decreases, and by the time you hit 300mm you're shooting with an f/5.6 lens — a considerably slower lens speed. In practical terms, what this means is that as you zoom out your lens, the viewfinder gets dimmer because the maximum aperture is getting smaller. In between 70mm and 300mm, you would have a mid-range aperture of roughly f/4. Most people don't notice the difference in viewfinder brightness, especially on bright, sunny days, but if you're working indoors a lot in dim lighting, it is something to keep in mind.

There are some zoom lenses (most of them in the professional category) that have a constant maximum aperture. My Nikkor 80-200mm f/2.8 lens, for example, always has a maximum aperture of f/2.8, regardless of the focal length that's being used. This is a great benefit in terms of viewfinder brightness and, again, it works well in low-light

situations, but generally these lenses are heavier, bulkier, and cost more money. If you're young, have strong shoulders, and have a lot of disposable cash, they're great, but living without them is not a major inconvenience.

Speaking of money, here's one last thought on lens speed: Lens speed and lens price are always related. The faster a lens is, the more it costs, and that's true for prime lenses and zooms. Before you break the bank and decide that you absolutely need a faster lens, compare the prices. Often the difference between an f/3.5-f/5.6 variable speed zoom and an f/2.8 constant-aperture zoom, for example, is enough to pay for a week's vacation in Hawaii (and I'm not kidding). While I have owned some very expensive lenses in my career and I have loved using them, I'm pretty sure that if I had it to do over again, I'd use the cheaper lenses and watch the sun set more in Maui. Probably.

AUTOMATIC LENS DIAPHRAGMS

One question that you might well be asking by now is this: *Why doesn't the viewfinder get darker when I have the lens set to a small aperture that lets in very little light?*

The answer is because all modern lenses have what is called an *automatic diaphragm* built into them (although this wasn't the case until Pentax introduced the concept in 1948). This simply means that no matter what aperture you have set on the lens, you are always viewing through the maximum aperture. The lens only stops down to the "taking" aperture (the f-stop that you are actually using to expose the shot) the instant that you press the shutter-release button. Once the exposure is made, voilà, you're looking at a bright viewfinder again.

note You may also hear lenses with automatic diaphragms referred to as auto-indexing or AI lenses.

THE CREATIVE POWER OF DEPTH OF FIELD

You may be getting the impression by now that a lot of the creative and technical aspects of photography hinge on that little hole in the middle of your lens — and you'd be right. As I mentioned at the beginning of the chapter, in addition to modifying and controlling exposure, adjusting the size of that opening has a radical effect on what is and isn't sharply focused in your pictures.

Without going into the optical physics of why aperture so profoundly affects what is and isn't sharp, the entire concept is based on one simple fact: A lens can only focus precisely on one plane at a time. While most of us are learning to take good pictures, we're paying so much attention to getting the subject sharply focused that we sometimes forget that sharpness (or lack of it) isn't limited to one single point in the image. If you are taking a portrait of your neighbor the farmer, for example, you can focus sharply on his eyes, the tip of his nose, or the brim of his John Deere cap, and that is the plane of sharp focus. Everything at that precise distance from the lens is equally sharp. But there is a zone both in front of (the front of his tractor) and behind (the corn in the field) that plane that appears in *acceptably* sharp focus. That region of acceptable focus is the *depth of field*.

Usually there is not a hard line of demarcation between what is in focus and what isn't; it's a gradual fall-off and, in many situations, that's exactly what you're after. In broad situations like landscapes, for example, it's hard to spot where the sharpness begins to fade. In the shot of the fishermen at sunset (see 4-5), I was focused on the fishermen on the distant jetty, but it's hard to spot a fall-off in sharpness anywhere in the frame.

In other situations, where a large aperture is used to limit depth of field, the line is more abrupt, and that itself can be a powerful creative tool. In figure 4-6, for example, I photographed the patterns of twisted vines and barbed wire on a fence in Iowa and used a relatively wide aperture of f/5.6 to limit focus to just the fence.

There is no "right" or "wrong" amount of depth of field — it's a totally subjective concept and is based entirely on your interpretation of a particular subject or scene.

The beauty of being able to manipulate depth of field is that you can use it to focus (bad but useful pun) attention on a particular subject. In a portrait, for example, you can limit depth of field to just the subject so that the background falls softly out of focus. Jennica Reis, a former student of mine (now turned professional), took the charming portrait of her daughters holding hands on a walk (see 4-7) and limited sharp focus to just the girls. By doing this, she's aimed our attention at

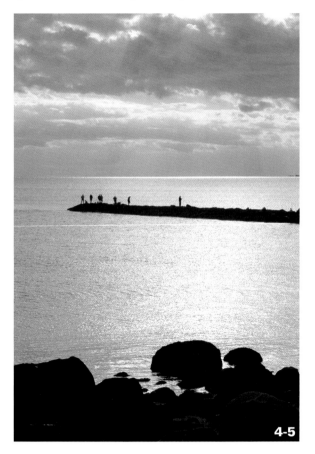

4-5

ABOUT THIS PHOTO *Although I was using a moderate f-stop for this shot, the entire frame is sharp because most of the scene is at or past infinity. Exposed with an 80-200mm Nikkor zoom lens at 1/1250 sec., f/9 at ISO 200, on a tripod.*

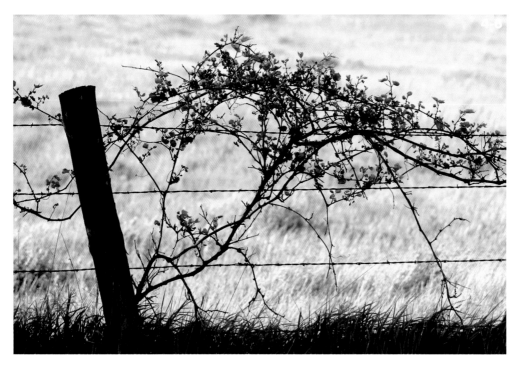

the little girls and lets the softer background create a quiet, contemplative setting.

The opposite is also true. In a landscape, for example I photographed the Saint Augustine National Military Cemetery (see 4-8) in St. Augustine, Florida, using a combination of a wide-angle lens and an aperture of f/16 to keep everything in sharp focus. Because the entire scene is sharply focused, the eye is free to wander, admiring the fine detail along the way. You won't always want toe-to-horizon sharp focus in a landscape, of course, but most landscapes benefit from a deep depth of field.

4-8

ABOUT THIS PHOTO *Keeping everything in sharp focus in a landscape lets the eye explore details throughout the frame. Photographed using an 18-70mm Nikkor zoom lens at 1/250 sec., f/16 at ISO 200, on a tripod.*

DEPTH OF FIELD FACTORS

Several factors affect the amount of depth of field in any given shot, including the focal length of the lens that you're using, your distance from the subject, and, of course, the lens aperture. While this chapter deals mainly with the effects of lens aperture, it's important to remember that aperture is not the *only* factor dictating the range of sharp focus. In order to effectively control depth of field, you must simultaneously consider all three primary elements: aperture, lens focal length, and subject distance.

APERTURE

All other things being equal (and I talk about those other things in just a moment), there is one simple rule to bear in mind when it comes to selecting aperture to manipulate depth of field: The smaller the aperture is, the more depth of field you have (see 4-9). The larger the aperture you're using, the less that is in sharp focus (see 4-10). If you're using a normal lens, for example, an aperture of f/22 provides near toe-to-horizon depth of field (again, all other factors being equal), while an aperture of f/2.8 provides almost none.

4-9

ABOUT THIS PHOTO *I used a relatively long 70-300mm zoom lens (at about 250mm) for this landscape of rolling hills, but I wanted to keep everything in sharp focus. Exposed with a 70-300mm Nikkor zoom at 1/40 sec., f/22 at ISO 200, on a tripod.*

ABOUT THIS PHOTO *Using a very wide aperture lets you render backgrounds completely out of focus — a great technique for accenting small but important subjects like this Red-winged blackbird. Shot using a 400mm Nikkor lens at 1/400 sec., f/5.6 at ISO 200, on a tripod.*

4-10

There is actually a mathematical formula (deep inside, you knew there would be) for how much the depth of field increases or decreases based on aperture changes: Each time you double the aperture (from f/5.6 to f/11 — a two-stop change), you double the distance of the depth of field. The reverse is also true: If you cut the aperture in half (from f/22 to f/11 — also a two-stop change), you cut the depth of field in half.

In choosing an aperture for a particular photo, then, it's very important that you consider your aperture choice carefully — which is why I find myself using the aperture-priority exposure mode more than any other exposure mode (and I strongly urge you to do the same). Remember, if you're not controlling depth of field through aperture choice and the other related factors,

then you're simply abandoning control over what is and is not sharp in your photos (other than the subject you've focused on), and I know you wouldn't do that.

It would be wonderful if there were a chart somewhere that told you exactly what aperture to use for any particular subject, and that any time you photographed that subject, all you had to do was look at the chart and pick the best aperture. The fact is, though, that while it's usually best to photograph, say, a landscape, at a small aperture (to get maximum near-to-far sharpness), there are times when you might want to photograph a landscape with a wide aperture to isolate focus on a single element. By focusing carefully on the forsythia (see 4-11) in this Connecticut landscape and choosing a wide aperture, for example, I intentionally let the barn in the background go soft.

4-11

And while you would normally shoot a portrait at a fairly wide aperture to limit focus to just faces, there are times when you will want to shoot pictures of people at very small apertures to keep their surroundings in sharp focus. I photographed my girlfriend Lynne (also known as my unpaid assistant) using a relatively small aperture of f/16, because I wanted to keep the environment of the Tucson desert sharp (see 4-12).

Keeping in mind that there are always exceptions to every generality, here are some thoughts on what I consider the three main groups of apertures (note that these aperture choices refer mainly to dSLR lenses and some advanced zoom digital cameras):

ABOUT THIS PHOTO *Understanding depth-of-field controls lets you select which parts of the image you want to appear in sharp focus. Exposed using a compact digital camera in the telephoto position at 1/400 sec., f/5.6 at ISO 100, handheld.*

4-12

ABOUT THIS PHOTO *Taking portraits in the hot sun of the Arizona desert guarantees that you'll have enough light to use small apertures. Shot with an 18-70mm Nikkor zoom lens and exposed for 1/400 sec., f/16 at ISO 200, handheld.*

■ **Small apertures for expansive detail.** The apertures between, say, f/16 and f/32, are what I call *expansive detail* apertures; their job is to keep everything from near to far in sharp focus. These small apertures are ideal for landscapes or travel scenes when your goal is to show as much detail as possible (see 4-13).

■ **Middle-range apertures for "safe" subjects.** There are many times when you're photographing a subject where depth of field really isn't much of a concern and the apertures are between about f/8 and f/11. These apertures are neither expansive nor limiting in the depth of field they provide, but they are quite useful for images where the main subject and the background are at relatively the same distance. In figures 4-14 and 4-15, which show relief sculptures on the main façade of Notre Dame in Paris, I knew that the subjects were

only a foot or two deep and that a moderate aperture would keep everything sharp. Also, because tripods aren't allowed in the plaza, I was able to shoot at a safe, handheld shutter speed of 1/1000 second by using a moderate aperture. (Incidentally, I converted the shot of the angel to monochrome in Photoshop using the Channel Mixer and Curves tools.)

■ **Large apertures for extracting subjects.** One of the most visually arresting tricks you can use to bring attention to a particular subject is to render everything but the subject out of focus. The apertures between f/1.4 (or whatever your maximum aperture happens to be) and about f/5.6 are what I call *extraction apertures*. You can use these wide apertures any time you want to dramatically extract a subject or pull it away from its larger environment (see 4-16).

ABOUT THIS PHOTO
I photographed this Iowa cornfield using an 80-200mm Nikkor zoom lens to condense the scene, but I used a small aperture of f/20 to keep everything sharp. Shot at 1/30 sec., ISO 200, on a tripod.

4-13

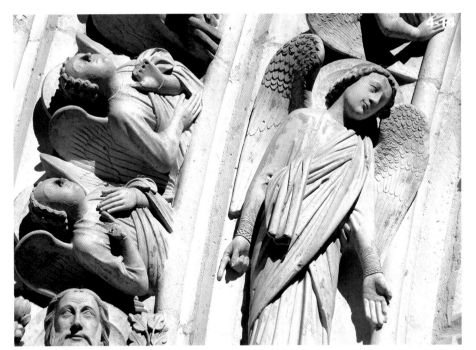

ABOUT THESE PHOTOS *The exterior of Notre Dame is a wonderland of interesting carvings, and I spent the better part of one afternoon photographing them. I particularly like the figure of Saint Denis holding his own head. When the subject is only a few feet deep, a middle-range aperture is just fine. Both of these photos were made with an 18-80mm Nikkor zoom lens at 1/1000 sec., f/8 at ISO 200, handheld.*

4-15

4-16

ABOUT THIS PHOTO *I photographed this colorful parrot at the St. Augustine Alligator Farm in Florida. I used a flash fill to brighten his colors and a small aperture to extract him from the background. Shot with an 80-300mm Nikkor zoom lens at 300mm at 1/60 sec., f/4.5 at ISO 200, handheld.*

x-ref The aperture-priority mode allows a fully automatic exposure mode, but it lets you choose the aperture (while the camera selects the corresponding shutter speed). I discuss this in more detail in Chapter 6.

tip As an alternative to lens scales, a company called ExpoImaging (www.expoimaging.net) makes a great handheld (it's about the size of a drink coaster) depth-of-field guide that provides a handy depth-of-field calculator for virtually all digital formats. All that you do is set the cropping factor (or APS-C format) for the camera you're using, the focal length of the lens, and the distance range that you want in sharp focus, and the scale tells you what aperture to set. It's harder to describe than to use — you'll be using it out of the package in under five minutes.

If you can train yourself to spot a subject and quickly match it up with an aperture group, you can speed up the process of choosing an aperture. This also helps you to identify what type of photo you're making. Again, there are always exceptions, but I've found that assigning an aperture category to a subject is a fast way to sum up my depth-of-field requirements.

Back in the days of 35mm cameras, most lenses had a depth-of-field scale etched into the lens barrel, and it was simple to look at the scale and know exactly how much of your scene was going to be in sharp focus. The scale consisted of pairs of color-coded distance markers that were linked to a particular f-stop. Some dSLR lenses still have depth-of-field scales, and using them is fairly simple: First focus on your main subject, then look at the color-coded distance markers, and find a pair that match the near and far distances that you want to keep in sharp focus. Set your aperture to the setting that is color-coded for those markers. Your lens manual should explain it in greater detail.

LENS FOCAL LENGTH

Lens focal length plays another important role in determining depth of field because the more magnification (the longer the focal length of the lens), the less depth of field you have at any particular distance and aperture. For example, if you're standing ten feet away from your main subject and you are using an aperture of f/8, the actual depth of field changes, based on the focal length of the lens (or the focal length you have set on your zoom lens). If you're using a wide-angle lens, you can have significantly more in sharp focus than if you were using a telephoto lens. Knowing this lets you match your lens choice to the subject and to the amount of near-to-far sharp focus you're after.

If you are photographing a landscape, for example, and you want everything from near to far to be sharply focused, a wide-angle lens provides a lot of depth of field. If, on the other hand, you're photographing a friend and you want the background to be out of focus, by choosing a moderate telephoto lens, you can drastically reduce the range of sharp focus.

You can also get much more radical with focal length if you need to render a particularly messy background out of focus. Look at the two photos of sunflowers that I shot in my backyard (see 4-17 and 4-18) and you can see the difference that a simple shift in focal length can make. The first shot was taken using a 70-300mm zoom lens set at 135mm, but my very messy backyard (and dilapidated fence) and strong highlights from the yellow house behind me drew attention away from the flowers — it was a very cluttered shot. But when I zoomed out to 300mm, the background became a soft and indiscernible blur (if only I could fix the actual fence that easily). I

4-17

switched momentarily to a horizontal format to see how the shot would look, and almost instantly, a bee landed on the flower — so I chose that as the better of the final shots. (When the photo gods give you a gift, just say 'thank you' and accept it.)

The key thing to remember is this: The longer the focal length of the lens (or zoom setting), the less inherent depth of field you have. The shorter the focal length of the lens, the more inherent depth you have. Again, this assumes that you are using the same lens-to-subject distance and the same aperture.

4-18

tip
Remember that as you change focal
lengths, the amount of depth of
field that you get from any particular aperture changes:
You get more depth of field with a wide lens, and less
with a long lens. While f/8 on a wide-angle lens might
provide a substantial amount of depth of field, using the
same aperture on a long telephoto lens (in the 400mm
range, for example) provides almost no depth of field.

SUBJECT DISTANCE

The third contributing factor in establishing
depth of field is subject distance — how far your
subject is from your lens. Once again, other fac-
tors such as aperture and focal length being equal,
the farther you are from your subject, the more
inherent depth of field you have, and the closer
you get to your subject, the less depth of field you
have. I photographed the still life (see 4-19) of
glasses and a carafe while relaxing at a sidewalk
café in Paris (actually, I think I was trying to look

busy so that the waiter wouldn't ask me any more
questions in French). I was using a 70mm zoom
setting and sitting less than 18 inches away from
the glasses, so only the rim of the wine glass is in
sharp focus. I could have switched to a wider lens
or used a smaller aperture, or stood up and backed
farther away, but I liked the look of the very shal-
low focus.

If you're photographing your travel companions
standing in front of a cathedral door, for example,
and you're using a normal lens set to a medium
aperture and standing, say, ten feet away, the odds
are that both your friends and the door will be
sharply focused. But if you were to move up to
four or five feet away from your friends, you'd find
that the doors behind them would rapidly fall out
of focus. The specifics, of course, would really
depend on the focal length of the lens and the
size of your sensor, but the concept is the same for
any camera or lens.

ABOUT THIS PHOTO
I've shot hundreds of photos in Paris, but I think I like this shot the most: A simple still life of used glasses at a café. Exposed using a 24-120mm Nikkor zoom lens at 1/250 sec., f/6.3 at ISO 200, handheld.

THE DEPTH-OF-FIELD PREVIEW BUTTON If you own a dSLR, your camera may include a feature called a *depth-of-field preview button.* When you press this button, your lens' aperture closes down to the actual shooting aperture, thus showing the actual depth of field in your viewfinder. The problem with this feature is that it's not that easy to see the image once you stop the lens down — because less light is entering the camera at smaller apertures, the image gets darker. If you're shooting with a lens that has an f/2.8 lens speed and then stop it down to f/22, for example, you've lost six stops of light. That's a lot of light to lose. I find that if I study the stopped-down image for a few seconds, my eye begins to adjust and I can get a fairly good idea of what's in focus and what isn't, but it's still not the most reliable view in the world. I use this feature a lot, but again, I only use it as a guide, and I don't put that much confidence in what I'm seeing.

caution Using your camera's review feature and studying your images on your LCD can be deceptive when it comes to depth of field. Because of the small size of the LCD, images always seem to look great and have a lot of near-to-far sharpness. But when you get home and download the images, you realize they're not as sharp as you thought. Don't depend on what you're seeing on the LCD. Some cameras have a feature that lets you magnify the LCD image and check details, and that is a far more reliable way to judge sharpness.

DEPTH OF FIELD AND COMPACT DIGITAL CAMERAS

If your primary or secondary camera is a compact digital camera, you may be feeling a bit left out of this discussion because you may not have the exposure controls that more advanced cameras offer, and so you may have far less ability to manipulate depth of field. But that might not be your only problem. Because of their small sensor size, these cameras only use the central portion of the lens — the sharpest area optically — and these two things combine to create an almost limitless amount of depth of field in most situations, such as my shot of Utah's Monument Valley (see 4-20). That's a good thing — provided you want a lot of depth of field. But on the other hand, if you're trying to limit the zone of sharpness, it can be a real nuisance.

Even if you do have control over your aperture settings and are able to select a wide aperture, your depth of field will still be greater (often substantially greater) than if you used that aperture with an advanced zoom camera or a dSLR. The smaller the sensor in the camera is, the greater the depth of field for any given aperture.

I first became aware of this situation while teaching an adult continuing education class in Westport, Connecticut. I had assigned the students to go out and shoot scenes with limited depth of field, and I made sure that even those with point-and-shoot cameras could control the aperture. I told them to shoot some scenes at a wide-open aperture, with sharp focus restricted to a specific subject. The next week during the photo review, several compact-camera users

ABOUT THIS PHOTO
Compact digital cameras have an inherent depth of field that's hard to beat when shooting broad landscapes like this one. Taken with a compact digital camera with the lens set to 7.1mm (about 28mm in 35mm terms); exposure was 1/320 sec., f/6.3 at ISO 100, on a tripod.

4-20

complained that even with the lens wide open, everything was in sharp focus — and they were right. It hadn't occurred to me that the smallness of the sensor would have that profound an effect on depth of field, but it did — and it does. You may have noticed this in your own attempts to limit the zone of sharpness.

Unfortunately, there isn't a lot you can do to defeat the laws of physics and restrict sharp focus, but there are a few things you can try. First, if you have scene modes and want to shoot a portrait and keep the focus limited, try switching to the action-priority mode or the portrait-exposure mode. Both of these modes give priority to selecting the fastest available shutter speed and, correspondingly, the widest possible aperture. This may or may not help, depending on the sensor size and the lens' focal length, but it's worth a try. The other trick you can use is to get as close as possible to your main subject because, as explained previously, the closer you are to your subject, the less depth of field there is. If you combine both of these methods, you may be able to "trick" the camera into shrinking the depth of field.

Don't despair if your attempts at shallow focus fail. Considering the benefits of having a camera that keeps everything in sharp focus without any effort, I wouldn't complain too much about the occasional inconvenience of not being able to limit sharp focus. There are a lot of professionals out there who can only envy your good fortune.

DEPTH OF FIELD AND MACRO PHOTOGRAPHY

Close-up or *macro* photography has seen a real resurgence since the introduction of digital cameras. One reason for this is that because of the small sensor size and the optical design of lenses, even extremely simple point-and-shoot digital cameras are able to take fantastic close-up photos. I've had students show up for classes with shots of moths and dragonflies, for example, that I would never have dreamed of taking with a film camera.

There is, however, probably no other area of photography where flaws in depth of field are as obvious as in close-up photography. The reason is simple: Because of the intense magnification required to create close-up photos, and because of the very limited lens-to-subject distance, there is almost no inherent depth of field. The closer you get and the more magnification that you use, the less depth of field you have, and with extreme close-ups, the range of near-to-far focus is typically an inch or less.

The solution is simple, of course: Use a smaller aperture to keep things sharp. The problem is that when you use a smaller aperture, you have to use a correspondingly slower shutter speed to keep the same exposure. Long shutter speeds mean that subject motion (and camera movement) are greatly exaggerated. Imagine that you're photographing a butterfly sitting on a flower (see 4-21), and your camera's meter in the program mode tells you that a correct exposure is 1/125 second at f/8. But at f/8, you can see on the LCD that you're not keeping the butterfly and the flower in focus, and so you stop the lens down to f/22. But f/22 is three full stops smaller, and so you have to slow the shutter speed three stops — to 1/15 second. If there's a whisper of a breeze or if that butterfly moves (see 4-22), that slow shutter speed blurs your subject — and so you've gained nothing.

ABOUT THESE PHOTOS *Both of these images of a monarch butterfly were shot within seconds of one another. In the sharp version (4-21), my shutter speed was set to 1/125 sec.; when I tried to slow the shutter down to gain a bit more depth of field (because the butterfly had turned on me and was no longer parallel to the camera back), he beat his wings and they became a total blur (4-22). Both shots taken with a 105mm Nikkor Micro lens, handheld, with the sharp frame at f/4.2, and the blurred one at 1/60 sec., at f/5.6, ISO 100.*

4-21

4-22

Another problem with stopping down so far is that you also start to bring bits of the background into sharp focus and erase that nice, soft background blur that you had at the wider aperture. It seems ironic that by stopping down enough to bring the subject into sharp focus, you start to bring the background into focus as well, but it happens so often and so annoyingly to me that I'm banned from a lot of my neighbors' gardens (they can't take the sound of a grown man whimpering in their gardens).

So what's the solution? Actually, there are a few good options. First and foremost, it's important that you keep your camera back (the sensor plane or film plane) parallel to your main subject. While photographing the same butterfly on a *Tithonia* blossom (again, see 4-21), I worked hard to keep the camera parallel to the butterfly just to keep it and the flower in sharp focus. In that case, it was tough because I had to wait for the butterfly to land on *that* blossom.

Another idea is to look for the plainest background you can find. While photographing a cactus in bloom in the Saguaro National Park (see 4-23) outside of Tucson, Arizona, I also positioned the camera so that I had only blue sky behind the cactus.

ABOUT THIS PHOTO *A rich, blue desert sky in Arizona was the best background I could find for this prickly pear cactus coming into blossom. Taken with a 105mm Nikkor Micro lens and exposed for 1/250 sec., f/11 at ISO 200, on a tripod.*

WHY YOU SHOULD ALWAYS USE A TRIPOD

There are no magic bullets to instant quality in photography, but if you want the quality of your exposures (and your photos overall) to improve suddenly and dramatically, I can give you one invaluable piece of advice: Buy a good-quality tripod and *use* it every single time you take a photograph. Yes, of course, there will be exceptions — like photographing your friends at dinner in a fancy restaurant ("Proper attire required — no tripods, please!"), but I'm certain that you will find that in reality, there are few excuses for not using a tripod. If you follow this advice, I promise it will vastly improve your photography and your creativity, and I have dozens of letters from students thanking me for improving their photography by pushing them to use a tripod.

Why is a tripod so important? There are many reasons, including the fact that tripods slow you down, (which is a good thing — thank you, Martha Stewart), make you consider your compositions more carefully (see 4-24), steady the camera, and even take the weight off of your shoulders

4-24

ABOUT THIS PHOTO *Using a tripod let me carefully compose this tricky composition of a yacht and its reflection in Fort Lauderdale, Florida. Shot with an 18-70mm Nikkor zoom lens and exposed for 1/320 at f/10, ISO 200, on a tripod.*

while you're working. But the most significant reason for using a tripod is this: With your camera firmly planted on a steady camera support, you are free to use *any exposure combination*. That is a huge advantage when it comes to creative exposures. Before I started using a tripod religiously, I would know that I needed a small aperture like f/11 or f/16 to get the correct amount of depth of field, but not having a tripod, I had to settle for a lesser aperture — and a lesser photograph.

On top of all of this, some subjects, like twilight (see 4-25) or night shots of cities or fireworks, are virtually impossible without a tripod. How are you going to take a 10- or 20-second exposure with a handheld camera? You simply can't. Also, by using a combination of a tripod and longer exposures you can avoid having to raise the ISO too high which will add digital noise to your pictures.

Also — and this is incredibly significant — you cannot do true comparative photo sets without using a tripod. If, for example, you decide to try and do a comparison of a deep versus a shallow depth of field (and you aren't just taking my word that using small apertures provide more depth of field, are you?), you simply can't do it without your camera locked down firmly on a tripod. Oh, you could get an approximately similar shot, but what good is that? The scientist in you needs a pure comparative situation: You need the exact same composition.

4-25

ABOUT THIS PHOTO *Twilight scenes like this afterglow that I captured in a Texas wildlife sanctuary require very long time exposures and that means using a tripod. Taken with a 24-120mm Nikkor lens and exposed for 1/6 second at f/11, ISO 800, on a tripod.*

One thing that I've found prevents a lot of people from buying and *using* (notice I keep emphasizing that word) a tripod is that they are a pain to set up. They're not. If you buy a good-quality, medium-weight tripod (don't buy a junky plastic tripod) and use a good ball head, you can set up a tripod and mount your camera in under a minute — probably faster. Once you get in the habit of using a tripod for every shot, you'll find yourself feeling naked and ill-equipped when you shoot without one.

Tripods come in a wide range of prices, weights, and features (as do tripod heads), so talk to other photographers or visit your local camera shop to see what's available. The features you're looking for are a tripod that is strong enough to hold your camera with its longest lens mounted and yet light enough so that you'll actually be willing to carry it into the field. Also, the tripod's controls should be easy to operate and large enough so that you can operate them in winter with gloves or mittens on. Most photo magazines (like *Outdoor Photographer*) run an annual review of tripods and, if you happen to live near a larger city, there are often photo trade shows (like PhotoPlus Expo in New York) where you can get a hands-on demonstration of every tripod on the market (and all the other photo goodies that you're lusting over).

Choosing the right tripod head is just as important as choosing the right tripod. Basically there are two types of heads: *pan-tilt* and *ballhead*. I vastly prefer ballheads to pan-tilt heads because while the latter let you turn your camera left-to-right or up-and-down, that is the limit of their movement. Ballheads (sometimes called ball-and-socket heads) use a ball in a locking vice arrangement and allow you to position the camera in virtually any direction. Also, because most loosen with a single control handle (unlike pan-tilt heads that use two separate handles), you can

hold the camera with one hand and loosen or tighten the head with the other — far more practical and much faster to use.

The other important tripod accessory you should invest in is a quick-release mount. These are two-part accessories that consist of a *mounting plate* that mounts to the bottom of your camera (via the threaded hole normally used for the tripod screw) and a *receiving plate* that mounts to the tripod. Using a quick-mount device makes mounting and dismounting the camera a two-second operation and, if you buy a good-quality mount, it is extremely reliable and safe. Again, read the photo magazines or visit your camera shop to see one demonstrated.

Lastly, many non-tripod toting photographers tell me that they can't shoot certain subjects if they're "chained" to a tripod. I really don't think that's true — it's largely just a matter of how you approach the shot. Suppose that you're taking a portrait of your kids sitting on a stone wall, for example. You could just crouch there with your handheld camera and try to compose a nice image and direct them to pose a certain way from behind the camera, but at that point you're just a disembodied voice and your cozy relationship with your kids evaporates. Or, you could put your camera on a tripod, use a remote release (a cable release or a wireless remote), and then stand a few feet away from your camera and devote your full attention to your subjects — making them laugh or using your hands to show them how to pose more comfortably. By talking to them without a camera in front of your face, you have a direct and personal interaction — you aren't a camera with a voice. As long as you focus carefully on their faces and they stay in the same general place, your pictures will be sharp, well exposed and much more relaxed

Use a tripod — it's the single best piece of exposure advice I can give you.

Assignment

Limit Depth of Field to Show Off Your Subject

Perhaps the biggest benefit of being able to control depth of field is that you get to match your choice of approach to your subjects. While using a lot of depth of field is a great way to add detail to expansive landscapes, doing the opposite — limiting depth of field to just a few feet (or even inches) — lets you isolate a subject from its background.

For this assignment, choose a subject (perhaps a friend or a pet) that is bold enough to stand on its own and that looks best when you use shallow depth of field to extract it from its surroundings. Remember, the three keys to reducing depth of field are using a large aperture, using a longer lens, and getting close to your subject. And because depth of field is so shallow, precise focus on your main subject is very important.

I photographed this sheep on a beautiful farm in Maine on a late afternoon one sunny summer day. As pretty as the farm was, I wanted the sheep to be the star of the shot, and so I used a long (360mm) zoom setting to isolate it from the background, and a wide aperture of f/5.6 to render the farmyard and the base of the barn out of focus. I had to talk to the sheep constantly to keep its attention.

Remember to visit www.pwassignments.com after you complete this assignment and share your favorite photo! It's a community of enthusiastic photographers and a great place to view what other readers have created. You can also post comments, and read encouraging suggestions and feedback.

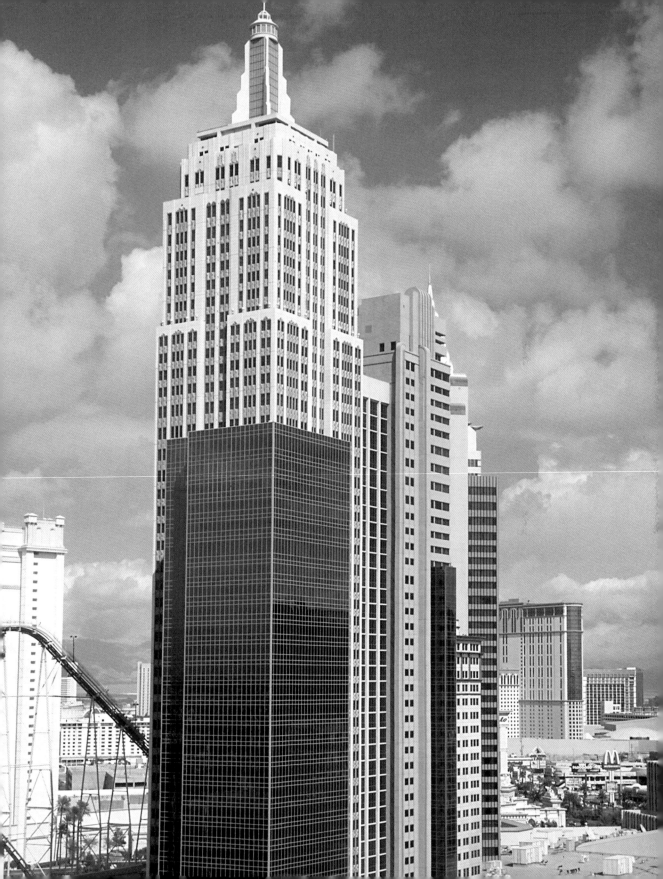

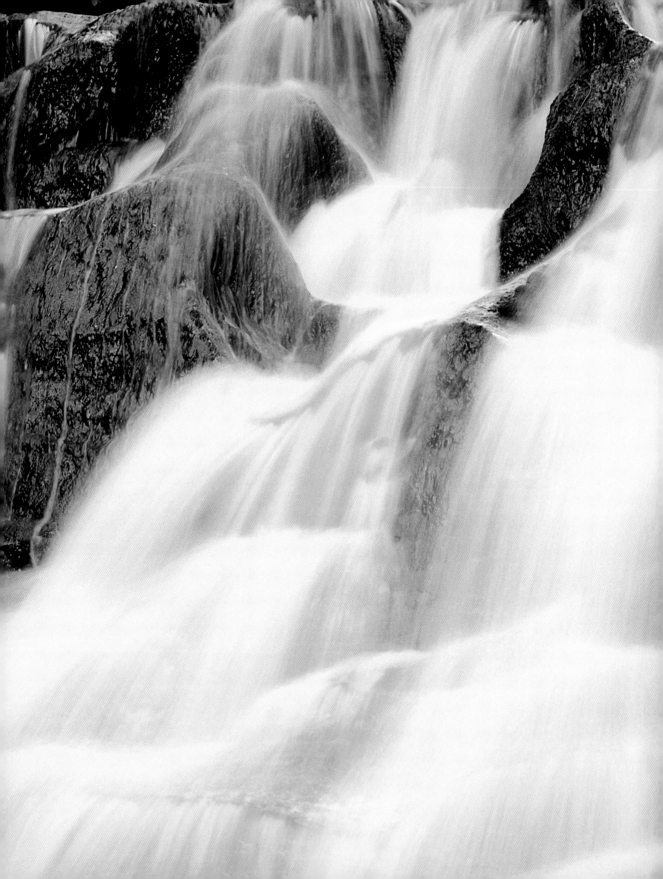

SHUTTER SPEED AND SUBJECT MOTION

Like the aperture, the shutter speed's primary job description is to control the light entering the camera. If you're working in extremely low light — shooting in the loft of an old barn in Connecticut, as I was in figure 5-1, for example — you can use a very long shutter speed to record every dimly lit nuance in the setting. Or, in very brightly lit situations, like the Arizona desert at high noon, you can increase the shutter speed to keep too much light from getting into the camera and washing away all of the important detail (see 5-2). Shutter speed is the gatekeeper at the door to your sensor, and he can hold the door open for as long as you like, or slam it shut in a flash.

5-1

ABOUT THIS PHOTO
I photographed the dim interior of this barn using just the light from a few small skylights. Exposed using a compact digital camera (at its widest zoom position) at 1/40 sec., f/4.2 at ISO 100, with the camera supported on a barn beam.

ABOUT THIS PHOTO *The Arizona sun provides all of the light you need for fast shutter speeds. I shot this photo at 1/1050 sec., using an 18-70mm Nikkor zoom lens; f/4 at ISO 200, handheld.*

Like aperture, the shutter speed you select plays a significant creative role, in this case as the interpreter of motion. You can use long shutter speeds to accentuate the rhythm and flow of moving subjects (see 5-3 to 5-5), very short shutter speeds to stop motion in its tracks, or moderate shutter speeds for subjects moving at, well, moderate speeds. Or, if you're in a creative mood, you can use a long shutter speed in combination with a moving camera and a stationary subject to create interesting abstract effects, as I did while jiggling the camera during a long exposure of Christmas lights (see 5-6).

ABOUT THESE PHOTOS *Ferris wheels are a fun subject to experiment with because they're colorful and almost constantly in motion. By making progressively longer exposures, I allowed the light pattern to turn from a slightly blurred image into a complete whirl of color and light. All three of these images were taken with an 18-70mm Nikkor zoom lens mounted on a tripod. Exposures were 1/2 sec. at f/8 in 5-3, 1 second at f/16 in 5-4, and 3 seconds at f/22 in 5-5. Once you get into the multiple-second exposures, the exact exposure time isn't important — it's just a matter of getting an interesting swirl of color. I used a slow ISO of 200 to be sure that I'd have long exposure times.*

Remember, because of the reciprocal nature of apertures and shutter speeds, every time you alter the aperture to manipulate depth of field, you have to make an equal change to the shutter speed in order to keep your exposure correct. Close down the lens three stops and you have to slow the shutter speed by three stops; open up the lens two stops and you have to speed up the shutter speed by two stops. It's a very and mutually-beneficial relationship, but it comes with one significant bit of fine print: If your subject is moving in any way (or if you or your camera are moving in any way), you must be aware that your shutter speed choice affects how motion is represented. Very often, the shutter speed that you end up selecting is in response to the aperture you've selected to control depth of field, which in turn creates a delicate creative balance between depth of field and subject motion.

5-3

5-4

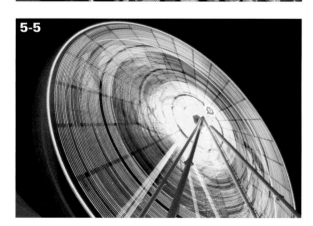

5-5

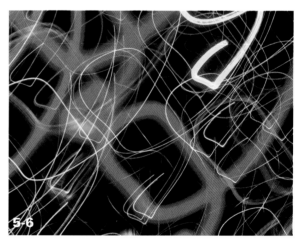

5-6

ABOUT THIS PHOTO *It's easy to create colorful, abstract patterns from holiday lights — just keep the shutter open and jiggle the camera during the exposure. This experimental shot was exposed using a compact digital camera at 1/8 sec., f/10 at ISO 100.*

In this chapter, I show you how your choice of shutter speed can produce some very illustrative results with moving subjects, as well as how you can combine fast shutter speeds and some basic understanding of subject movement to arrest motion completely. I also show you some tricks for using shutter speed, and techniques like lens "zooming" to paint with light and color.

THE SHUTTER SPEED PROGRESSION

Shutter speed settings are simple to explain because they represent just one thing: how long your camera's setting remains open. When it comes to remembering which shutter speed lets in more light, it's fairly simple (provided you paid attention in your fractions class in second grade) because there's no abstract or trick math going on — each shutter speed number represents a fraction of a second of exposure time. In other words, a speed of "30" is actually 1/30 second, and "1000" is 1/1000 second. Most cameras these days also have an extended range of shutter speeds that includes full seconds and, in some cases, minutes. Usually, full seconds are indicated by a quote mark after the number, but you should read your manual to see how these speeds are indicated on your camera.

A typical shutter speed range, as I explained briefly in Chapter 2, usually runs from 30 seconds or so at the long end to mere thousandths of a second at the other. The longer the exposure time, naturally, the more light reaches your sensor. A standard sequence of shutter speeds (going from longest to shortest) might look like this: 30 seconds, 15 seconds, 8 seconds, 4 seconds, 2 seconds, 1 second, 1/2 second, 1/4 second, 1/8 second, 1/15 second, 1/30 second, 1/60 second, 1/125 second, 1/250 second, 1/500 second, 1/1000 second,

WHAT IS A SAFE HANDHELD SHUTTER SPEED? Although most of us like to blame our jiggly pictures on poor lenses or a moving subject, the truth is that most blurred images are the result of camera shake — trying to handhold a camera at too long a shutter speed. In the days of 35mm cameras, one formula that many photographers used to determine safe handheld shutter speeds was to use a shutter speed equal to or faster than the reciprocal of the focal length of the lens they were using. In other words, if you're using a 100mm lens, you should use a minimum shutter speed of 1/125 second or faster. Because actual focal lengths have changed with digital cameras, the formula no longer holds up. But if you know the focal length of your lens in its 35mm equivalent, then you can use the formula. Your camera manual can tell you your focal lengths, both in actual size and in their 35mm equivalent. If your camera has image-stabilization technology, you may be able to use substantially slower shutter speeds and still get sharp results. Be aware, though, that some anti-shake systems work better *without* a tripod because the systems are programmed to expect some camera vibration and they tend to provide erratic results when tripod-mounted.

1/2000 second, and so on. Many dSLR cameras have shutter speeds as fast as 1/8000 second — presumably for those among us trying to stop bullets in midair. While these speeds represent the traditional (that is, mechanical) stops found on pre-digital cameras, you may find that your digital camera also has intermediate stops.

The key thing to remember is that each progressive *whole* step in the sequence represents either a doubling or halving of the adjacent shutter speed. In other words, if you go from 1/250 second to 1/125 second, you double the light reaching the sensor; if you go from 1/250 second to 1/500 second, you cut the light in half. If baking is one of your hobbies, you'll have an easy time visualizing which shutter speeds let in more light by comparing them to the fractions marked on a measuring cup: 1/2 cup of water is obviously just one-half as much as a full cup — and 1/4 cup is one-half of 1/2 cup. (This still doesn't explain to me why baking times change if you live at a higher altitude.)

In addition to the speeds listed above, many cameras have a "B" or "Bulb" setting that lets you keep the shutter open for as long as you like. With the camera set to this mode, you simply press the shutter release once to open the shutter, and then again to close it.

MANIPULATING MOTION: THE CREATIVE POWER OF SHUTTER SPEED

In the early days of photography, pioneering landscape photographers like William Henry Jackson and Carleton E. Watkins hauled giant wooden cameras around on the backs of mule teams so that they (the photographers, not the mules) could document the American wilderness (Watkins frequently worked with a glass-plate camera that made 18 x 22-inch negatives). Exposure times for their massive images were measured in many minutes, often up to an hour. There were no shutter-speed dials, and the length of an exposure was based purely on experimentation and the responsiveness of the materials involved. Photographers spent a lot of time just watering the mules and admiring the scenery while the exposures took place. (But then again, if it took you months or even years to get to a great overlook to take a picture, why rush the exposure?)

Today's cameras give us the luxury of dictating the exposure times that we want to use, and this provides a large degree of creative control when it comes to how we interpret all types of moving subjects. It doesn't matter if it's a slow-moving subject like a gently rambling stream, or a fast one like a rocket blasting off into space; you are free to choose shutter speeds that capture the action in the way that you envision it (see 5-7 and 5-8). The degree to which you freeze or exploit motion is really only limited to the inherent motion of the subject and your imagination.

Interestingly, you can find motion in all sorts of subjects that you might not necessarily think of as moving subjects. Many photographers, for example, have experimented with creating streaks of light from stars in the night sky by using exposures of several hours. Others have used high-speed cameras and very brief flash exposures to stop the motion of things like a droplet of water splashing on a dish or the wings of a hovering hummingbird.

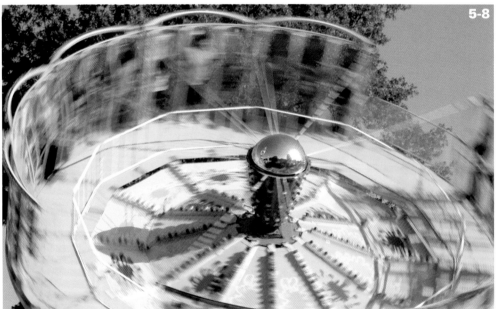

ABOUT THESE PHOTOS *In 5-7, I chose to use a fast shutter speed of 1/800 second and a wide aperture of f/5.6 to stop virtually all of the motion of this colorful carnival ride. In 5-8, I decided to play with the motion a bit and reduced the shutter speed by five stops to 1/30 second, and to compensate for the longer exposure, I closed the lens down to f/32. Both exposures were made with a 70-300mm Nikkor zoom lens, using a fence rail to steady the camera.*

x-ref For some interesting examples of high-speed photography using multiple flash units, check out Tom Callahan's photos of hummingbirds in Chapter 11. Tom is a former student of mine and has captured some extraordinary images of hummingbirds in flight.

STOPPING TIME WITH FAST SHUTTER SPEEDS

The ability to completely freeze motion is one of the most interesting and extraordinary aspects of photography. Think about some of the amazing still images that we've all seen: race cars toppling end-over-end halted in mid tumble, a ballerina frozen like an ice statue at the apex of a pirouette, and athletes in every conceivable sport absolutely arrested in time (see 5-9). If some poor soul in an Olympic diving competition whacks her head on the diving board, a dozen ultra-sharp, detailed photos of the instant of impact show up in *Sports Illustrated* a few days later.

Until the invention of photography, no one had ever witnessed such things, and now we take them for granted. In fact, since 1877, when a photographer named Eadweard Muybridge used his camera to prove that a trotting horse does indeed have all four hooves off the ground at one point, photographers have been obsessed with the camera's ability to reveal the hidden nuance of every type of movement.

Today, with shutter speeds in the thousandths-of-a-second range common to most digital cameras, getting great stop-action shots is completely within your grasp. In fact, with a little bit of knowledge

ABOUT THIS PHOTO
Is he out? Photographer Doug Jensen used an extremely fast shutter speed of 1/1250 sec. to capture this base runner sliding into a very close call. Shot with a 145mm lens and exposed at f/2.8, ISO 200, handheld. ©Doug Jensen.

5-9

about the nature of moving subjects and a good sense of timing, you'll find yourself making very respectable stop-action shots in no time.

The actual shutter speed that you need to freeze motion depends on several factors, including the following

◼ **The speed of the subject.** Relatively slow-moving subjects, such as a person walking (see 5-10) can be stopped at fairly moderate shutter speeds. Other factors, as you'll see next, can contribute to how much action you can stop with a particular shutter speed, but in general, slower forms of motion can be stopped at speeds between 1/125 and 1/500 second. The faster the shutter speed you can use in any given situation, the safer you are in

terms of stopping both subject movement and camera shake. Of course, if you're using a tripod, the latter won't be an issue.

As subject speed increases, of course, you also have to increase the shutter speed. Jennica Reis' great image of the little girl playing in the fountain was photographed at a shutter speed of 1/400 second, which not only stopped her motion, but also froze the spray of water into an interesting pattern (see 5-11).

x-ref The shutter-priority mode lets you set the shutter speed while the camera chooses the correct corresponding aperture. I talk more about this mode in Chapter 6.

5-10

ABOUT THIS PHOTO *Slow-moving subjects, such as these two women walking on the St. Augustine, Florida, fishing pier are fairly simple to stop with relatively moderate shutter speeds. Photographed using an 18-70mm Nikkor zoom lens with an exposure of 1/320 sec., at f/9, handheld at ISO 200.*

The direction of the action. The direction of motion relative to your camera is another important factor in choosing a shutter speed to stop action. As a rule, action coming toward or going away from the camera is the easiest motion to stop, while motion moving across your path is the most difficult. Subjects moving in a diagonal relative to your camera position fall somewhere in between and can usually be stopped with moderately fast shutter speeds. Keeping these concepts in mind and using them to select the best camera

position will help you maximize subject sharpness even in very dim lighting when you're forced to use slower shutter speeds.

You can, for example, often arrest the motion of relatively fast-moving subjects with a surprisingly slow shutter speed if you're careful to position yourself so that you're looking directly at the subject as it comes toward — or moves away from — your camera — which is why a lot of sports shooters photograph track meets facing the finishing line. I was able to stop the action of a group of inline skaters on Montparnasse Boulevard in Paris using a relatively slow shutter speed of 1/160 second because the pack was heading directly away from the camera (see 5-12). Similarly, Gavin Zau, a former student of mine and one of the most traveled people I know, was able to capture his great shot of a bicycling milkman delivering the early-morning milk in Delhi, India, at a relatively slow shutter speed (5-13) because the action was coming directly toward the camera.

5-11

ABOUT THIS PHOTO *Kids and fountains always seem to make for interesting photos. Photographed with a 100mm Canon lens at 1/400 sec., f/4 at ISO 400. ©Jennica Reis.*

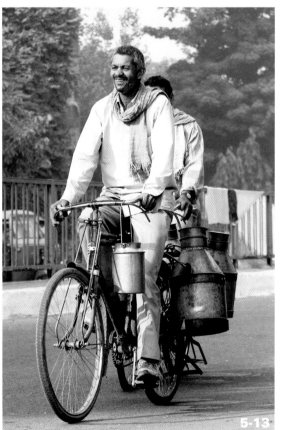

You'll need a much faster shutter speed to completely stop action when it's moving parallel to your camera path. Photographer Derek Doeffinger, for example, had to use a shutter speed of 1/750 second to completely freeze the motion of the Ski-Doo going across his path (see 5-14). On the other hand, I was able to capture this boy running on a Rhode Island beach with both feet off the ground (see 5-15) at a relatively slow speed of 1/250 second because he was moving diagonally across the frame — and hopefully quite a bit slower than the Ski-Doo.

ABOUT THIS PHOTO

Nothing tests your action-stopping skills like a Ski-Doo ripping past you at high speed on a lake. Photographer Derek Doeffinger exposed this shot at 1/750 sec., using a 300mm Nikkor lens, f/6.7 at ISO 160. ©Derek Doeffinger.

5-14

ABOUT THIS PHOTO

Diagonally moving subjects require shutter speeds a bit faster than subjects coming toward or going away from you, but a bit faster than those going past you sideways. Taken with a 70-300mm Nikkor zoom lens at 1/250 sec., f/9 at ISO 200, handheld.

5-15

The peak of motion. If you've ever watched a high diver going off a diving board, or a pole-vaulter going over a crossbar, you may have noticed that there is a brief instant when they are at the peak of their upward momentum, when they appear — however briefly — to be suspended in midair (see 5-16). This short hesitation is known as the *peak of action*, and you can exploit this brief pause in motion to capture very sharp action photos. It takes a bit of studying whatever event you're watching to be able to predict when that lull will come, but if you can time your shots right, it can be a very useful technique. Capturing action at the peak is particularly useful when the lighting conditions are somewhat dim and your range of fast shutter speeds is limited. It's still worth using the fastest shutter speed that you have available if the lighting allows, but taking advantage of this natural energy peak is a great trick for getting action photos.

Your distance from the subject. Because working at close distances — either by physically moving closer or using a long telephoto lens — magnifies any motion, it also requires that you use a faster-than-normal shutter speed (see 5-17). Typically, I move up an extra shutter speed (or two, if light allows) every time I either cut the distance to the subject in half, or double the focal length of the lens in use. If you're using a 200mm lens to photograph kids playing soccer and you're using a shutter speed of 1/400 second, for example, then you should *at least* move up to a shutter speed of 1/800 second if you move to, say, a 400mm lens or walk closer to the action. Ideally, I would always move up to the fastest speed available if depth of field is of no concern (and with long zoom and telephoto lenses, depth of field is pretty nonexistent anyway).

5-16

EXAGGERATING MOTION

As much fun as it is to freeze moving subjects using high shutter speeds, it's also a lot of fun to use slow shutter speeds to exaggerate or embellish them. Everything, from the water coming from your lawn sprinkler to fireworks displays (see 5-18) can make fascinating subjects for long exposures. One of the most interesting aspects of this kind of work is that it's completely experimental — you have no way to know what the images will look like in advance because the camera can do something that your brain can't do: It can accumulate patterns of light, regardless of how long you leave the shutter open. You can also use motion in more subtle ways by combining a

ABOUT THIS PHOTO *Telephoto lenses magnify motion so stopping them requires an even faster shutter speed. Photographed with a 200-400mm Nikkor zoom lens and exposed for 1/800 at f/10, ISO 200, on a tripod.*

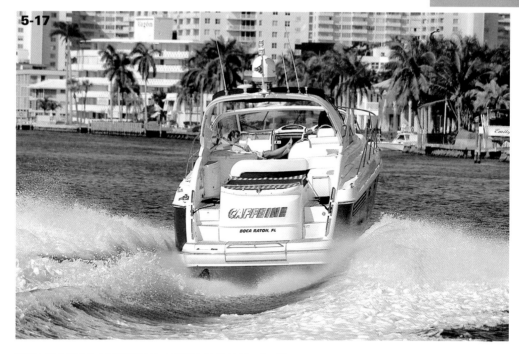

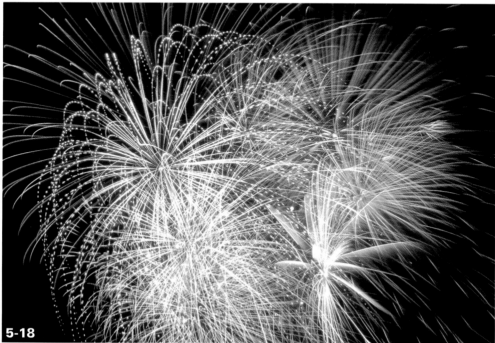

ABOUT THIS PHOTO *Fireworks are a great subject for experimenting with long exposures because you can leave the shutter open as long as you like. I used an 18-70mm Nikkor zoom lens for this shot and kept the shutter open for 64 sec., f/29 at ISO 200, on a tripod.*

sharp image of your main subject with a blurred background. In 5-19, for example, my friend Doug Jensen who is a well-known videographer by profession and a sport photographer by avocation used a relatively slow shutter speed and a technique called *panning* (moving the camera with the subject) to capture a sharp image of the bicyclist with a blurred background.

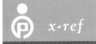

x-ref Summertime brings a lot of fireworks displays, and with them come some great and easy photo ops. I talk more about how to shoot fireworks in Chapter 9.

This ability to record patterns of motion can produce some very creative and surprising images, and once you start to photograph moving subjects in this way, you'll find yourself getting addicted. There are a number of special techniques for capturing motion patterns, and each produces interesting results. With some techniques, you let the motion write its own story in light on the sensor by keeping the camera steady and letting the subject move; with others, you move the camera while the subject remains still. Here are a few techniques for capturing motion:

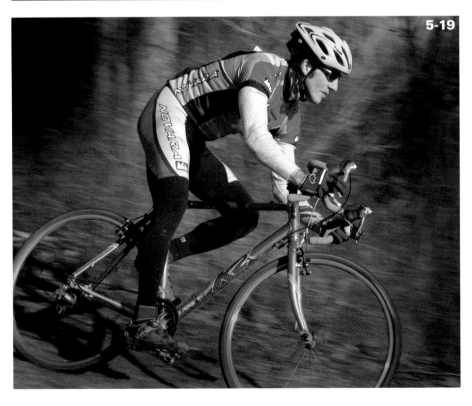

5-19

ABOUT THIS PHOTO
By moving the camera with the subject and using a relatively slow shutter speed, the photographer blurred the background to create this dynamic action shot. Photographed with a 45mm lens and exposed for 1/160 sec. at f/10, ISO 200, handheld. ©Doug Jensen.

■ **Use long exposures and a steady camera.**
Find an interesting moving subject and plant your camera firmly on a tripod, and you can get some interesting motion effects. Subjects are easy to find — traffic at night, carnival rides by day or night, waves crashing on the beach, or even an antique steam-powered sawmill (see 5-20). Again, the actual shutter speed you use depends on how much existing light there is and how fast the subject is going.

The only way to discover the most effective shutter speeds is to experiment. In the photo of the waterfall (see 5-21), for example, I mounted my camera firmly on a tripod (with a camera bag hanging from the tripod for extra steadiness), and shot several exposures from 1/30 second to several seconds. I kept an eye on the LCD after each shot as a guide to exposure times, and kept adding to the shutter speed until I saw the effect I liked.

ABOUT THIS PHOTO
I didn't have my tripod with me when I found this steam-powered sawmill at a state fair, but I lowered my shutter speed to 1/30 second to capture the motion of the spinning flywheel. Taken with a 24-120mm Nikkor zoom lens at f/20, ISO 200.

5-20

tip There will be times when you're making long daylight exposures and there is simply too much light to let you expose the subject for long periods of time. The problem is that you run out of equivalent f-stops to control the amount of light entering the lens. You can reduce the light simply by attaching a neutral-density filter to the front of your lens. These filters are available in a variety of densities to hold back anywhere from one to four stops of lighting without affecting color or sharpness.

ABOUT THIS PHOTO *Kent Falls in Kent, Connecticut, is one of the state's prettiest waterfalls. This shot was taken with a 24-120mm Nikkor zoom lens at 1 second, f/22 at ISO 200, on a tripod.*

5-21

■ **Use the panning technique to keep the subject sharp and the background blurred.**
Panning is a fun technique to use when you want to keep your subject sharp but blur the background, and professional sports photographers use it quite often. The technique works particularly well with subjects moving side-to-side across your path, such as Derek Doeffinger's photos of the Mennonite farmer in his horse-drawn buggy (see 5-22) and motorcycle riders (see 5-23).

This technique involves tracking the subject using a relatively slow shutter speed. The shutter speed depends somewhat on the effect you're after, and also on the speed of the subject; usually speeds of 1/30 or 1/60 second are long enough to blur the background, but not so long that you run the risk of also blurring the subject. Panning takes some practice because not only do you have to keep the subject in the same place in the frame as it moves and as you move the camera, but with a dSLR

ABOUT THESE PHOTOS *Any moving subject that travels parallel to your shooting position creates a good opportunity for using the panning technique. The Mennonite carriage in 5-22 was photographed using a 250mm Nikkor lens at 1/30 sec., f/22 at ISO 100. The motorcycle riders in 5-23 were shot with a 60mm Nikkor lens at 1/15 sec., f/19 at ISO 100. Both images ©Derek Doeffinger.*

5-22

5-23

and some zoom cameras, the viewfinder may shut off during the exposure, blocking your view of the subject. If your subject is traveling the same path over and over — runners at a track meet, for example — you'll get several opportunities to get the timing down and that can be quite useful. Again, experiment with shutter speed and the speed of your camera movement.

■ **Create motion effects with the zoom technique.** Zooming is a fun technique that became popular during the 1970s when zoom lenses for 35mm SLR cameras first hit the mainstream market. To create the technique, set your camera to the shutter-priority or manual-exposure mode and set a shutter speed that gives you enough light and also allows enough time to "rack" through the zoom-lens range during the exposure. I typically zoom with shutter speeds between 1/15 and 1/2 second, depending on the focal-length range of the zoom. The idea is to set the zoom at one extreme of its range, and then, as you press the shutter release, to twist the zoom collar on the lens (or use the rocker switches on a compact or zoom camera — small cameras do a great job with this technique) and try to time your twist to the length of the exposure.

It really doesn't matter if you zoom from the widest-to-longest focal lengths or vice versa, and if you like, you can pause during the zoom or only use part of the range. This is an experimental technique, and you can use it in daylight or at night, although it's much easier at night because you have longer exposure times to work with — and because the night lights make great subjects (see 5-24 and 5-25). Naturally, I suggest using a tripod, but to be honest, I often find myself zooming with a handheld camera because sharpness simply isn't an issue.

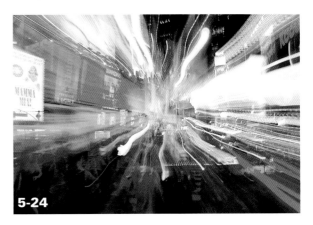

5-24

ABOUT THIS PHOTO *There are few places better to experiment with zooming night lights than in the "neon canyon" that is Times Square. Taken with a 10-20mm Sigma zoom lens from the middle of Broadway, exposed at 1/4 sec., f/13, ISO 1600, handheld.*

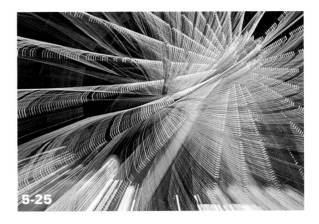

5-25

ABOUT THIS PHOTO *This is the same Ferris wheel that's in the earlier shots, but this time I zoomed my 18-70mm Nikkor lens during a long, 1.3-second exposure with the aperture set at f/22, ISO 200, on a tripod. The curve in the outermost lines comes from the rotation of the ride during the exposure.*

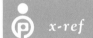

CHAPTER **5**

LONG SHUTTER SPEEDS AND DIMLY LIT INTERIORS

When confronted with a dark space, the first thing a lot of people do is to pop on the flash — which is rarely the most attractive light and is often completely useless. In a large space such as New York's Grand Central Terminal (see 5-26), turning on your camera's built-in flash is about as helpful as spitting on a forest fire. Your camera's built-in flash has a distance range of about 12 to 15 feet maximum, and beyond that the light drops off rapidly. Flash (particularly on-camera flash) also destroys any inherent ambiance that exists naturally in most interiors.

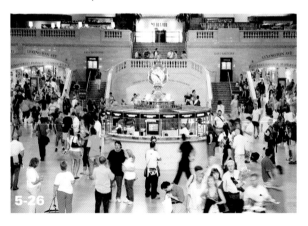

5-26

ABOUT THIS PHOTO *Some spaces are simply too big for flash to have any effect and the only thing you can do is raise the ISO and shoot with the existing light. Shot with an 18-70mm Nikkor zoom lens; exposed for 1/8 second at f/11, ISO 800, handheld.*

Because most digital cameras let you set timed exposures of up to 30 minutes, there are virtually no dark places that you can't capture with long exposures. In addition, most dSLR cameras have a "Bulb" setting that lets you take exposures for as long as you like (or until your battery runs out and the shutter closes, whichever comes first).

Taking readings of dim interiors can be tricky because not all TTL meters respond well to very low-light, low-contrast situations (although most handheld meters excel in such situations).

> **x-ref** In Chapter 11, I talk about some flash techniques that you can use to light large interiors — and I provide some tips for making flash exposures more attractive in almost any situation.

Fortunately, while the meters may falter a bit in taking readings, digital cameras are wonderful at recording dimly lit scenes; in fact, there have been times when I've taken exposures in almost no light not expecting to get an acceptable photograph and was pleasantly surprised that the exposures were just fine. Inside Notre Dame (see 5-27), for example, I wanted to get a shot of the candles being lit by parishioners and tourists but, other than the candles and a small amount of light coming from the stained-glass windows, it was virtually dark — and yet by boosting my ISO to 1600, I was able to get an image that while not as luminous as I would have liked, at the very least, reminds me of the deeply somber mood inside the great cathedral. In some situations you simply have to take what you can get and move on.

The wonderful Mission San Xavier del Bac (see 5-28) south of Tucson, Arizona, has been beautifully restored, but the interior is extremely dim. Your eyes adjust in time to the spectacular colors, but it's tough to get a good photo. Again, I wanted a shot of the colorful walls, and so rather than not shoot (flash is forbidden), I took my chances, made a long exposure (handheld), and I love the photo.

One problem you encounter with long exposure times is digital noise, which is explained in Chapter 2. You can switch to a higher ISO setting to make the exposures shorter, but alas, high ISO speeds also create noise. Some cameras (including both of my Nikon dSLR cameras) have very little noise with high ISO speeds, but I do sometimes notice it in exposures of one-half second or longer. Still, noise is a minor issue to me most of the time, and I'm grateful to pay that price to get photos in nearly dark locations.

5-27

5-28

Assignment

Experimenting with the Motion of City Lights

Although many people put their cameras away after the sun has set, it's fun to go out prowling through the night looking for colorful shots of night lights — especially if you live near or are visiting a big city like New York. There are a lot of ways to shoot a city at night, but perhaps one of the most fun techniques is to use a long exposure time and jiggle or swirl the camera around during the exposure. One of the great things about shooting pictures like this is that you don't have to lug a tripod around because you're not trying to keep the camera steady. Also, because you aren't trying to capture short exposures, you can leave the ISO at a relatively low speed, such as ISO 100 or 200.

For this shot of lights in Times Square in Manhattan, I stood on an esplanade in the center of Broadway and took a series of exposures between 1 and 10 seconds each, and just jiggled and wiggled the camera in different directions. After each shot, I looked at the LCD to see the result. This shot was made using an exposure of 1/4 sec., f/18, ISO 1600.

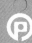 Remember to visit www.pwassignments.com after you complete this assignment and share your favorite photo! It's a community of enthusiastic photographers and a great place to view what other readers have created. You can also post comments, and read encouraging suggestions and feedback.

TRAINING WHEELS OFF: GOING BEYOND THE GREEN MODE

All digital cameras have a "green" or fully automatic exposure mode — a mode that makes all of your exposure decisions for you, regardless of what your subject is or what types of situations you're encountering. For the vast majority of camera owners, that's exactly where the exposure-mode dial remains, unless, of course, their six-year-old gets a hold of it and starts spinning dials wildly (which might actually lead to some interesting experimental photos). There's absolutely nothing wrong with taking pictures in the green mode because in a lot of ordinary situations, like the colorful and brightly lit little vignette that I shot

in front of an antique store in Greenville, Maine, that mode works just fine and usually produces very acceptable exposures (see 6-1).

The problem with using this mode exclusively is that not all subjects are "ordinary" and not all photographers see the world in the same way. While you might see a landscape as a great time to pile on all of the depth of field you can, for example, another photographer might choose to limit focus to a single tree or rock outcropping. In the photograph of the Château de Chenonceau (see 6-2), for example, I wanted to keep everything from the garden to the château sharply

6-1

ABOUT THIS PHOTO *The beauty of having a fully automatic mode is that you can get great-quality images in what is basically a point-and-shoot mode. Taken with a 70-300mm Nikkor zoom lens and exposed for 1/1000 sec., f/8 at ISO 200, handheld.*

ABOUT THIS PHOTO *The aperture-priority mode helped me to get good depth of field for this shot of Chenonceau in the Loire Valley region of France. Taken with an 18-70mm Nikkor zoom lens at 1/250 sec., f/16 at ISO 200, on a tripod.*

6-2

focused, and so I used a small aperture. For the giant saguaro cactus (see 6-3), however, all that mattered was that the cactus itself was sharply focused — the background simply didn't matter. That's where exposure modes come in handy. The ability to tell your camera which aperture to use, for example, provides you with complete control over depth of field. And by setting the shutter speed, you have absolute control over how motion is interpreted.

Turning away from the fully automatic exposure mode on your camera for the first time is kind of like tossing away the training wheels on a bike. Suddenly you're completely on your own with only your self-confidence and newly acquired knowledge between you and the photographic pavement. Without your camera to make all of

the aperture and shutter-speed decisions for you, you're left to balance and steer your own way to better pictures. But just as with riding a two-wheeler for the first time, you're going to love the freedom of riding without a net, because it's in the experimentation and taking chances that you find true photographic freedom.

In this chapter, I walk you through the basics of both the primary exposure modes and the "scene" or subject modes that many cameras have, and I explain why you might choose one mode over another. It's not likely you'll ever use all of the exposure modes hidden in the labyrinth of menus and dials on your camera, but identifying a few useful ones can certainly help you get more fun, not to mention better pictures, from your camera.

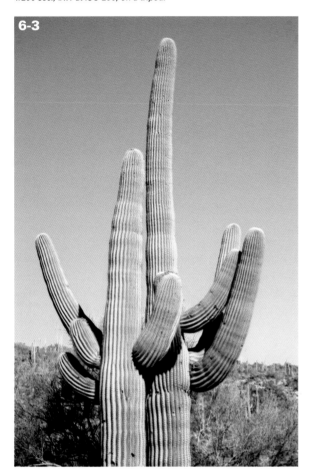

6-3

THE PRIMARY EXPOSURE-CONTROL MODES

Although some simpler point-and-shoot and compact cameras don't offer them, a growing number of zoom cameras and virtually all dSLR models not only offer a fully automatic exposure mode (and often two of them), but they also offer "priority" modes that let you select either the aperture or shutter speed (while the camera automatically selects the correct corresponding setting). These two additional modes are perhaps the most useful modes available, because between them, they give you absolute control over both depth of field and subject motion — as a serious photographer, you can't live without them (although if your camera lacks them but has subject modes, as I discuss next, there are ways you can exploit scene modes to do the same thing with somewhat less precision control). In addition, your camera may offer a manual mode that has very distinct advantages.

AUTOMATIC AND PROGRAMMED MODES

The automatic and programmed modes found in all types of digital cameras are the simplest of all exposure modes to use: you point the camera and they select both the aperture and shutter speed for you. These modes are often referred to as the "idiot" modes because . . . well, for obvious reasons. But don't let that intimidate you from using them. When you are shooting in situations that are well lit (particularly bright, front-lit scenes), and neither depth of field nor subject motion are vital factors, it's perfectly fine to use these modes. I use them quite often and get great results. I photographed the lamppost (see 6-4) seconds after hopping out of my car in Camden, Maine, and all I did was literally point and shoot in the program mode (and because I was on my way into a shop to buy fudge, it's a good thing because otherwise I might have passed the shot by).

Many cameras have both an auto and a programmed mode — although typically it's only the auto mode that is marked in green on the exposure dial. Is there a difference? Yes, and although the specifics may vary somewhat from camera to camera, basically the difference is that in the auto mode, you have limited or no override ability.

In other words, in this mode, the camera makes all of the exposure choices and you're just an

ABOUT THIS PHOTO *Sometimes pretty photos just land in your lap and that was the case here — I happened to park my car in front of this lamppost. Taken with a 24-120mm Nikkor zoom lens and exposed for 1/250 sec., f/9 at ISO 200, handheld.*

observer (see 6-5). If the camera decides on a shutter speed that you think is too slow, very often you have no recourse but to either accept that speed or move on to another mode. Similarly, if the camera decides that a flash is necessary for an indoor shot, you're going to get a flash unless you take steps to shut it off. Also, in the auto mode you are typically not able to change the ISO or white balance settings and must rely on the camera to select the best settings

for you. Again, depending on the camera, certain other functions, such as exposure compensation and advanced flash modes, may not be accessible in the auto mode.

The programmed mode is a bit different and considerably more flexible. In this mode, while the camera selects the shutter speed and aperture, there is often a "command" or "shift" dial that lets you choose from other different but equivalent combinations of shutter speed and aperture. For example, if you're photographing your dog belly-flopping from the diving board into the pool and the camera chooses an exposure combination of 1/125 second at f/8, and you think you need a faster shutter speed to stop your dog in mid-leap, you can spin the command dial to get an exposure of 1/500 second at f/4. That setting, as you now know, provides exactly the same amount of light, but gives you an action-stopping shutter speed. In addition, in this mode, the camera may force you to make some exposure choices manually — turning on the built-in flash if you choose to use flash, for example. By the same token, you can usually also change other settings, such as the white balance or ISO settings.

 tip | Check your camera manual for an explanation of the specific differences among the modes.

APERTURE-PRIORITY MODE

In the aperture-priority mode, you select the aperture setting and the camera chooses the corresponding shutter speed for a correct exposure. This is the exposure mode to choose when controlling depth of field is the most crucial part of your exposure setting. Because being able to manipulate the range of sharp focus is usually very important in my work, this is the exposure setting that I use for the vast majority of my shooting.

If you're photographing a landscape where great depth of field is essential, for example, you can set a very small aperture, and the camera selects the correct shutter speed. While sitting on a deck in Maine, I wanted a shot of the harbor (see 6-6), but I wanted to keep everything from the flowers in the window boxes to the boats in sharp focus, and so I used an aperture of f/20 with a wide-angle lens. Keep in mind, however, that if you are selecting a very small aperture, the shutter speed

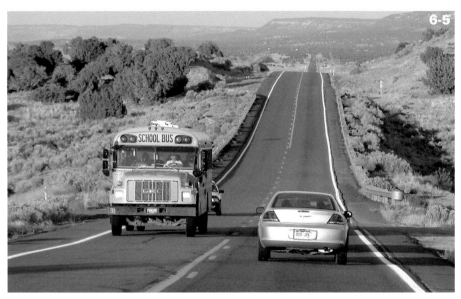

that the camera chooses may be too slow for handheld work, and so you'll have to support the camera with something other than your hands (the necessity of owning a tripod arises again). Some cameras provide a viewfinder warning to let you know that you've exceeded the safe shutter speed zone, but alarm or not, it's something to keep your eye on.

You can also use this mode to subdue backgrounds by intentionally selecting a larger aperture (see 6-7) and letting the camera choose a correspondingly fast shutter speed. Again, however, your camera may run out of fast shutter speeds in brightly lit situations. If, for example, your meter provides a correct exposure of 1/250 second at f/16 and ISO 200 (a common meter reading in bright sunlight), but you want to limit depth of field severely by choosing an aperture of f/2.8, then this requires a five-stop change (f/16 to f/11 to f/8 to f/5.6 to f/4 to f/2.8). In order to get a properly exposed image, you would need to have a top shutter speed of 1/8000 second (1/250 to 1/500 to 1/1000 to 1/2000 to 1/4000 to 1/8000) — again, a five-stop change. Some cameras have shutter speeds that fast, but many don't.

As mentioned in the previous chapter, if you should run out of fast shutter speeds, the only option is to lower your ISO speed (if possible) or put neutral-density filters on your lens to cut down on the light.

SHUTTER-PRIORITY MODE

Whenever concerns about subject motion — whether for creative reasons or just to keep your subjects sharp — outweigh depth-of-field considerations, the shutter-priority mode is the way to go. If

6-7

ABOUT THIS PHOTO *I came across this colorful lizard on the front lawn of a gift shop in southern Arizona and used a wide aperture to subdue the distracting background. Taken with a 24-120mm Nikkor zoom lens; exposed at 1/125 sec., f/5.6 at ISO 200, handheld.*

you're photographing knights jousting at the local Renaissance fair (see 6-8), for example, giving priority to choosing a high shutter speed guarantees you more action-stopping power. Conversely, when I was photographing the seaplane taxiing on Moosehead Lake in Maine (see 6-9), my priority was to get a sharp image of the plane, and so I used the shutter-priority mode to select a relatively fast shutter speed of 1/500 second.

6-8

6-9

One thing to be aware of when you're in this mode is that as you shift to faster or slower shutter speeds, your corresponding aperture changes can create potentially extreme changes to the depth of field. As you shift to a slower shutter speed, for example, your camera chooses smaller apertures that, if the aperture is small enough, cause the depth of field to increase noticeably. In some situations, of course, this can be a coincidental benefit. To photograph the waterfall in

figure 6-10, I wanted to use a slow shutter speed to blur the water, and that in turn supplied me with a very small aperture that created excellent near-to-far sharp focus. Look at the two close-up details of the same shot (see 6-11 and 6-12) to see how the difference in shutter speed affects the appearance of just the moving water.

Conversely, as you move to faster shutter speeds, the camera is forced to choose wider and wider apertures, and they in turn begin to shrink the near-to-far focus range. These changes may or may not be an important factor (see 6-13), but it's something you must keep a constant eye on or

ABOUT THIS PHOTO
For this scene, I selected a slow shutter speed to create a smooth flow of water and, as a result, I got a lot of depth of field. Taken with an 18-70mm Nikkor zoom lens, exposed at 1/40 sec., f/18 at ISO 200, on a tripod.

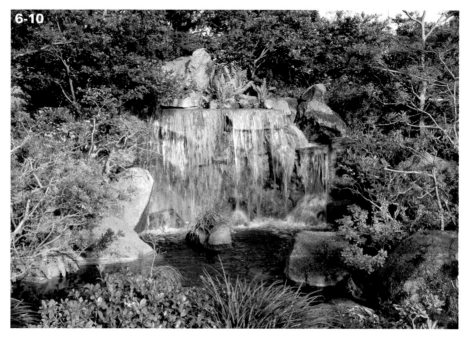

ABOUT THESE PHOTOS *These are detail shots of the same scene in figure 6-10, and were shot from the same location with a long lens, at two different shutter speeds. Figure 6-11 was exposed at a fast 1/500 sec. (at f/7.1), and figure 6-12 was shot at the same exposure as the wide shot, at 1/40 sec. and f/25 (the aperture was smaller because the light increased slightly while I was shooting). Both exposures were made with an 80-200mm Nikkor zoom lens, at ISO 200.*

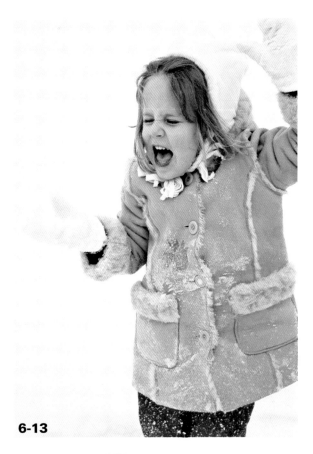

6-13

ABOUT THIS PHOTO *Fast-action portraits like this little girl playing in snow require fast shutter speeds, but depth of field is of almost no concern. Taken with a 55mm Canon lens at 1/1600 sec., f/5.6 at ISO 200, handheld. ©Jennica Reis.*

the look of your image can change radically. Again, though, if your primary purpose in selecting this mode is to stop or exaggerate motion, then that is your primary visual concern, and depth of field has to remain a secondary factor.

The shutter-priority mode is also an excellent choice for night photography and indoor photography, because there are times when you must resort to using very slow shutter speeds in order to get an acceptable exposure. I photographed the

little sea creature in figure 6-14, for example, at the Mystic Aquarium in Mystic, Connecticut, in a dimly lit room. I had to reduce the shutter speed to 1/25 second just to get an exposure. I would have loved to have a bit more depth of field, but I was forced to shoot with the lens wide open. Similarly, I photographed the full moon rising over a marsh in Texas (see 6-15) and had to shoot with my 400mm lens at its maximum aperture just to get enough light, because if the shutter speed had been any longer, the natural orbit of the moon would have caused it to blur.

MANUAL-EXPOSURE MODE

Many dSLR cameras and a growing number of zoom and advanced compact cameras also have a manual-exposure mode where you set both the shutter speed and the aperture manually (hence the name). In this mode, you're basically telling the camera that you'll solve all of your own exposure dilemmas.

While the camera has a display in the viewfinder that tells you when you've set the correct exposure, it won't help you if you haven't (although some cameras tell you how far off you are if you haven't). In other words, it sits there and waits patiently while you spin through the aperture and shutter speeds until you've found what the camera thinks is the correct exposure. You're not only throwing away the training wheels in this mode, but you've gone around the bend and your big brother has stopped chasing after you to make sure you're safe. In the manual mode, you're on your own.

 x-ref

Chapter 9 is devoted entirely to taking pictures at night — it offers a lot of good information on how to use your camera after dark.

ABOUT THIS PHOTO
*Taking pictures in very dim
locations like this saltwater tank
at the Mystic Aquarium requires
very slow shutter speeds.
Photographed with a 70-300mm
zoom lens at 1/25 sec., f/4.5 at
ISO 800, handheld.*

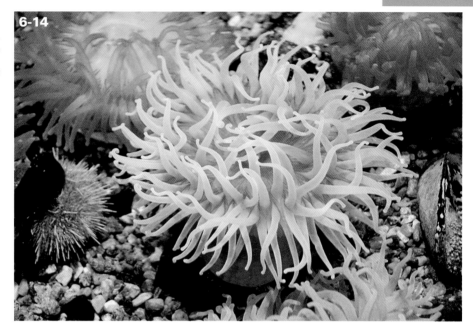

6-14

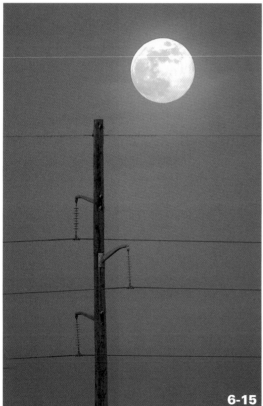

6-15

The manual mode has several advantages, and as imposing as it might seem to you at first glance, it's actually a very handy mode. If you're using a hand-held meter, for example, you can simply set your exposure-mode dial to "M" (the typical indicator of the manual mode) and then set the exposure that your handheld meter suggests. Your camera's built-in meter may still tell you (usually in a bar graph of some sort at the bottom of the viewfinder) if it agrees with its handheld rival, but you are under no obligation to take the camera's advice.

A more common situation for using the manual mode is when you're using either your center-weighted or spot-metering mode to take close-up readings of particular areas of a scene and you want to lock in those readings as you move the camera around or zoom the lens in and out. In these modes, remember, you are only using a portion of the viewfinder area for your meter reading. You can see in figure 6-16, for example, that while the

ABOUT THIS PHOTO *I was photographing the sunset in a
marsh in Port Aransas, Texas, when I turned to see this full moon rising
behind power lines. Taken with a 400mm Nikkor lens at 1/100 sec., f/4 at
ISO 800, on a tripod.*

143

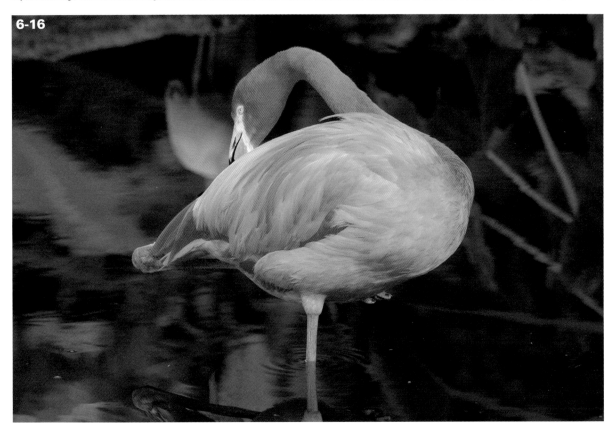

6-16

flamingo is very bright, the background is nearly black. To get a correct exposure, I took a center-weighted reading of just the bird and then manually set that exposure. Why didn't I just use the center-weighted mode? The main reason was that I kept adjusting the focal length of the zoom lens, and in wide positions the dark background would have had too much influence, even on the center-weighted reading. By taking the reading and then using the manual setting, I was able to essentially lock in that reading, regardless of the zoom setting.

You can use the same technique with bright beach or snow scenes, or any time the main subject is small in the frame and you want to override meter readings. In the shot of the cowboy standing in the barn door at a county fair (see 6-17), I was afraid

that the dark frame of the doorway might influence the exposure and take away from the silhouette effect I was after, and so I took a center-weighted reading of the merry-go-round and used the manual-exposure mode to lock in that reading.

Perhaps the most frequent use of the manual mode, though, is to simply override the exposure that your camera is recommending, or when you're simply experimenting with exposures. In night photography, for example, I often use the manual mode and double the exposure times until I see something on the LCD that I like. That was exactly the case in the night harbor shot (see 6-18) when I started with an exposure of four seconds and kept doubling the time until I reached an exposure of around 28 seconds.

ABOUT THIS PHOTO
*The only way to get a pure sil-
houette is to lock in your expo-
sure for the bright background.
I made this shot with a
24-120mm Nikkor zoom lens,
1/125 sec., f/5.6 at ISO 200,
handheld.*

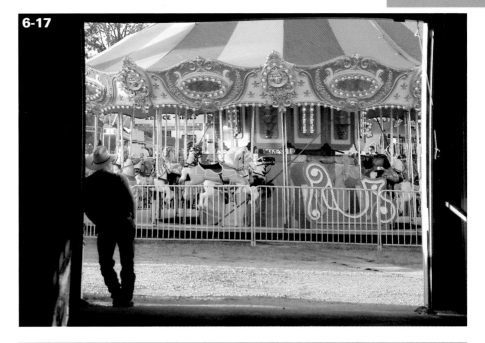

ABOUT THIS PHOTO
*Night photography is tricky for
meters; it's much simpler if you
switch to the manual-exposure
mode and experiment with
exposure times. This harbor
scene in New London,
Connecticut, was shot using an
18-70mm Nikkor zoom lens at 32
sec., f/13 at ISO 200, on a tripod.*

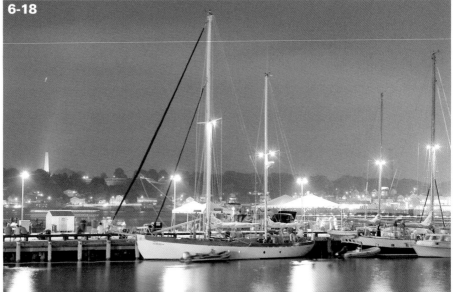

SCENE MODES

If you've looked carefully at your exposure mode dial (or scrolled through your menu options) you've no doubt found a plethora of curious little icons of things like a person running (no, it's not the bathroom-break mode), a little mountain peak, and a person's head. These are the icons for what are called *scene modes*, or "subject modes" as they're called on some cameras. These modes serve as shortcuts to getting a premium exposure with specific types of subjects.

These modes are quite handy to have, and I highly recommend experimenting with all of them because in the long run, they may save you a lot of time and brainpower. In particular, if you are still not comfortable with the actual numbers involved in setting apertures and shutter speeds, but you understand the general concepts (that is, that you might want a lot of depth of field in a landscape or want to freeze action in a sports shot), then these scene modes can become the warm, cozy friends that you always hoped to find in a camera. They are simple to use and they do a very good job.

Keep in mind, however, that when using these modes, the camera may dictate certain settings, including file quality (usually high-quality JPEG), white balance, ISO, color space, and metering pattern.

The following is a selection of some of the more common and useful scene modes, although you may find a lot more hidden on your particular camera. Some manufacturers, in fact, have become amazingly specific with their modes — like night-portrait modes (great fun) and a fireworks mode for shooting your Fourth-of-July photos.

■ **Landscape mode.** Usually indicated by a small silhouette of a mountain on the mode dial, this mode allows the camera to choose both the aperture and the shutter speed, but gives priority to selecting the smallest aperture possible so that you get maximum depth of field (which manufacturers assume is what most people want — and they're right). However, the camera does have to compromise to be sure that you get a shutter speed that is safe for handheld shooting. This is a great mode to be in if you're driving around the countryside on a Sunday afternoon or while on vacation, and want to get good landscape and scenic shots without any technical fussing around (see 6-19). You can also use this mode in any situation where you want a moderate or better amount of depth of field, such as in these shots of Christo and Jeanne-Claude's art installation, The Gates, in Central Park, New York City (see 6-20 and 6-21).

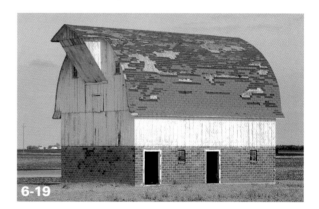

6-19

ABOUT THIS PHOTO *I have an absolute fascination with old barns, particularly those in Iowa. This one was photographed with a 24-120mm Nikkor zoom lens, exposed for 1/1000 sec. at f/8 at ISO 200, on a tripod.*

ABOUT THESE PHOTOS

Both of these photos of Christo and Jeanne-Claude's art installation, The Gates, were shot in the landscape mode because I was simply there to stroll through the show and enjoy. Both were taken with an 18-70mm Nikkor zoom lens at 1/320 sec., f/10 in 6-20 and 1/160 sec. at f/7.1 in 6-21, both at ISO 200, handheld.

6-20

6-21

- **Sports/action mode.** Just as you would imagine, this mode (which is usually represented by an icon of a person running) chooses both the aperture and shutter speed for you, but it gives priority to selecting the fastest available shutter speed, while disregarding any depth-of-field considerations entirely (see 6-22). The goal here is to stop action, but don't think only in terms of sports; anything that's moving is fair game for this mode, including kids on the backyard swings, your dog playing in the lawn sprinkler, or even a carnival ride in motion (see 6-23).

6-22

ABOUT THIS PHOTO *A moment after she knelt to feed this beluga whale, the trainer stood up and the whale leaped up to say goodbye. Fortunately, I was in sports mode and the camera exposed the shot with a 400mm Nikkor lens at 1/400 sec., f/10 at ISO 200, handheld.*

6-23

ABOUT THIS PHOTO
The thing I like about this carnival ride shot is that the fast shutter speed froze the riders' legs in a somewhat surreal arrangement. Photographed with a 70-300mm Nikkor lens at 1/800 sec., f/7.1 at ISO 200, handheld.

■ **Night-scene mode.** Most digital cameras have at least one night-scene mode, and some cameras have several, offering you the option of having the flash fire automatically in one mode, and not using the flash in the other. This exposure mode is indicated by an icon of a building with a moon over it. The non-flash version of this mode is excellent for shooting twilight city scenes (see 6-24), skylines, or even sunsets, while the flash version is good for including people or some other important foreground subject (see the next bullet for "Night-portrait mode."). In this mode, the camera usually tweaks exposure in two ways: It automatically selects a higher ISO speed, and it gives priority to providing the slowest possible shutter speed so that you can record darker scenes with more detail.

■ **Night-portrait mode.** Much like the night-landscape or night-scene mode, the night-portrait mode (typically indicated by a silhouette of a head with a star above it) sets a longer-than-normal shutter speed (compared to what it

would set for a daylight scene, for example), but it also combines that longish exposure with a burst from your built-in flash. The purpose of this dual manipulation of the exposure is so that you can, for example, photograph a person standing in front of an artificially lit scene and record both the face and the background in a nice balance. I photographed this "living" Statue of Liberty in Times Square (see 6-25) around midnight on a hot and crowded July night, and used the night-portrait mode to create a nice balance between her (actually, I think it was a him in the costume) and the bright lights of Broadway.

> *caution* In the night-scene and night-portrait modes, the camera may set a shutter speed that is too low for handholding. Don't automatically assume that your shots will be sharp simply because the camera lets you take the picture. Check the shutter speed that the camera has chosen (it's usually displayed in the viewfinder or LCD) and, just to be safe, always try to steady the camera on something solid like a car fender.

ABOUT THIS PHOTO
The Seine in Paris is most beautiful at twilight when there is still light in the sky and the dinner barges and nearby buildings have their lights on. Taken with an 18-70mm zoom lens at 1/25 sec., f/4 at ISO 800, supported on a bridge.

6-24

6-25

ABOUT THIS PHOTO
The night-portrait mode works great when you need a flash to illuminate your subject in front of a bright, colorful backdrop like Times Square. Taken with an 18-70mm Nikkor zoom lens at 1/60 sec., f/4.2 at ISO 400, handheld.

Different cameras handle this mode differently: Some fire the flash first and then extend the shutter speed, while others create a long exposure and then fire the flash just before the exposure ends. The difference between these two styles of exposure really has to do with the way the camera is handling moving subjects (if any) during the exposure. With some cameras the flash fires, the ambient light exposes, and then the shutter closes. When you use this mode and have subjects (traffic, for example) moving in the background of the scene, the streaks might appear to be going the wrong way — an odd phenomenon that is simply a by-product of the design. Other cameras take the ambient exposure first and then fire the flash just before the shutter closes — and so the motion lights appear more normal (a system called *rear curtain sync*). Most cameras use the latter system — read your manual to see how yours handles it.

One caution, though: When you're using this mode, it's important to keep the camera steady because, otherwise, the long exposure time blurs subjects in the background or even creates a ghost image of your subject. You can, of course, take advantage of this to create some wild effects.

■ **Portrait mode.** Because most portraits look better when the depth of field is kept shallow, the portrait mode (usually indicated by a silhouette of a head) was created to automatically bias the exposure toward a wide aperture. In this mode, you get enough depth of field to keep an individual person sharp, but the background is generally out of focus (see 6-26). Also, with most cameras, this mode automatically fires your built-in flash to lighten up facial shadows. On some cameras, you have the option to turn the flash on or off, while on others you don't. This is an excellent mode to use if you're hanging around by the pool with the kids or shooting at the family reunion.

6-26

ABOUT THIS PHOTO *You can't ask for a better subject than a girl and her dog — and the portrait mode is ideal for quick shots like this one. This shot was made with a 24-120mm Nikkor lens at 1/160 sec., f/4.2 at ISO 200, handheld.*

■ **Close-up mode.** Almost all digital cameras have a great facility for making good close-up photos, and even some very inexpensive cameras make terrific macro photos. However, the complexity of the close-up mode (as well as the minimum close-focusing distance) varies from camera to camera, and each operates a bit differently; it's important to read your manual to see exactly what is happening when you switch to this mode. The primary thing that happens in this mode is that your lens shifts into a macro (close-up) focusing setting that significantly reduces the close-focusing distance of your camera — often to within a few inches or less of the front lens element (and you wouldn't believe the optical-accessory workarounds we had to deal with to do this in pre-digital days). Taking the close-up photo of the *Clivia miniata* plant (see 6-27) with my Canon Rebel dSLR was as simple as switching to that mode and firing away.

The other aspect of this mode is that the camera usually sets a small aperture in order to provide the depth of field that is so inherently shallow in all close-up work. The trade-off here is that in order to give you better depth of field, the camera has to either slow down its shutter speed (which leads to camera and subject shake) or turn on the flash (which can ruin the mood of a shot instantly). In order to give you back some control, the best close-up modes let you choose either auto-focus or manual focus (even my compact camera lets me focus manually — which is an incredible advantage and something to keep in mind when shopping for a new camera) and also let you turn the flash on or off. Again, reading your manual can answer a lot of questions about just what capabilities your camera has for close-ups.

6-27

ABOUT THIS PHOTO
The close-up mode on my dSLR camera automatically fired the flash in this shot — which turned out to be acceptable here, although I like the ability to shut the flash off. This shot was taken with an 18-55mm Canon lens at 1/60 sec., f/5 at ISO 100, on a tripod.

Assignment

Pick a Mode, Any Mode

Chances are that regardless of what type or brand of digital camera you own, it is packed with a selection of scene modes that let you take quick-and-easy shots of everything from night landscapes to close-ups of bugs in your garden. For this assignment, choose a mode that relates to a subject you enjoy shooting, and then photograph it using the related scene mode. It's easy to leave the camera "in the green" and never explore the rest of the exposure-mode dial, and so hopefully this exercise will get you comfortable with other modes.

For this assignment, I decided to see just how close I could get to one of my favorite flowers — the beautiful bleeding hearts that grow with wild abandon in my garden. I used a 105mm Nikkor micro lens and put my Nikon dSLR in the close-up mode, which automatically turned on the built-in flash (you can see some highlights in the pink area of the flower reflecting the flash). There's only a tiny amount of depth of field in the shot — but then again, the flower bud is only the size of your thumbnail. Taken at 1/60 second, f/10, at ISO 200.

Remember to visit www.pwassignments.com after you complete this assignment and share your favorite photo! It's a community of enthusiastic photographers and a great place to view what other readers have created. You can also post comments, and read encouraging suggestions and feedback.

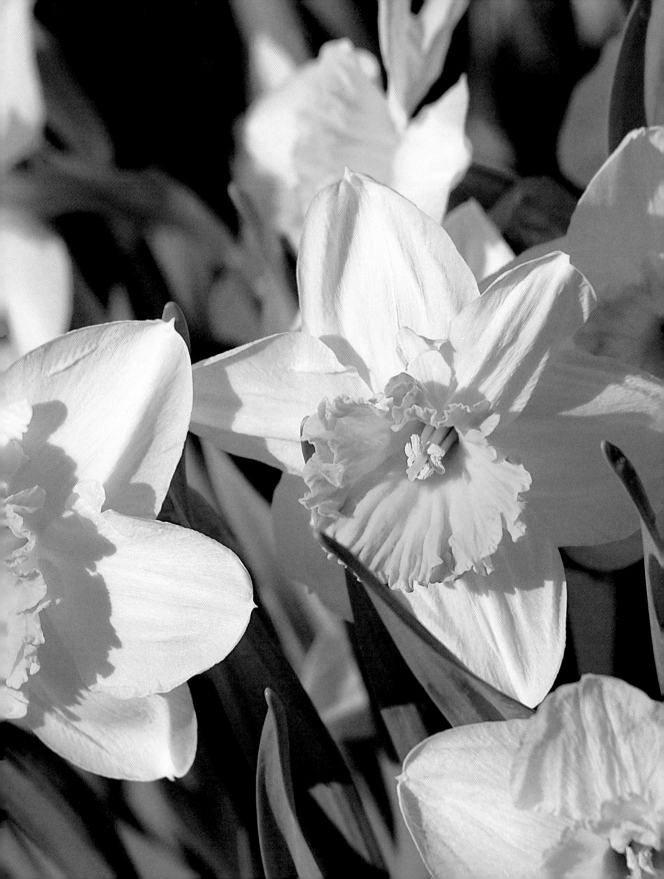

There's a charming 1970s movie called *The Owl and the Pussycat* that stars George Segal and Barbra Streisand as a pair of misfit New Yorkers whose worlds unexpectedly collide. Hamilton's character is a wannabe writer named Felix and during the course of the film, Streisand's character (a down-and-out part-time hooker) comes across one of his unpublished manuscripts where he uses the phrase "The sun spit morning into Julian's face . . ." Streisand's character (Doris) launches into a tirade of literary (not to mention personal) criticism and demands that he explain how the sun can *spit* morning. She is aghast and perplexed by his choice of verbs. It's a very funny scene.

The truth is though, the sun does spit — and it licks and it kisses, it carves and caresses and soothes, and it colors and obscures and adorns. The sun's light illuminates and embellishes the shapes and textures and forms of the world

around us in myriad different ways, some so subtle we barely notice them until we see and study them in photographs, others so bold the results are too harsh to even look at. The sun, of course, not only provides the light that we see by (without it we would inhabit a very cold and dark blob without a solar system to call home), but it is also the master painter of everything we see. Capturing the many moods of natural light (see 7-1) requires that you be able to anticipate when the most beautiful and dramatic moments will occur, and that you be prepared both technically and emotionally.

That way, when the sun does occasionally spit out morning, if you're lucky, you'll be ready to capture that exact moment. That is the magic of natural light: It never lights our world the same way twice, and it constantly paints the world anew with an ever-changing and unpredictable

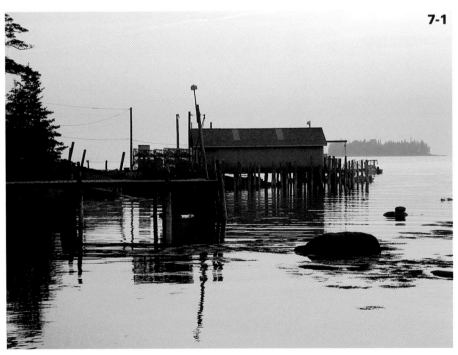

7-1

ABOUT THIS PHOTO
The drama of daylight is never-ending, from the first rays of sunrise until it sets in a burst of color. Photographed in Stonington, Maine, with a compact digital camera. Exposed at 1/460 sec., f/3.6 at ISO 100, on a tripod.

palette of colors, moods, and emotions. For photographers, it is both a worthy adversary and a wonderful co-conspirator. More than any other topic that you can study in your journey as a photographer, light is both the most profoundly complex and the most fun.

> **idea** The next time you want to take some photographs and bad weather is keeping you from shooting, head to your local library and study the way that other photographers have used natural light. Ansel Adams, Galen Rowell, John Sexton, David Plowden, Franz Lanting, and Pete Turner are among the photographers whose books have inspired me. My personal favorites are *Cape Light* by Joel Meyerowitz and *The Last Places on Earth* by Eric Meola. Find a photographer whose work you love and you will find inspiration and a lighting mentor.

A DAYLIGHT PRIMER

Daylight has many different qualities, and as cold and calculating as it might seem to divide them out and analyze them, it will absolutely help you to *see* light more intimately if you become a little analytical in your thinking about it. For example, in addition to the intensity of illumination that it provides, light has several other unique characteristics, including color, direction, and quality. Each of these characteristics is also greatly affected by things like weather, time of year, and, of course, time of day. The more you study the qualities of daylight — even if that just means gazing out at the landscape as you drive to work in the morning and noticing how the light is making the autumn leaves translucent — the more you'll begin to recognize the variety of moods that daylight offers. And the more you think about light as the purveyor of mood, the more interesting and intense your photos will become.

Studying light will also help you deal with different lighting situations; if you can immediately recognize and define a few of the qualities of light, you can match your photographic approach to any given scene much more quickly. If you know, for example, that early morning light is much softer than midday light (it is), you know that you will have less of a problem with contrast and glare by taking photos of your garden early in the day. Similarly, if you are aware that direct overhead light at high noon creates shadows under noses and in eye sockets, you can be prepared to combat those problems by turning on your flash or moving your subjects into the shade. And when it comes to capturing pretty sunsets, you already know that the sun sets in the west, but what you might not know is that the best colors often happen *after* the sun has set, in what photographers call the *afterglow* (and I'll discuss that later in this chapter).

WHITE BALANCE AND THE COLOR OF DAYLIGHT

Although we often think of daylight as "white" or even colorless, in fact, the color of daylight changes continually from dawn until dark, and often in some pretty dramatic ways. We've all looked out the kitchen window as the sun was just beginning to creep over the horizon, seeing the backyard or the city bathed in a violet-blue light and then watching as that cool glow turned to gold as the sun rose. These are the extreme times of day, and the color of daylight is much more obvious (see 7-2 and 7-3).

ABOUT THESE PHOTOS *Look how different the mood is in these two shots — both made on the same river a few days apart. The first image, 7-2, was photographed in the pink light of a wild dawn, and 7-3 was photographed as the sun broke out on a stormy afternoon. The dawn shot was taken with a 70-300mm Nikkor zoom lens at 1/60 sec. at f/4.5, and the afternoon shot was made with the same lens at 1/125 sec. at f/5.6. Both were at ISO 200 on a tripod.*

7-2

7-3

Most of the time, though, the shifts in color are so subtle that we rarely notice them, and even when there is a strong colorcast to the daylight, our eyes adjust so quickly that everything seems "white" or colorless very quickly. The sensor in your camera, however, is programmed to record daylight as it exists on a bright, clear, sunny afternoon — or about 5400 on the Kelvin scale that I'm sure you will remember from your high school physics class. And I'm sure you also remember that the Kelvin scale was named after William Thomson, also known as Lord Kelvin (1824-1907). No? Oh, well, you were probably sick that day.

Color temperature is the primary way for describing the color of various light sources, including daylight. Color temperature is indicated in units called Kelvin. It increases as the colors go from red to blue. Daylight, for example, is right in the middle, at about 5000-5400K.

In the film days, if you were shooting color film, you had to buy a film that matched the color temperature of your primary light source. If you were using daylight as the main source, for example, you simply bought daylight-balanced film. If you were using tungsten, however, you bought tungsten-balanced film. And, of course, if you were using an offbeat light source — like fluorescent lamps — you would have to filter the lens to match the film you were using.

The reason that films — and the sensor in your digital camera — need to be balanced to the light source is that otherwise, the images will have a strong colorcast. You've probably used daylight film indoors under tungsten lamps, for example, and were surprised when the images came back with a reddish or orange cast. That shift happened because daylight film is balanced to give proper color with daylight, which has a very blue color and the tungsten lights are more orange in color. The reverse could also happen: If you were

to use tungsten-balanced film outdoors, the images would be overly blue because they have built-in blue filtering to counteract the red of the tungsten lamps.

Because it would be impossible to switch sensors for each different light source (but wow, wouldn't the manufacturers love to sell you a whole set of sensors!), digital cameras solve the color-balance problem with a control called *white balance*. The white balance control (you'll find it in your camera's set-up menu) lets you tell the camera exactly what type of light source you'll be using. The wonderful thing about this setting is that, unlike the film days when you had to switch films or re-filter the lens, you can simply tell the camera that you're switching light sources and all of your images will be perfectly color balanced — regardless of how many times you change lighting. The idea was actually borrowed from the professional video world (it was essentially a Hollywood invention designed to let videographers find neutral white in any scene), where it has been in use for decades.

Most cameras offer you a choice of methods for setting the white balance:

- **Automatic white balance.** The default setting of your camera in the auto-exposure mode is for auto white balance. That means that your camera measures the color of the light and takes an educated guess about the source — and in most ordinary circumstances, it does a very respectable job. As long as you're in this mode, you can roam freely from light source to light source and not have to worry about white balance.

- **Selective white balance settings.** In addition to the auto setting, your white balance menu typically provides a choice of several settings that are targeted at specific light sources and daylight situations, including daylight, open

shade, cloudy day, tungsten, flash, and fluorescent lighting. Some cameras get even more specific about light sources, and many dSLR cameras even let you set the white balance by selecting the actual Kelvin units. In the first four shots of the barn, I've used four different white balance settings so that you can see how each changes the look of the image (see 7-4, 7-5, 7-6, and 7-7). Here, very briefly, is how each of these settings affects your images:

> **Daylight.** Images shot in this mode lean toward a bluish white. Unless you like slightly cool images, you are better off using the cloudy day setting for most outdoor scenes.

> **Shade or open shade.** This setting adds a reddish tint to counteract the very blue light of deep or open shade, and it's the mode you should use in shade or on very cloudy days. I also use it in normal sunlit scenes to warm them up, although some people might find this a bit too warm in tone.

> **Cloudy day.** This is my setting of preference for most of my outdoor portrait and landscape work. The cloudy day setting warms things up, but it does so in a more subtle way than the shade setting. You get a nice late-afternoon feel to outdoor scenes in this mode.

> **Tungsten.** Unless you like really reddish/orange interior shots, you should use this setting whenever you are shooting with normal tungsten room lights. This setting adds blue to the scene to absorb some excess red, and will provide nice neutral tones indoors — just be sure the bulbs in the lamps are really incandescent tungsten bulbs and not the new energy-saving fluorescent bulbs that so many people are using

these days (which are already very blue). You can also use this setting outside for a cool moonlit look.

> **Electronic flash.** Because flash is generally very blue in color, this filter adds warmth — similar to adding the cloudy day or shade setting to a daylight scene. I sometimes use this setting when I'm shooting with a flash; however, most of the time I'll experiment between this and the cloudy day setting, and often the cloudy day setting wins out. Just shoot a few frames in each mode and see what you prefer.

> **Fluorescent.** Fluorescent lamps are difficult to balance because different brands and types of bulbs, and even different wattages, all produce radically different colors of light; as a result, there is simply no way to predict what any given light will do. You can (and should) experiment with this setting versus the daylight setting or even the flash setting when you're working with unknown light sources (this includes vapor-type lamps that you find in industrial settings and many city street lamps).

If you've ever landed in a plane at night, you can look at one parking lot and see a warm golden glow, while another lot across the street is green or purple in color. The difference is very obvious when you're looking down from above, and it provides good evidence that these lamps really do produce a wide range of colors. The difference isn't so easy to see when you're standing on the ground taking pictures, which is why experimenting is so important. If your camera lets you fine-tune settings, you can also experiment with various levels of correction within a particular setting.

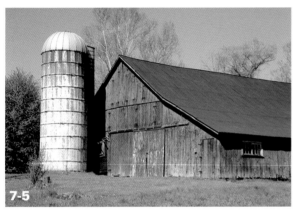

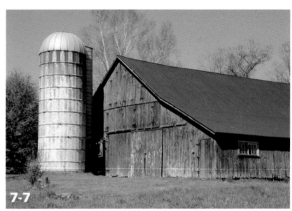

ABOUT THESE PHOTOS *Each of these shots was made using a different white balance: 7-4 fine weather, 7-5 cloudy day, 7-6 cool white fluorescent, and 7-7 tungsten, respectively. You can see that the fine weather and cloudy day balance settings have a more natural and warm look to them, while the two artificial light settings are very blue. All four shots were made with an 18-70mm Nikkor lens and exposed at 1/80 sec., f/20 at ISO 200, on a tripod. Absolutely no additional color changes were made in editing.*

WHY SET THE WHITE BALANCE YOURSELF? Why would you want to set the white balance manually when the camera will do it automatically for you? One reason is that some photographers are just compulsive control freaks who need to set everything — and there's nothing wrong with that if it includes you (because it certainly includes me a lot of the time). More importantly, though, is the fact that you are a better judge of the lighting situation than your camera. For example, you know when you are working in tungsten versus fluorescent lighting, but your camera may not always guess correctly. Or you may be shooting in a room that has tungsten lamps on, but you might be shooting a portrait by window light.

> **P** *tip* When it comes to seeing how the preset white balance choices will affect a given scene, don't just take my word for it; shoot a series as I did with the barn. Just put your camera on a tripod and shoot the same scene using each of the different white balance options. You may find that you like using the "wrong" white balance for certain subjects — using the cloudy day setting on a sunny day, for example.

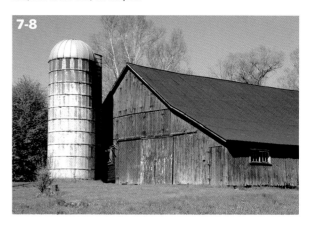

7-8

■ **Creative white balance settings.** There are also good creative reasons for manually setting the white balance. If, for example, you want to warm up a daylight shot on a sunny but very neutral-looking day, you can set the white balance to cloudy day and it will warm up the scene noticeably. Why? Because when you set the balance to cloudy day or to shade, the sensor is being told that the light is much bluer than it might actually be, and so it adds extra red filtering (warmth) to the scene. In 7-8, I wanted to maximize the warmth of the scene because I was shooting in the cool light of midday, and so I set the balance to the "shade" setting. Similarly, if you were shooting a sunset and wanted it to look like a moonlit landscape (in Hollywood they call that "day-as-night" shooting), you could set the balance to tungsten.

■ **Custom white balance settings.** In addition to being able to set the white balance to specific preset choices (and even manually setting the color temperature), most dSLR and some advanced zoom cameras allow you to create a white balance setting based exactly on the light source you're using. You create this setting by selecting the custom white balance mode from your menu and then making a test exposure. It's extremely important that the surface that you're setting the balance for be *white*, however, because the camera is

going to set the balance for that color. If you're using a surface that has a slight pink or yellow tint, for example, all of your photos shot with that setting will pick up that tint, because you're essentially telling the camera that that particular surface is white.

There are a few companies that make cards for custom-setting white balance; these cards have a degree of built-in warmth in their tonality and provide a very pleasing warm balance for portraits and landscapes. The company that I prefer is WarmCards (www.warmcards.com), and they offer a set of three cards (in two different sizes) that let you select exactly how much warmth you want to add. Take a look at the pair of shots (see 7-9 and 7-10) of artist Norman Rockwell's studio in Stockbridge, Massachusetts, and you can see the difference in warmth; the first frame was shot in the daylight white balance mode, and the second shot with custom white balance using a Warm-2 Card.

Setting custom white balance with your own surface or a manufactured one is a simple procedure: You set the white balance to "custom," fill the frame with the source card, and then expose a frame. Until you reset the

white balance, the camera retains that setting. This mode can be particularly useful in mixed-light settings or when you don't know the exact type of light (again, especially with vapor lamps in industrial situations) that is illuminating the scene.

7-9

7-10

ABOUT THESE PHOTOS *I shot Norman Rockwell's studio in the Berkshire Mountains on a very cloudy day, and despite the red building, the scene lacked warmth. The first shot, 7-9, was made using the daylight white balance setting in my dSLR, and 7-10 was made using a Warm-2 Card from WarmCards. Both shots taken with an 18-70mm Nikkor zoom lens and exposed at 1/200 sec., f/7.1 at ISO 200, on a tripod.*

ⓟ *note* If you're shooting in the RAW format and processing your own images, you will have a second chance to revisit your white balance options. In Photoshop, for example, you can choose from a drop-down menu that contains the standard white balance presets, or you can manually adjust the tint and the color temperature of the images.

LIGHTING DIRECTION

Thanks to the rotation of the earth on its axis and the elliptical orbit of the earth around the sun, the direction of sunlight on all earthbound subjects is in a constant state of flux. Just when you thought the morning light was so soft and pretty falling on the front of your garden, the sun starts its ascent into the afternoon sky and the light begins to come down from on high. A few hours later, the same sunlight is now hitting your garden from a low angle again, but this time it's behind the flowers. It's a relentless cycle that fine-tunes its angles and intensities a bit throughout the changes of the seasons, and that constantly repaints the look of the world around us. Even better, all of this visual variety is free for the looking.

The great thing about the continuous change in direction of the sun's light is that it provides the same subjects with a host of different looks. That wildflower meadow that looks so washed out under the harsh top light of an overhead sun positively glows in the yellow radiance of backlighting by late afternoon. And the peeling paint on your porch that looks so, well, unattractive and unkempt, in most light becomes a festival of interesting shapes and textures when the light comes at it from the sides.

And even if you can't wait for the light to change on a particular subject, you can often turn your subject (like a jack-o'-lantern on your front steps or your kids sitting in the pile of leaves you just raked) until you see a lighting direction you like. Remember too that with many subjects, if you don't like the direction of the light relative to your shooting position, you can often walk around the subject and change the lighting direction. You can't walk around a mountain, of course, but there are a lot of subjects that will benefit from a change of position.

While poking around under the Eiffel Tower one September afternoon, for example, I came across the bust of Alexandre Gustave Eiffel, its designer (see 7-11 to 7-13). At first I tried photographing the gold-painted figure using the sun as a front light (see 7-11), but the light was glaring and I had a tough time taming the highlights. Next, I tried using the sun as a sidelight by facing the statue nose-to-nose (see 7-12), but the contrast was strong and somewhat distracting. Finally, I placed the statue between the sun and myself (see 7-13) and exposed for the sky to create a silhouette — this is the shot I like the best. I shot about two-dozen frames from different angles and with different lenses, but knowing that taking a few steps around the subject would change its look is what rescued the shot.

Each direction of light has its own visual characteristics and may require some slight exposure adjustments. There are the four main categories of light direction, which I describe in the following sections.

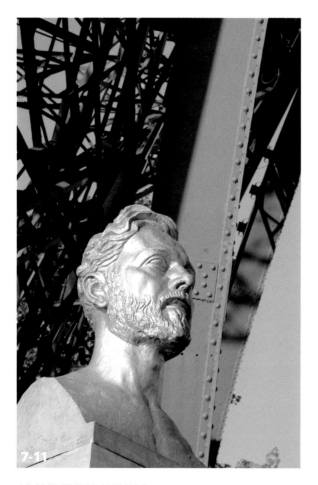

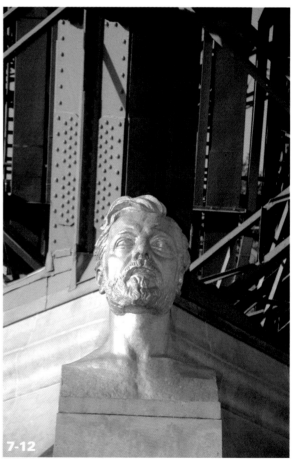

ABOUT THESE PHOTOS *Three different views of the statue of Alexandre Gustave Eiffel from three perspectives show the changes that shooting position has on light direction. All three were shot within a few minutes of each other using an 18-70mm Nikkor zoom. The frontlit view in 7-11 was exposed for 1/200 sec., at f/7.1, the sidelit version in 7-12 at 1/500 sec., at f/4.5, and the silhouetted backlit version in 7-13 at 1/500 sec., at f/6.3 exposed based on a sky reading. All ISO 200, handheld.*

FRONT LIGHTING

Light falling on the front of subjects tends to illuminate them like a spotlight, providing bright colors and a bright, even illumination (see 7-14). This is the light a lot of photo books are telling you to use when they suggest that you "keep the sun coming over your shoulder." That is often good advice. It's certainly nice not to have to deal with dark shadows (as most of the shadows will fall behind the subject and you won't see them), and it's always great to have enough light to evenly light your subjects. The only problem with front lighting is that it tends to be a bit two-dimensional — lacking any of the shaping or modeling that you get from side- or backlighting. Front light is ideal when bright colors and a clean look are desired (see 7-15). Exposure is simple with front lighting, however, because a straight matrix reading generally provides excellent exposure.

TOP LIGHTING

Top lighting has both good and bad sides. On the good side, because the light is coming from above, it generally casts an even illumination across the tops of your subjects and effectively ignites surface colors. On the downside, the lighting is usually fairly flat and casts shadows in some important areas — filling eye sockets with dark shadows in outdoor portraits, for example, or creating hard shadows under the nose and lips. In some situations, however, the burst of color you get is great, and the shadows it creates aren't that much of a negative. In my shot of red-rock cliffs in southern Utah (see 7-16), there really wasn't anything to cast shadows, and the bright top lighting brought out the colors of the landscape. Similarly, in 7-17, all of the shadows fall below the hose and the sprayer, but the bright colors really "pop" because of the top light. Exposing for top-lighted subjects is straightforward, and you can almost always trust your matrix meter reading.

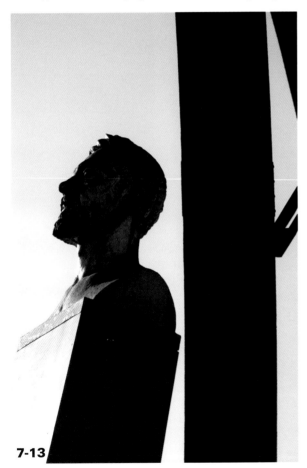

7-13

ABOUT THIS PHOTO *Any time you want to make bright colors pop, front light does the job. I shot this carnival sign in bright, late-afternoon front lighting using a 24-120mm Nikkor zoom lens. Exposed at 1/320 sec., f/10 at ISO 200, handheld.*

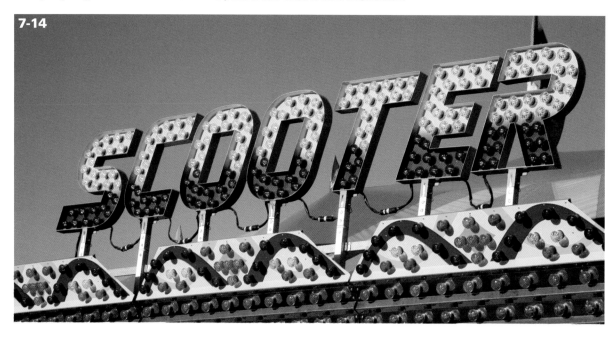

7-14

7-15

ABOUT THIS PHOTO
I shot this on assignment for the Hi-Ho D'Addario oil company, which wanted a bright, colorful shot of their freshly painted oil tanks. Low-angle late-afternoon light provided ideal front lighting. Taken with a 24-120mm Nikkor zoom lens, exposed at 1/1000 sec., f/7.1 at ISO 200, on a tripod.

ABOUT THIS PHOTO
Top lighting isn't generally great for landscapes, but it worked here in bringing out the intense colors of the cliffs. Taken with a compact digital camera (lens set to 280mm in 35mm terms) and exposed at 1/95 sec., f/7.4 at ISO 100, on a tripod.

ABOUT THIS PHOTO
I found this colorful hose on a dock in Falmouth, Massachusetts, and couldn't resist the bold colors. Taken with a compact digital camera and exposed at 1/2000 sec., f/8 at ISO 100, handheld.

SIDELIGHTING

Light coming from the side of your subject, particularly with landscapes and many close-up subjects, is perhaps the prettiest light direction. The beauty of sidelighting is that the light tends to bring textures out in all types of surfaces because, as it passes over the surface of objects, it creates shadows. Also, because sidelighting is most often found early and late in the day, it usually has a very soft and warm quality (see 7-18). In broad landscapes, light coming from the side also gives scenes a great feeling of depth because the elongated shadows create a feeling of three dimensions. You have to be careful about strong shadows, though, as too many cause the subject to become confusing and contrasty; a few bold shadows are far more effective. Exposing for sidelit subjects is pretty straightforward, but you may find that adding an extra one-half to one full stop of exposure compensation opens up the shadows a touch without washing out highlights.

7-18

ABOUT THIS PHOTO *Late-afternoon sidelight brought out the downy texture of this little duckling on a lily pad at the New York Botanical Garden. Photographed with a 70-300mm Nikkor lens, exposed at 1/640 sec., f/5.6 at ISO 200, handheld.*

tip Flash is one way to open up facial shadows in side- and backlighting situations, but you can also use homemade reflectors to do the same thing. A piece of strong cardboard with a piece of aluminum foil taped to it (shiny side out), a piece of white art board, or a commercially made reflector will work. For a warm look in portraits, buy some gold foil at a craft supply shop and use that on a cardboard backing. It's simplest to use a reflector if you place the camera on a tripod and then handhold the reflector exactly where you want it.

BACKLIGHTING

You've been told these things hundreds of times: Eat all of your vegetables, don't play with your food, and don't take pictures shooting into the sun. The food advice *might* be good, but you can ignore that last bit of bad counsel. Shooting toward the sun produces a very interesting style of lighting called *backlighting* that can be beautiful — especially in portraits, close-ups, and landscapes.

The beauty of backlighting is partly that it's unexpected. Because so many photographers have been told not to shoot into the sun, you just don't see as many photos shot that way. Translucent subjects (leaves, flowers, hair) look terrific in backlighting because strong backlighting makes them glow, as if lit from within (see 7-19). In landscapes, backlighting creates a wonderful sense of three dimensions because it throws its shadows toward the camera, exaggerating the sense of depth. In portraits, backlighting can create a pretty rim of light around your subject's hair and boldly illuminate the colors in the background. In

ABOUT THIS PHOTO
Backlighting is particularly pretty on translucent subjects like these tulips. Photographed with a compact digital camera with a 10.2mm zoom setting and exposed at 1/160 sec., f/4 at ISO 64, handheld.

7-19

the photo of my girlfriend sketching on the front porch of Château de la Bourdaisière in central France (see 7-20), I used the late afternoon sun to enhance the sense of depth in the surrounding landscape. I tried shooting similar shots from other angles, but the lighting just didn't have the same punch — I really like the way the greens in the background are aglow.

But while backlighting can be one of the prettiest forms of natural light, you must observe a few simple rules in order to get the exposure correct. It's important whenever possible to keep the sun out of the frame because it tends to overpower the rest of the scene and wreaks havoc with meters. I occasionally use the sun as an element in a composition, but usually only when it's very low in the sky and hazy skies are moderating the intensity of the light. Also, you usually need to add an extra stop or two of light (depending on the degree of contrast between background and foreground) so that the brightness of the back-lighting doesn't underexpose important areas.

Using backlighting behind opaque subjects (see 7-21) is also the key to creating great silhouettes. By exposing for the bright area (in this case, the sky), you turn the subject into a stark shape.

> **x-ref** Fill flash is an excellent way to combat overly contrasting backlighting, especially in portraits. I discuss the technique of using fill flash in Chapter 11.

ABOUT THIS PHOTO *Environmental portraits are especially striking with backlighting because it illuminates the colors in the background. Photographed with an 18-70mm Nikkor zoom lens. Exposure was 1/500 sec. at f/5.6, and a small amount of fill-in flash was used to keep the subject's face open. ISO 200, handheld.*

7-21

QUALITY OF LIGHT

Daylight can have many qualities or levels of intensity, depending largely on what time of day (and what time of year) you're shooting and what the weather is like. If you've ever wandered around Miami Beach or Tucson on a bright summer day, you know exactly how harsh and penetrating daylight can be. But put a thin layer of clouds in front of the sun, and what was a bold, unforgiving blast of sunlight becomes a cozy, soft light that caresses the landscape gently and reveals textures and colors that were once hidden in deep shadow.

Light quality can loosely be grouped into one of four categories: normal, hard, diffuse, and heavy overcast.

- **Normal light.** I don't know if this is a genuine category or not, but I tend to think of light that is neither too bold nor too soft as "normal." In normal daylight, you can trust most types of meter readings at face value (provided

your subjects are of average reflectance and you're not photographing black sheep in snow), and shadows and highlights will play nicely together within the frame (see 7-22). Look for normal lighting at mid-morning or late mid-afternoon (not at noon) on clear days or when there is just a thin veil of clouds.

7-22

ABOUT THIS PHOTO *The light in this shot leans a little toward the hard side, but it was "normal" enough that I was able to shoot at the matrix meter reading and not make any adjustments. Exposed with an 18-70mm Nikkor zoom lens at 1/160 sec., f/10 at ISO 200, on a tripod.*

HARD LIGHT

If you're going to be taking a lot of pictures, especially if you're traveling a lot and can't be picky about the lighting, you're going to have to deal with harsh, contrasty lighting — there is simply no avoiding it. Harsh light happens, of course, on clear days when the sun is unfiltered by any type of cloud cover, and the closer you get to midday, the more intense the light becomes. Harsh lighting creates two problems: blown-out highlights and deep shadows. Sometimes that contrast is simply too intense to maintain in a single image, and some part of the image is sacrificed. If you're careful, though, you can find ways to use harsh lighting by avoiding shadows and finding angles that take advantage of the spotlight quality that harsh lighting has. There is no place less forgiving in terms of harsh light and contrast than the deserts of the Southwest, but by shooting from a low angle and using a radiant blue sky as a backdrop, I was able to exploit the hard sun that was illuminating the tangle of saguaro cacti in 7-23.

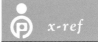

x-ref Contrast is a constant problem on bright days, especially when the sky is clear and the sun is high. You learn more about how to handle excessive contrast in Chapter 8.

DIFFUSE LIGHT

Probably my favorite type of lighting is when the sky is covered by a thin, high layer of clouds that softens the light just enough to give landscapes a quiet, romantic quality. The nice thing about lightly overcast skies is that contrast is no longer a problem and colors are more saturated. Metering is also fairly simple in diffuse light because the light is so even across the scene. Simple compositions, like the Japanese gardens in 7-24 and 7-25, seem to lend themselves well to soft lighting because shadows are absent for the most part, and so there is not a lot of visual competition in the frame.

7-23

ABOUT THIS PHOTO
Don't stop shooting when the light gets too hard; just find creative solutions. I photographed this saguaro near midday in a Tucson desert using a 10-20mm Sigma zoom lens. Exposed at 1/60 sec., f/14 at ISO 200, with a polarizing filter, on a tripod.

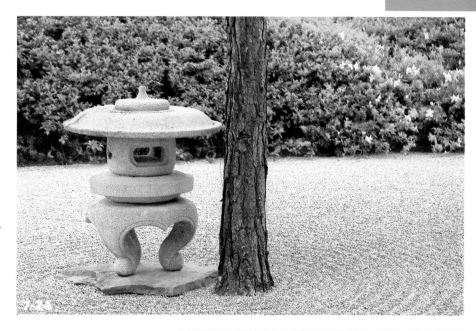

ABOUT THESE PHOTOS *Soft lighting from a thin layer of clouds creates a nice open lighting for landscape vignettes like these shots of two different Japanese gardens. The shot of the gravel garden in 7-24 was taken with a 24-120mm Nikkor lens and exposed at 1/125 sec., f/5.6 at ISO 200, on a tripod. The image of the ferns in 7-25 was shot with a compact digital camera and exposed at 1/4 sec., f/6.5 at ISO 100, on a tripod.*

Portraits are particularly nice on diffuse days, and even if the existing light is somewhat harsh, you can simulate the softness of that kind of lighting by moving your subjects into an area of open shade (see 7-26).

HEAVY OVERCAST

It seems that wherever I travel, I arrive just when the sky is clouding over. It can be very frustrating. But clouds are a part of every photographer's life, and you either get used to them or you just don't shoot very often. Cloudy days do have some minor negative sides: They steal away several stops of light, at the very least, and they create a very blue daylight. However, the loss of light is easily solved with a tripod which will allow you to safely make longer exposures and the blue coloring can be remedied with a change of white balance. On the plus side, heavy cloud covers eliminate all contrast problems, and they provide a beautifully soft, wrap-around light for both portraits and landscapes. Meter readings also tend to be very reliable on cloudy days because of the

overall evenness of the illumination. Also, if you're lucky when you're out shooting on an overcast day, the sun will break out and create a nice contrast between your main subject and the cloudy skies (see 7-27).

TIME OF DAY

All of the aspects of natural light that I've discussed so far in this chapter — color, direction, and quality — are influenced to a large degree by the time of day that you're shooting. In fact, from the very first rays of light that turn night into day until day slips back into night, the color, direction, and quality of the sun's light are constantly changing; that's what makes outdoor photography so interesting and unpredictable. I always find it fascinating that you can drive by the same roadside hotdog stand year after year, and then one day the light hits it just right and you are compelled to pull the car over and get the shot (see 7-28). Great light can be a total surprise like that, but it can also be somewhat predictable if you know what to expect at different times of day.

7-26

ABOUT THIS PHOTO
Open shade mimics the look of a diffuse sky, and it's great for group shots. Photographed with an 18-70mm zoom lens and exposed at 1/400 sec., f/5.6 at ISO 200, handheld.

ABOUT THIS PHOTO *I photographed this tour boat on Moosehead Lake in Maine on an extremely overcast day. Luckily, though, as I was shooting, the sun slipped out and gently illuminated the boat. Photographed with a 70-300mm Nikkor lens; exposed at 1/800 sec., f/7.1 at ISO 200, handheld.*

ABOUT THIS PHOTO
Although I'd seen it hundreds of times before, this local icon caught my attention when a burst of golden late-afternoon sun flooded in through the windows. I'm glad I got the shot, too, because it was torn down a few months later. Exposed using a 12-24mm Nikkor zoom lens at 1/25 sec., f/14 at ISO 200, on a tripod.

DAWN AND TWILIGHT

About one-half hour or so before the sun rises until the sun actually hits the horizon and we enter the golden hours (which I'll talk about in a moment), and then again after the sun has set but there is still light in the sky, is perhaps the most beautiful light you will ever see. Unfortunately, unless you're an early riser (I'm definitely not) or stay out until after the sunset shooters have gone home, you won't know just how amazing this light is. There is a brief time at both extremes of the day when the heavenly blue of the sky does a slow melt into various shades of turquoise and orange light that is just spectacular.

Exposure times are generally long, and the magic is brief, but if you get one great shot, it makes the day (and sometimes an entire shooting trip) worthwhile. Shooting at this time of day is also easy because you have quite a bit of latitude with exposure. I tend to take readings from the middle range of sky tones (not the brightest or the darkest areas) and then bracket from there — often as much as three stops on either side of the meter reading. In the shot of the Arizona desert shown in 7-29, I had photographed the sunset but decided to wait to see what the twilight would bring — and it brought me beautiful colors and a silver crescent of moon. This is one of my favorite shots of all time.

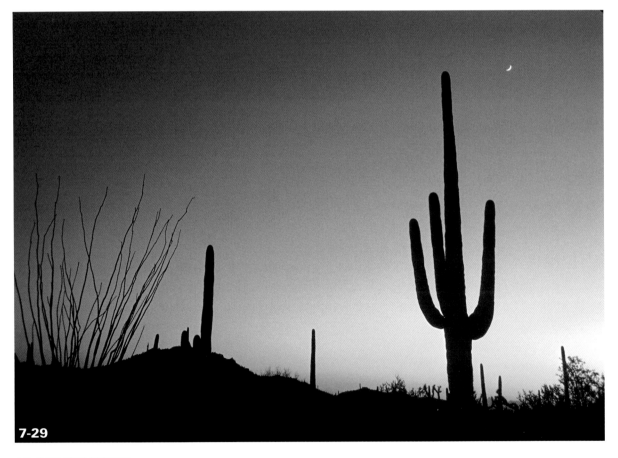

7-29

ABOUT THIS PHOTO With coyotes howling all around me and the knowledge that I was deep in rattlesnake country, I waited a bit nervously for these twilight colors. Shot with a 28mm Nikkor prime lens and exposed at 1/2 sec., f/11 at ISO 400, on a tripod.

MIDDAY LIGHTING

You would think that because midday is the brightest time of the day, it would be the simplest to photograph. It's not. Midday sun (particularly in summer when the sun is directly overhead for a longer time) is harsh, casts deep black shadows, and creates many unsolvable contrast situations. In winter the light is less intense (particularly in northern areas where the days are shorter) and the light softens a bit. Top lighting is generally a very flat type of light in terms of depth (not contrast), largely because shadows fall under subjects rather than on their surfaces (that would reveal form and texture), behind them (that would reveal shape), or in front of them (that would show depth).

Top light is not entirely without some merits, however. Top lighting from afternoon sun can actually enhance certain subjects because it produces rich, intense colors that always have a bright, cheerful feel. And sometimes, of course, you're stuck with it because you just happen to find a photograph that you can't come back for later. I photographed the Navajo gentleman under an overhead sun, and you can see the hard shadows on his face and the horse's body (see 7-30) — sometimes you just have to take what you find.

7-30

ABOUT THIS PHOTO *This handsomely dressed Navajo horseman was photographed at John Ford Point in Monument Valley under a blazing midday sun — because that's when I happened to be there. Exposed with a compact digital camera (zoom set to 54mm) at 1/600 sec., f/5.5 at ISO 100, handheld.*

7-31

THE GOLDEN HOURS

I'm often asked by students and in interviews what the single thing is that beginning photographers can do to improve their photography; my stock answer is: Do most of your shooting in the *golden hours*. Photographers refer to the first hour or two after sunrise and the last hour or so before sunset as the "golden hours" because this is when the light is soft and yellow and intensely pretty (see 7-31). The difference that this time of day can make on even the most average of landscapes is astounding, and all you have to do to see that is to go sit in a park about two hours before sunset and then watch as the park descends into a golden aura over the next hour or so.

idea

If you really want to see how profoundly time of day can affect any subject, here's a little challenge that my father (also a photographer) gave me when I was asking him about this topic: Next time you have a day free, find a subject, pack a lunch and some reading material (or a chatty friend), and photograph it from dawn until dusk. Just plant your tripod in one place, and every 15 minutes or so, take another frame — regardless of how interesting or wrong the light might look. When you download the images, you'll have an extraordinary "face book" of your subject in all different lights.

The light is also gentler during these times of day (see 7-32), which means that shadows are less black and highlights are less frequently burned out — in other words, the contrast is totally manageable. Golden hour light is also fairly easy and reliable to meter (particularly using matrix metering), but you do have to be careful that there isn't any glare off of bright surfaces that is fooling your meter. Other than that, the golden hours provide a nice point-and-shoot type of lighting that will improve your photos (especially your travel shots) immeasurably.

7-32

ABOUT THIS PHOTO *The gentle contrast of "golden hour" light is great for intimate little landscape vignettes like this shot I took on a Maine farm. Taken with a 70-300mm Nikkor zoom lens (at 300mm), exposed at 1/160 sec., f/5.6 at ISO 200, handheld.*

Assignment

There's Gold in Them There "Golden Hours"

One of the keys to making great outdoor photos on a consistent basis is to use lighting that flatters your subject, and that's true whether you're photographing a portrait, a landscape, a close-up, or a travel photo. By far the best time to find attractive lighting is to go scouting in the "golden hours" — the first hour or 90 minutes after sunrise and before sunset. For this assignment, whatever subject you decide to photograph, I'd like you to restrict your shooting to the "golden hours." Read your local paper to find out when the sun rises or sets, and limit yourself to shooting within 90 minutes of that time.

I photographed the odd little "old Florida" scene shown here a bit south of Ocala, Florida. Discovering old Florida is one of my favorite photographic escapes, and I was thrilled to find this abandoned, orange-shaped (and -colored) store alongside a local highway. But the sun was just above the horizon when I found it, and so I had to rush to get the right lens mounted and the tripod in place, and figure out the best exposure. I love the way the late light is firing up the orange color and making the building pop out from its surroundings. It was shot with a 10-20mm Sigma zoom lens, exposed for 1/60 sec., at f/13, ISO 200, on a tripod.

Remember to visit www.pwassignments.com after you complete this assignment and share your favorite photo! It's a community of enthusiastic photographers and a great place to view what other readers have created. You can also post comments, and read encouraging suggestions and feedback.

THE EASY WAY OUT: SIMPLIFYING DIFFICULT SITUATIONS

METERING CHALLENGES

HANDLING CONTRAST

CREATING DRAMATIC SILHOUETTES

HISTOGRAMS: A VISUAL AID FOR SEEING CONTRAST

Earlier in this book I talked in a fair amount of detail about finding a good middle tone in your scenes, metering that middle tone carefully, and, if necessary, adjusting the exposure to give you a good overall set of tonal values with most *average* subjects. Unfortunately, a lot of compositions that we're likely to be attracted to fall outside of the realm of what your camera considers to be average. These scenes are the problem children of the exposure world; they're the ones that require extra individual attention and that may require a skill set (not to mention a level of patience) that is more demanding of the practitioner — you. With the vast amount of knowledge you already have, however, these skills should be easy for you to master and, in fact, you probably know more about how to solve them than you might think.

Part of the reason that photographers are attracted — like moths to a flame, it seems — to difficult subjects is because they often represent extremes in nature (or in manmade situations) that stand out from the ordinary. It's the extreme character of these subjects — the conflict or delicacy of tones — that lures us to a scene to study it further. As photographers, we're looking for scenes that are above and beyond the ordinary, that call to our sense of visual uniqueness. In other words, we're drawn by the challenge of recording light, and there's no avoiding answering the challenge, try as we might.

Subjects are difficult for various reasons. Sometimes it's that age-old photographers' nemesis, contrast. As you learn in this chapter, what the human eye can ascertain in terms of tonal range and what your sensor can record are two very different things. Other times, all of the tones are gathered into extreme ends of the tonal scale (see 8-1), either in groups of very bright tones (high-key subjects) or dark tones (low-key subjects), and either one can present a real exposure challenge.

In this chapter, I present some of the most common difficult subjects you're likely to encounter, and I try to provide some simple solutions to make them more manageable. There's no simple solution

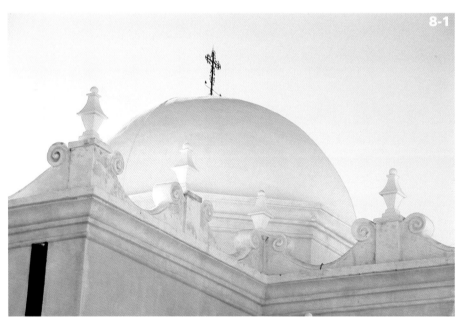

8-1

ABOUT THIS PHOTO
The white dome of an Arizona mission church shining in the desert sunlight is a tough subject to expose correctly. I added two full stops of compensation. Shot with a 55mm Nikkor lens, exposed at 1/250 sec., f/11 at ISO 200, on a tripod.

for tough exposure situations, and this is why you
see so many photographers sitting by the road
scratching their heads. There's no situation you'll
encounter, however, that can't be solved with
some enlightened and thoughtful consideration

METERING CHALLENGES

While you always have to be careful of which
metering mode you use and what parts of a scene
you meter from, with most normal subjects those
are the only real concerns — and your meter will
handle those subjects very accurately. Metering
becomes more of a challenge when the tonal
range of the subject starts to become more

extreme or tonally lopsided. Then you not only
have to take care how and where you meter a
subject, but you also have to make decisions that
very often involve compromises. In the photo of
Merrick Butte (see 8-2) in Utah's Monument
Valley, for example, I had to decide if I wanted to
meter only the brightly lit red rocks — which
cast the foreground into black shadow — or mod-
erate the exposure a bit to save some foreground
detail. Because I liked the extreme contrast of red
rocks and black shadow, I chose the former.

In the following sections I discuss some of the com-
mon extreme lighting and metering situations and
provide some ideas for how to combat them — or
at least for finding an acceptable compromise

8-2

ABOUT THIS PHOTO *There's no way I could have exposed to get detail in the foreground here
without washing out the brilliant color of the red rocks, and so I metered the rocks, ignoring the fore-
ground. Taken with a 24-120mm Nikkor zoom lens, exposed at 1/15 sec., f/9.5 at ISO 100, on a tripod.*

(although there are times when, because the lighting is so extreme or the contrast so high, I put the camera away and wait for a better day). But you'd be surprised at how many good exposures you can get from challenging situations if you think them through and are willing to make some visual sacrifices. It's worth taking a chance and shooting the frame, even if you think you're going to lose the battle because, after all, the worst you can do is ruin a photograph — and it's not like we haven't all done that a few thousand times.

LIGHT SUBJECTS, DARK BACKGROUNDS

Photographing white subjects against a black background can be tricky, but the decisions you have to make are easier than you might think. Because you know the background is going to be black, you can totally ignore what happens to it. Black is black — forget about it. It's far more important that you capture some detail in the white areas, and the way to do that is to take a reading from the white areas *only* and then experiment with exposure compensation to add extra brightness to the whites or meter the dark areas and subtract exposure to make sure they remain black and not gray (which would also cause the white to overexpose). Remember, if you meter directly from the white subject and use that meter reading, you'll be turning the whites gray. If you meter the black and use that exposure, you'll get gray where you want black. If you meter the white areas, I suggest you start with at least one stop of exposure compensation (+1) and then increase it in third- or half-stop increments until you reach two stops of compensation (+2). Alternately you could meter from the dark area and then subtract exposure using compensation to be sure that the black areas don't record as gray. In photographing the white ibis in 8-3, for example, I metered the dark water and used -2/3 stops of exposure compensation to make sure the water went black and the bird kept detail in bright white areas.

8-3

ABOUT THIS PHOTO
A white ibis photographed at the Merritt Island National Wildlife Refuge in Titusville, Florida. Photographed with a 400mm Nikkor lens, exposed at 1/640 sec., f/9 at ISO 200, on a Rue Groofwin Pod.

For me the ultimate test of photographing white against black comes every September when my night-blooming *Cereus* plants flower (see 8-4). These plants (the blossoms are the size of dinner plates) bloom only one night a year and only for that one night — if I ruin the shot, I have to wait another year to get another chance. I have to use a flash because they reach full bloom around 3 a.m. and I'm usually lying on my stomach on wet grass. For this shot, I also used two high-powered flashlights to add some warmth and interest to the lighting — the straight flash shots are usually pretty boring. The exposure challenge is not just using flash on a white flower — the camera handles that pretty well — but then using compensation to adjust for the flashlights. It's entirely a matter of experimentation and checking the LCD panel.

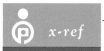

x-ref For a quick refresher on metering and the concept of middle gray, see the explanations in Chapter 3.

8-4

ABOUT THIS PHOTO *Photographing white flowers at night is challenging, and I should probably haul studio lights out to the patio, but I don't. Shot with a compact digital camera, exposed at 1/30 sec., f/6.3 with flash and flashlights, and +1.3 stops of compensation, at ISO 100, handheld.*

note I often shoot shore birds using my car as a blind. Because I'm using very long lenses, often 400mm or longer, I need a steady camera support. One solution I've found is the Rue Groofwin Pod manufactured by Leonard Rue Enterprises (owned by famed wildlife shooter Leonard Lee Rue). This combination ground-roof-window pod can be mounted to a car window opening in seconds and provides a very steady shooting platform. See www.rue.com for more information.

DARK SUBJECTS, LIGHT BACKGROUNDS

Photographing scenes where the dominant subject is dark and the background is substantially brighter presents something of a reverse challenge. What you have to do now is to retain detail in the dark areas while trying not to blow out the background. Unlike white-on-black situations, you usually *do* want detail in the dark areas (though not always), and that's where the challenge lies. One danger is that the bright background influences your meter reading, making your camera think the dark subject is lighter than it really is, thus underexposing the important subject in the foreground area. The solution to that is to fill the frame entirely with just the subject or use your center-weighted meter to isolate just the dark tones.

However, this can create another problem: Because you are metering the dark areas and your meter wants to turn them to a lighter middle tone, you have to use minus compensation to keep them dark. Again, how much compensation is a matter of the actual brightness level of your subject and how much detail you're after. If you have a dark-brown subject like the bison in figure 8-5, I suggest starting with at least minus one stop of compensation. Sometimes dark subjects can be deceivingly dark, and you have to use even more compensation. I've photographed bison on a number of occasions, and yet I'm always surprised by just how dark they are compared to their surroundings — in this case, brightly lit prairie.

When you underexpose the main subject from the meter reading, of course, the background is going to go darker than you're seeing it, which is fine as long as it doesn't conflict with the subject to the point where you can't separate one from the other.

Another solution that you can try is to wait until the subject moves into more even lighting, or wait for better lighting so that the subject and background are more evenly lit. By photographing the bison in figure 8-6 in a patch of bright sun, the bison's coat is much lighter, and even though it's substantially darker than the grass around it, it seems like a more balanced scene.

tip Sometimes judging the difference in tonalities during editing can be tricky to do without help. But if you are using Photoshop to edit your images, you can compare the brightness of various parts of a scene very quickly by calling up the Curves dialog box and then using the Eyedropper tool to sample various brightness levels. By simply moving the Eyedropper tool around in the image, you will see where that tonality falls on the curve.

BRILLIANT SUBJECTS AND WHITES WITH DETAIL

Subjects like snow, sand, and white flowers — anything where white is the predominant color — present one particular difficulty: It's tough to keep detail in the white areas without turning them somewhat gray. The situation gets more difficult if the whites are brilliantly lit by hard sunlight because the camera's sensor is only capable of recording so much highlight detail before those tones just burn out (especially if there is a lot of contrast in the scene). So my first suggestion is that if you're photographing something that is a bright white, like snow on a brilliant sunny day, come back when the light is less intense — and I don't say that to be flippant because sometimes the only solution is to wait until the light is more cooperative. If you can come earlier or later when the light is at a softer angle and is less intense, a lot of your problems will solve themselves.

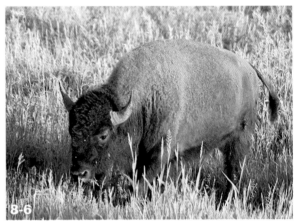

ABOUT THIS PHOTO *Both bison and prairie are brightly lit in this scene, which creates the impression that both are more even in tonality — although the bison is still substantially darker. Shot with a 70-300mm Nikkor zoom lens, exposed at 1/125 sec., f/5 at ISO 200, on a Rue Groofwin Pod.*

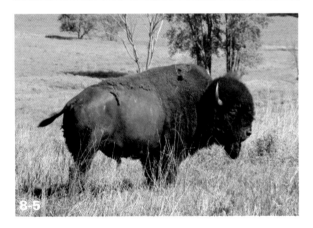

ABOUT THIS PHOTO *A bison photographed at the Neal Smith National Wildlife Refuge in Iowa. I used -1 stop of exposure compensation to keep the bison's color dark. Taken with a 70-300mm Nikkor zoom lens and exposed at 1/250 sec., f/9 at ISO 200, handheld.*

It's also important to remember that you have to meter snow and other white subjects, knowing that the reading you are getting is just a starting point — you need to use exposure compensation (adding exposure) to keep the snow white. If you shoot at the meter reading as is, you underexpose the scene by a stop or two, and perhaps more, and your lovely white snow becomes your lovely gray snow. The balance is tricky, though, because you don't want to add so much exposure that you begin to lose texture detail in the white subjects. In both shots of the snowy cemetery (see 8-7 and 8-8), I provided plus 1.7 stops of exposure compensation from the metered reading and was able to retain surface texture. Had I increased the exposure much more, the texture would have been obliterated.

ABOUT THESE PHOTOS *Backlighting (in 8-7) and sidelighting (in 8-8) help to bring out the texture in this snowy scene and help the snow retain surface detail. Both were shot late in the day (thus the long shadows) to somewhat soften the lighting intensity. Both shots were made with an 18-70mm Nikkor zoom lens and exposed at 1/320 sec. at f/9, and 1/400 sec. at f/10, respectively, both at ISO 200, on a tripod.*

Incidentally, in these photos I used backlighting (see 8-7) and sidelighting (see 8-8) to give texture to the surface of the snow. Any time you can incorporate texture into a white surface, you help to keep the subject from burning out.

Most white subjects require experimentation, and I strongly recommend bracketing your exposures in half- or third-stop increments (on the overexposure side only) by up to two stops. I used bracketing to photograph the white barns (see 8-9) because it was twilight when I spotted them in rural Iowa and they were lit largely by a full moon. Trying to juggle moonlight, fading twilight, and white barns had me literally talking to myself aloud (which isn't all that uncommon, granted). I knew that the meter was going to have a tough time in such low light. I shot the wider frame (see 8-10), thinking that I was setting

8-9

ABOUT THESE PHOTOS *Photographing these white Iowa barns in the moonlight at twilight presented quite an exposure challenge, and to get both of these shots, I bracketed from center-weighted meter readings of the barns. Both were shot with a 70-300mm Nikkor lens and exposed at 1/4 sec., f/9 at ISO 200, on a tripod; both with +1.3 stops of exposure compensation.*

8-10

myself up for a contrast nightmare because it contained some darker subjects, but it turned out I liked that shot better because it also captured some of the blue twilight cast. Again, experiment with exposure and composition with any white subjects and you increase your chances of having a good exposure.

DARK AND LOW-KEY SUBJECTS

Whenever the overall bias of a composition is toward the darker tones, and bright or even middle-tone subjects are minimized (see 8-11), the scene is described as *low key*. Often such scenes have a sense of mystery and foreboding about

them, and using a low-key tonal range is a great way to add emotional impact to your images. People tend to study low-key images longer because, like watching a Hitchcock film alone in the dark, they are searching for the dark presence to pop out of the shadows. Low-key scenes can have bright tones or even highlights in them, but the predominant feeling should be one of dark tones and dim lighting. In fact, by minimizing the area given to bright tones, you actually intensify its visual interest. When photographing low-key scenes then, it's important to intentionally limit highlights by underexposing the overall scene, if necessary.

8-11

ABOUT THIS PHOTO *A prize-winning giant pumpkin at a state fair in Connecticut was mostly hidden in shadow when I found it, creating a great opportunity for a low-key image. Taken with an 18-70mm zoom lens and exposed at 1/100 sec., f/5 at ISO 200, handheld.*

Stormy landscapes (see 8-12) can offer a great opportunity to find low-key scenes. I photographed the dark, brooding scene of Monument Valley at the end of a rainstorm just as the distant sky began to lighten. I intentionally exposed for the brighter areas of the scene so that the buttes in the shadows would remain dark and mysterious.

HIGH-KEY SCENES

In the exact reverse of low-key scenes, *high-key* images are built almost entirely of bright tones and highlights, and often lean toward pale hues and pastels. In the same way that low-key scenes can tolerate limited highlight areas, high-key compositions can carry some dark tones — particularly if you place them along the edges or in just one small area (see 8-13). Fog, snow, and brightly lit wildflower meadows all make potentially good high-key subjects.

You can often fabricate or exaggerate high tonal ranges by slightly overexposing an image — just be careful not to lose important subject detail. I intentionally over-exposed the scene of penguins (see 8-14) shot underwater at an aquarium to brighten their environment and make it seem cooler and more like the Antarctic (even though these are South African penguins that have probably never seen any ice).

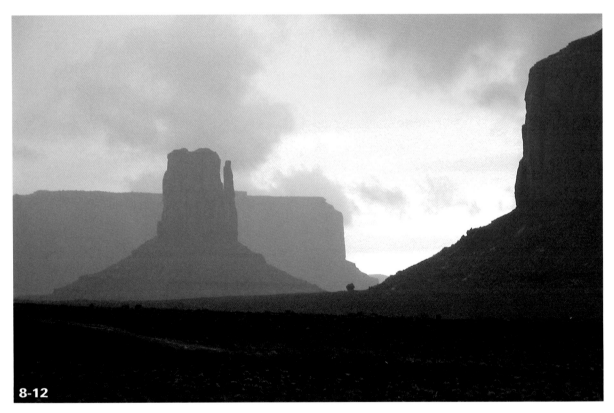

8-12

ABOUT THIS PHOTO *Everyone photographs the Southwest in bright sunlight, but sometimes the menacing skies of a storm-battered day provide more drama. Photographed with a compact digital camera at 1/25 sec., f/3.6 at ISO 100, on a tripod.*

ABOUT THIS PHOTO *Foggy days can provide a good hunting ground for high-key scenes because the fog tends to subdue and lighten even the darkest tones. Taken with a 24-120mm Nikkor zoom lens, exposed at 1/40 sec., f/4.8 at ISO 200, on a tripod.*

ABOUT THIS PHOTO
I spent an hour by an aquarium window waiting for these penguins to swim by, and so I had plenty of time to plan the high-key exposure. Taken with an 18-70mm Nikkor zoom lens, exposed at 1/100 sec., f/5 at ISO 200, handheld.

DAPPLED DAYLIGHT

Although I am intensely attracted to dappled sunlight, where highlights and shadows are sprinkled in large blotches or long streaks throughout a scene (see 8-15), it has always been one of my biggest exposure challenges. It's tough to find an exposure that retains both highlight and shadow details without obscuring important subject areas. The problem is that if you underexpose to save highlights, then you turn the shadows black, and if you open up to lighten the shadows, the high-

lights blow out. My solution is usually to sacrifice some shadow detail by exposing for the highlights, thereby slightly underexposing the shadows. Of course, I can moderate some of this contrast using the Curves adjustment feature in editing, but even then it often requires additional masking — a complex editing task. The best solution is to trust your matrix meter and, if you feel insecure about the exposure, bracket a half to a full stop in both over- and underexposed directions — and then check your LCD and histogram to see where the extreme tones have landed.

ABOUT THIS PHOTO *Forests, like this pine forest along the northwest coast of Florida, present a real exposure challenge. Taken with a 10-20mm Sigma zoom lens and exposed at 1/25 sec., f/14 at ISO 200, on a tripod.*

STRONG COLOR CONTRASTS

I am very attracted to bright, bold colors, and I particularly like it when I find a subject where there is a strong clash of colors — either within the actual subject (see 8-16) or between various elements of a scene (see 8-17). Strong color contrasts are easy to expose for, and I tend to trust the matrix meter if the lighting is fairly even, but I always underexpose the subjects by at least a full stop. Underexposing subjects, particularly those with vibrant colors, saturates the colors and intensifies the existing contrasts. Nature is a particularly rich source of color contrasts, and some of them are downright startling. I photographed these black swans (see 8-18) floating through a river of green algae in the Loire Valley in France, and no one believes the colors are real — but they're completely accurate. I did use a fill-flash to brighten the details in the black swans.

ABOUT THIS PHOTO *Mexican pottery is full of rich, wonderful colors, and by getting close to this container and filling the frame, the color contrasts jump out at you. Photographed with an 18-70mm Nikkor zoom lens, exposed at 1/80 sec., f/4.5 at ISO 200, on a tripod.*

8-16

ABOUT THIS PHOTO
Carnival rides are just dripping with vibrant colors, and in this scene the late-afternoon sun just illuminated them. Shot with a 70-300mm zoom lens, exposed at 1/320 sec., f/9 at ISO 200, handheld.

8-17

195

8-18

ABOUT THIS PHOTO *Black swans gliding through a pool of green algae — nature never stops surprising me with brash and unexpected color combinations. Taken with an 18-70mm Nikkor zoom lens, exposed at 1/60 sec., f/4.5, with flash, ISO 400, on a monopod.*

HANDLING CONTRAST

Many of the problems related to both exposure and metering are a product of the same dark villain of the photography world: too much contrast. The problem stems from the simple fact that your eyes and brain can tolerate (and even thrive on) a far greater dark-to-light ratio of tones than the sensor of your digital camera. This range of tones that your eyes and your camera's sensor can interpret is called the *dynamic range*.

Compared to the dynamic range that your eyes can discern, your camera is a lightweight contender. While my eyes had no trouble seeing detail in some dark foliage behind the sunflower shown in figure 8-19 and could also see detail in the bright yellow petals, when my digital camera's sensor was set to record those yellow highlights, the background fell into almost total darkness. The fact is that your eyes have a dynamic range equal to about 24 f-stops when the pupil is opening and closing (it would shrink to about 10 to 14 stops if the pupil were to be in a fixed position), while digital cameras have a paltry range of just 5 to 9 stops (with most consumer-level cameras probably around a 6- or 7-stop range). In other words, your eyes can see a contrast range of about 10,000:1, while your camera is in the neighborhood of 1,000:1.

There are, however, some steps you can take to bring extremely contrasty subjects closer to the range that your camera can tolerate. While these solutions won't solve the contrast problem entirely, they can provide tools for you to combat excessive contrast.

■ **Use portable reflectors to lighten up shadows in nearby subjects.** If you're photographing portraits, close-ups, or still-lifes — any subject where you are working reasonably close — you can use small reflectors to open up dark shadow areas. There are a lot of commercially made collapsible reflectors that come in silver, white, and gold, and many are reversible. (I use Westcott's 14-inch silver/gold reflectors, which sell for under $25.) These reflectors are small enough to pack in a camera bag and then pop out to their working size. Using a reflector is a lot simpler if you have an assistant to hold it or if you put your camera on a tripod so your hands are free. The nice thing about reflectors is that they don't use batteries, they're lightweight, and you don't need to know a thing about lighting to use them: You simply aim them at the dark areas you want to illuminate and shoot (see 8-20).

8-19

ABOUT THIS PHOTO *High-contrast situations often force you to make a decision between recording details in the highlight or shadow areas — here I chose to expose for the flower. Taken with a 70-300mm Nikkor zoom lens at 1/1000 sec., f/5, ISO 200.*

8-20

ABOUT THIS PHOTO *While doing some white-balance tests with this composition, I used a homemade reflector consisting of gold foil taped to a sheet of cardboard to add warmth to this autumn shot. Taken with a compact digital camera and exposed at 1/4 sec., f/6.7 at ISO 100, on a tripod.*

■ **Use the fill-in flash mode on your built-in flash to open shadows.** I photographed my girlfriend's hands holding tubes of newly purchased beads (see 8-21) against the Arizona sunset, because the colors of the beads reminded us of the desert colors. The contrast between her hands and the beads was just too great, however, and so I popped on the flash and was able to bring up the level of the beads to more closely match the intensity of the sunset.

A flash is usually more powerful, but also a little less flexible than using a reflector, because the light can only come from the camera position (unless you use an off-camera accessory flash). The nice thing about a flash, however, is that if you have your camera with you, you always have a good method for dealing with contrast (at least for nearby subjects).

8-21

ABOUT THIS PHOTO *One way to add interest to a sunset is to hold something in front of the sky, but it requires a flash boost to the foreground subject. Taken with a 70-300mm Nikkor zoom lens, exposed at 1/60 sec., f/10 at ISO 400, handheld.*

x-ref

In Chapter 11, I delve further into using both built-in and accessory flash units for fill-in flash.

■ **Shoot your subject at times of the day when there is less contrast.** If you're photographing outdoors using only existing light and you think the contrast is beyond your camera's dynamic range, you may be shooting at the wrong time of day. Deep shadows and burned-out highlights are a sure sign that you're trying to force a

square peg into a round hole. I originally tried photographing these cows on an Amish farm near Lancaster, Pennsylvania (see 8-22), on a very bright and sunny afternoon, but soon realized I was wasting my time — there were no tricks that were going to soften this extremely contrasty situation. Instead of being frustrated by the light, I used the time to scout other nearby locations, then came back later in the day when the sun was gentler and being filtered by a light cloud cover.

HDRI: THE ULTIMATE TOOL FOR COMBATING HIGH CONTRAST

The problem with reproducing a very extreme contrast range in a single frame is that your camera's sensor has a finite dynamic range. Even the best digital sensors are limited to recording a maximum contrast range of about nine stops (and that's being optimistic). A new technique has emerged recently, however, called HDRI or *high dynamic range imaging* (originally developed for computer-generated images, it is often simply called HDR) that can vastly extend the dynamic range of the images you take.

HDRI works by using software to assemble a series of identically composed frames of the same subject, each with a different exposure. Instead of taking one shot of a contrasty scene, for example, you can take several different exposures and then merge them into a single image using specially designed software. Let's assume you're taking a landscape of a very contrasty scene and you decide to use three separate exposures. You make your first exposure by metering only the extreme shadow areas to get excellent detail in those shadows. You don't have to worry about where the highlights or midtones land because you won't be using them. You then make a second exposure for the midtone areas, and this time, you ignore both shadows and highlights. You then make a third exposure by metering just the highlight areas, without concern for where the shadow or midtone regions are landing.

When you merge these three images using the HDRI software, you get one image that incorporates the detail from each of the three exposures. It's quite a creative miracle, and it is a rapidly growing area of digital photography. There are other related techniques emerging, like *tone mapping,* and together these methods of managing contrast hold a lot of creative promise.

ABOUT THIS PHOTO *Black-and-white cows on a bright day in an open field are a recipe for contrast problems. Shot with a 35mm Nikkor lens and exposed at 1/160 sec., f/5 at ISO 100, on a tripod.*

■ **Find a better angle and work with the light on one side of the subject.** Often you can minimize the effects of contrast by simply repositioning yourself (or waiting for the subject to move) so that you can shoot with the light. When I first saw the paddleboat on Bantam Lake in Connecticut (see 8-23), it was coming directly toward me and I was faced with both a bright side of the boat (to the left) and a dark side (on the right). By waiting until the boat approached closer to the shoreline and then turned so that one entire side was facing the light, the shadow side was mostly hidden. The bonus was that the sun glinting off of the bright boat created a colorful and cheerful reflection in the water.

ABOUT THIS PHOTO
The right angle is sometimes the best way to overcome contrast. I shot this pretty paddleboat, called the Jubilee, late on an early-autumn day. Shot with a 70-300mm Nikkor zoom lens, exposed at 1/320 sec., f/4.8, ISO 200, handheld.

■ **Exploit the contrast and make it a part of
your image design.** The old saying, "if you
can't beat 'em, join 'em," has some truth
when it comes to extreme contrast. If you
can't find a way to solve the contrast problem
in a particular scene, find a way to use it cre-
atively. Very often, the contrast between
highlights and shadows creates interesting
and bold patterns that may obscure some of
the finer detail of a subject, but create pat-
terns that are just as worthy as subjects.
While photographing the Vanderbilt
Mansion in Hyde Park, New York, I was con-
fronted with a contrast range that no camera
could handle, and so rather than walk away
empty-handed, I looked for compositions that
exploited the contrast (see 8-24). Similarly, I
photographed the ferry (8-25) crossing Long

Island Sound during an approaching storm
when the sky was nearly black but the ferry
was still lit by sunlight. The ferry looks kind
of stark to me in this shot, but the mood of
the shot is exactly as I experienced it.

■ **Use interesting shadows as design elements.**
Whenever there is high contrast in a scene,
there are usually interesting shadows to be
found. Take time to explore for shadows when
the light is too intense for photographing
larger scenes or landscapes. Shadows are the
flip side of bright highlights, and they can
create some fascinating and unexpected
shapes and patterns. I found this interesting
shadow at a rest stop on the way to Sedona,
Arizona; it was cast by a decorative partition
in a hand railing (see 8-26).

8-24

ABOUT THIS PHOTO
*By contrasting the dark shad-
ows and brighter columns, I
was able to create a pattern
from the extreme contrast in
this shot. Photographed with a
compact digital camera and
exposed at 1/500 sec., f/5 at ISO
100, handheld.*

8-25

8-26

■ **Use deep shadows to create modeling effects and establish form.** Another handy task that shadows perform in contrasty situations is to give form to three-dimensional objects. In the relief carvings shown in figures 8-27 and 8-28, for example, I was able to use the brilliant sun that was shining on the surface of Notre Dame Cathedral to create realistic-looking portraits. In flat light without any substantial shadowing, the faces appear much less three-dimensional. By wrapping around the contours of the stone carvings and creating interesting but not distracting shadows, the stone figures seem much more human. Shadows like this can also be used to give other objects form — such as tree trunks, rock outcroppings (see 8-29), and architectural details. In both of the examples here, I exposed for the highlights because I wanted to exaggerate the blackness of the shadows.

ABOUT THESE PHOTOS *These relief portraits took on a much more three-dimensional human look, with shadows helping to embellish their features. Both shot with a 70-300mm zoom lens and exposed at 1/640 sec., f/6.3 at ISO 200, handheld.*

ABOUT THIS PHOTO *I exaggerated the sense of form and volume of this rock outcropping near Sedona, Arizona, by taking advantage of the dark shadows created by early-morning sun. Photographed with a compact digital camera and exposed at 1/75 sec., f/6 at ISO 100, on a tripod.*

CREATING DRAMATIC SILHOUETTES

Perhaps one of the simplest — and surely one of the most fun — ways to deal with very high contrast is to create a silhouette. When the difference between a dark foreground subject and a very bright background is extreme, turning the scene into a silhouette is a perfect solution. Creating silhouettes is simple; all that you need is a relatively opaque (light can't pass through it) foreground subject set against a bright background, as in figure 8-30.

Exposing for a silhouette is incredibly simple: Just take a reading for the bright background, use that reading, and forget the foreground. Your goal with most silhouettes is to turn the foreground black, and by exposing purely for the bright areas, you automatically cast the foreground into blackness. It is important, though, that you take your readings directly from the bright area and that you don't include the shape or subject, or you may begin to see too much detail in the foreground (see 8-31 and 8-32).

The most important aspect of creating any silhouette is to have a recognizable shape as your subject. Most of us are familiar with the shape of a giant saguaro cactus (see 8-33), and so we know immediately what the subject is. The more colorful the background, of course, the more dramatic and the prettier the shot will be. Sunset and twilight are excellent times of day to look for bold silhouette shapes because you have a naturally occurring, colorful sky. Exposing just for the sky also helps to saturate the sky colors.

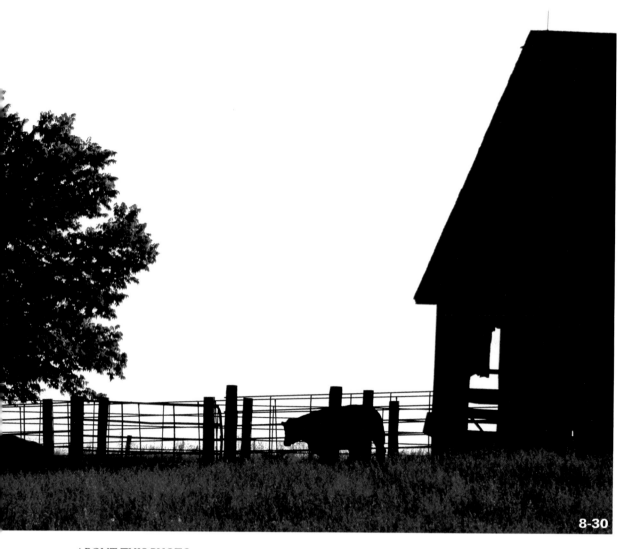

8-30

ABOUT THIS PHOTO *A rural farm scene is reduced to just black-and-white shapes by exposing carefully for the sky and letting the foreground subjects go black. Shot with a 70-300mm Nikkor zoom lens and exposed at 1/160 sec., f/18 at ISO 200, on a tripod.*

8-31

8-32

8-33

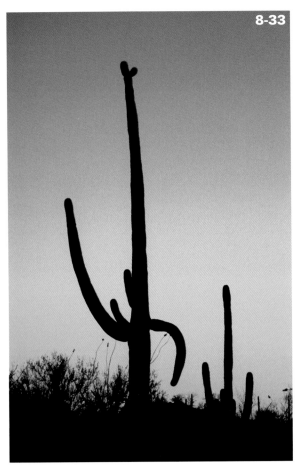

ABOUT THIS PHOTO *Bold shapes against colorful skies make excellent silhouette subjects. Photographed in Tucson, Arizona, using a 70-300mm Nikkor zoom lens, exposed for 1/13 sec., f/4.2 at ISO 400, on a tripod.*

Incidentally, although we often look to nature for silhouette subjects, you can also find them in a lot of manmade objects. I used an old piece of circuit board (salvaged from a copy machine) laid on a light table to create this high-tech silhouette pattern (see 8-34). The original board was green, but I shifted the color using the Hue and Saturation controls in Photoshop.

HISTOGRAMS: A VISUAL AID FOR SEEING CONTRAST

Almost all digital cameras have a playback option to show you a *histogram* of each image you've recorded. The histogram is a graphic display that shows you the tonal distribution within a particular image (you'll find an option to call it up in your menu system). The histogram display looks like a cross-section silhouette of a hillside, and registers pure black at the extreme left end and

8-34

ABOUT THIS PHOTO *To create this shot, I laid a sheet of translucent printed circuit board on a light table and then exposed for the lighter tones. Shot with a 55mm Nikkor Micro lens and exposed at 1/4 sec., f/8 at ISO 400, on a copy stand.*

pure white at the right end. As you look at the display, the hills and peaks to the left represent the shadow areas, the ones in the middle represent midtones, and the highlights are displayed on the right end of the graph. Technically, the display represents 256 areas of brightness within any given scene.

In some respects, this display can be quite useful because it shows you the tonal distribution in one glance and lets you know where the largest groups of tones are located — you might see a concentration of bright tones on the right side of the graph if there is a lot of sky in your photo, for example. It is especially useful in alerting you to the fact that you may have stark areas of white or black without details, as indicated by solid lines at either the extreme right (highlight) or left (shadow) areas of the display.

One problem with the histogram is that with most cameras (not all — some have a live histogram preview), you only see the display after you take the photo. You can't change anything by looking at the histogram, and you certainly can't change the lighting in a scene unless you're working in a studio (in which case the histogram can be a lot more useful).

Another inherent problem with using this feature is that if you look at it and see a tremendous amount of dark on the left side (a lot of shadow areas), you might think you've messed up the exposure. But the truth is that your scene might contain a lot of shadow areas, and so the histogram is *supposed* to have a lot of dark hills to the left. It can be downright frightening to see all those black hills and peaks on the left (or to the right), but quite often they belong there. There will certainly be times, however, when you want solid blacks or even (more rarely) whites without detail and so to alter your exposure based on the histogram would be a mistake.

And that's exactly where the histogram can get you into trouble: Imagine that you shoot a photograph of a nice country scene with a dirt road, a dark-red barn, and a white sky, and assume that the barn is the largest subject in the scene. When you look at the histogram, you see a lot of concentrated hills at the left edge of the scene (they represent the dark road and the big barn), and you might be tempted to add some exposure to shift them a bit to the right. The trouble is that the barn might have looked perfectly good as a dark tone, and by adding exposure, you're taking away from the drama of your photograph. You are letting the graph dictate "correctness" instead of drama.

While the histogram can be a good device for seeing approximately where the tonalities lie in a photo, it can also be misleading and intimidating.

It's far better to look at the preview of the actual image and see if it looks like what you were after. Even though the LCD is not a great means of judging exposure (particularly when you're working in bright daylight), when viewing it combined with studying the histogram, it can provide a good starting point for judging both exposure and contrast. As you gain experience in viewing the histogram, you may find that it helps you to know when the tonal range needs to be shifted by either an increase or decrease in exposure (underexposing shifts the hills to the left, while overexposing shifts them to the right), and that can be a good thing.

There is a lot written about histograms on the Internet — probably more for than against — and it's worth spending a few hours reading about this subject to make up your own mind.

Assignment

Turn High Contrast into a Colorful Silhouette

Creating colorful silhouettes is a lot of fun because you can reveal common subjects in a graphic and dramatic way. And making silhouettes with a camera is almost as much fun as the ones that you cut out of construction paper in grammar school. For this assignment, find an interesting shape and photograph it against a bright background. You can choose a sunset sky, a white wall, or any bright background — just use your imagination.

I took my shot for this assignment at the Mystic Aquarium while I was trying to get shots of curious penguins that came up to the glass to look at people (maybe the penguins call it a human zoo). I wanted to get a shot of penguins and people, but didn't have much luck. Then a mother and her son showed up, and when the mother made the pointing gesture and the son looked up, I knew I would like the shot. The colorful aquarium made an nice background for the shot, and all I had to do was trust the meter reading of the water. Taken with an 18-70mm Nikkor zoom lens. 1/125 sec., f/5.6, at ISO 400.

Remember to visit www.pwassignments.com after you complete this assignment and share your favorite photo! It's a community of enthusiastic photographers and a great place to view what other readers have created. You can also post comments, and read encouraging suggestions and feedback.

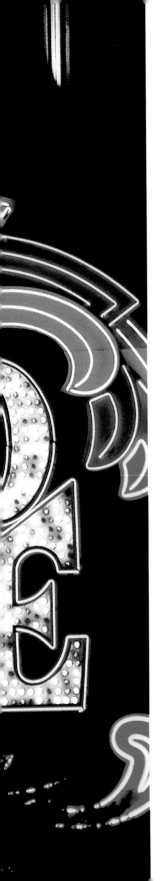

PHOTOGRAPHY AFTER DARK AND IN EXISTING LIGHT

CONSIDERATIONS FOR NIGHT SHOOTING

A WORLD OF NIGHTTIME SUBJECTS

For a lot of photographers — even very dedicated ones — photography is largely a daytime hobby. When the sun sets, they pack up the cameras and wait for another day. But if you limit your shooting to daylight hours, you're missing a lot of great photo opportunities and some fun shooting experiences. From the jack-o'-lanterns on your neighbor's front step, to the traffic coming and going on Main Street, to the bright lights of Broadway, the night is full of interesting visual possibilities. And all that you need to capture the color and light of the nighttime world is a tripod, a lot of memory card space, and the willingness to experiment a bit (and to miss the occasional extra hour of sleep).

Taking pictures at night isn't much different than shooting in daylight, but the results are almost always surprising. If you've never photographed a neon sign up close, for example (see 9-1), you'll be surprised at just how colorful and exciting they can be in a photograph — and how easy they are to capture. And the after-dark world isn't the only place to find unusual and challenging existing-light subjects: Concerts, indoor sporting events, and building interiors (including your own home) all present interesting technical and creative challenges.

Finding nighttime and low-light subjects is easy, and even ordinary things that fade into the background during the day can become quite interesting after dark. The local McDonald's restaurant might not seem like the most glamorous subject in the world by day, for example, but it seems to glow like a beacon at night (see 9-2). If you want to get a little more adventurous and add motion to the nighttime mix, things like traffic patterns and carnival rides can turn into extraordinary images when combined with a long exposure. In summertime, almost every town and city has an annual fireworks display that provides great opportunities for night shots.

9-1

ABOUT THIS PHOTO *I walked under this sign dozens of times before I decided to pull out the camera and shoot it one night. Shot with a compact digital zoom camera and exposed at 1/45 sec., f/4.5 at ISO 400, handheld.*

ABOUT THIS PHOTO
I've always found it interesting how mundane subjects like the local McDonald's restaurant can seem more attractive when they are lit up at night. Photographed with an 18-70mm Nikkor zoom lens, exposed at 1/30 sec., f/4.5 at ISO 400, handheld.

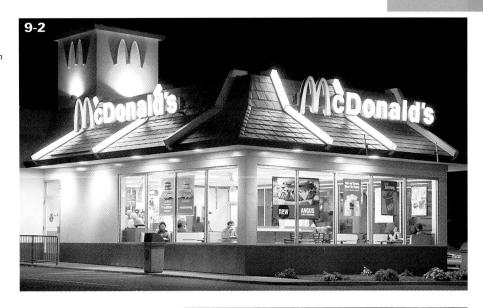

Travel offers great opportunities to practice your night and low-light photo skills, and some destinations — like the Las Vegas Strip — seem as if they were invented for the sole pleasure of photographers. Where else can you find a volcano that erupts in a flamboyant fury of pseudo fire and lava every half hour like clockwork as in 9-3?

In this chapter, I introduce you to some of the very simple techniques involved in shooting pictures after dark, and I also talk about the specifics of some common after-dark subjects.

CONSIDERATIONS FOR NIGHT SHOOTING

Shooting after dark is considerably more experimental than daytime photography, and (in the beginning, at least) the results are somewhat less predictable, but it is really no more challenging that daytime photography. Because night shooting usually involves substantially longer exposure times and unknown or unpredictable light temperatures, however, you need to be concerned about holding the camera steady, minimizing

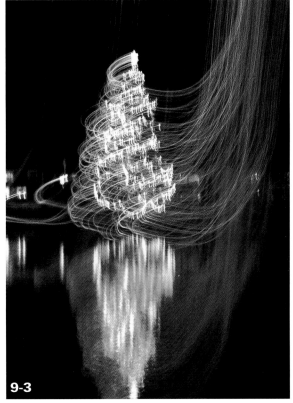

ABOUT THIS PHOTO *The volcano at the Mirage Hotel and Casino in Las Vegas is a favorite among photographers and a fun challenge for nighttime shooting. I shot this with a compact camera, exposed at 1/25 sec., f/1.8 at ISO 400, resting on a fence.*

213

digital noise, and choosing the best white balance. Here are some of the main technical considerations that you'll encounter, and some brief suggestions that will help you get good night photos the first time out.

> **tip** If you're out shooting after dark and you don't have a tripod handy, you can steady the camera considerably by rolling up a sweater and placing it on a car fender or a trash can and using this as a kind of "beanbag" support. In fact, you can even make a disposable, lightweight beanbag by filling a zipper bag with a pound or so of dried beans — a good trick to keep in mind when traveling. I've even used a zipper bag filled with sand from the beach as an impromptu camera support.

LONG EXPOSURES VERSUS HIGHER ISO

Almost every time I take a night or low-light photograph, I ask myself the same question: Should I use a longer exposure time and keep the ISO low to get better image quality, or should I raise the ISO so I can use shorter exposure time? The fact is that higher ISO settings and long exposure times *both* lead to increased image noise. I really don't mind noise in night photos, and so I tend to give that issue minimal consideration. (There are also some very good noise-reduction software programs available if you find that noise is affecting image quality.)

Your primary consideration should be subject motion. Because you will be using a tripod a lot of the time (you will, won't you?), camera movement won't be an issue. Subject motion, however, is always a consideration. If you want to freeze action as much as possible, then shifting to a higher ISO can buy you a few more stops of shut-

ter speed. On the other hand, exaggerating the motion of night lights (traffic streaks, fireworks, carnival rides) is very often a desirable thing, and so using a slow ISO and a longer shutter speed is a good working combination. For me, the larger questions are always: Is there motion here, and how do I want to capture it?

There will be times when you're shooting without a tripod and you will be forced to raise the ISO, so go ahead and raise it. I had to raise the ISO to 1600 to photograph the famous Rose window in Notre Dame Cathedral (see 9-4) because I was already using the fastest lens I had with me and tripods aren't allowed — I simply had no choice. The image isn't as sharp as I would like, but in situations like this, I always feel that it's better to raise the ISO and suffer some digital noise than to simply stop shooting.

FAST LENS VERSUS HIGHER ISO

The same questions discussed previously apply here, but you can often gain a stop or two of extra light by using a faster lens; however, unless you're a night-shooting addict, I would never buy a faster lens just to gain some extra speed. The combination of faster ISO and a good tripod is just as effective and owning one saves you from potentially buying several fast lenses. The one advantage that a faster lens does have in dark situations is a brighter viewfinder — and that can be a real blessing (it's one place where the EVF, or electronic viewfinders, in some cameras have a real advantage, because they boost the brightness of the viewfinder image).

> **x-ref** I discuss the value of faster lenses in Chapter 4.

ABOUT THIS PHOTO
By raising the ISO to 1600, I was able to photograph this beautiful stained-glass window, with a relatively long 80-200mm Nikkor zoom lens. The scene was exposed at 1/60 sec., f/4.5, handheld.

9-4

COLOR TEMPERATURE CONSIDERATIONS

Modern artificial lighting can provide some pretty complex and unpredictable color temperatures, and there's really no way to know how a particular light source will look without shooting some test shots. As I discussed earlier in this book, you can set a custom white balance (see your camera manual for specific instructions) by placing a white card in the scene and then using your custom white balance feature to program the camera. Even so, very often the lights at night are mixed from dozens of sources, and if you balance one of them, the others may still record incorrectly. I kind of like the wide assortment of colors that the night produces, and I rarely take the white balance setting off of automatic unless I need to get very precise colors.

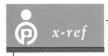 *x-ref*

For a more detailed discussion of white balance and how to set a custom white balance, see Chapter 7.

TRY CAMERA RAW FORMAT

For those of you who have cameras that offer the RAW format and have the software to open and edit these images, it can be very useful for night shooting because you can adjust the color temperature of the image and the overall color tint (which together comprise the white balance), or choose another white balance preset after the fact. While I split my daytime shooting between RAW and high-quality JPEGs, I almost always shoot night images in RAW format for this reason. Another advantage of RAW format with night shots is that you can adjust the exposure (which is essentially changing the ISO speed) over a range of several stops — very useful because metering at night is tougher than during the day. In the Adobe Photoshop Raw interface, you can also adjust the shadows and brightness controls separately, which makes it much easier to manage contrast — and night scenes are always inherently contrasty.

DON'T BE AFRAID TO USE THE FLASH

If you're photographing broad scenes like city skylines or shots of the Las Vegas Strip at night, a flash won't do you much good. Considering that the distance range of most built-in flash units is less than 15 feet or so (pity all those poor souls popping off flash shots at nighttime baseball games), using a flash with a large outdoor scene at night is pointless. There will be a lot of times, however, when the subject you want to shoot won't have enough ambient lighting and your only recourse is to use the flash. I really wanted a shot of this bar sign in Port Aransas, Texas (see 9-5), but I was just too exhausted from a day's shooting (and too full of Texas shrimp) to haul out the tripod — so I took the lazy way out and used a flash. Hey, if it works, use it.

METERING NIGHT SCENES

Metering outdoor nighttime scenes can be particularly tricky because you often have large dark areas and very small bright areas. If you're shooting in Times Square, for example, you have a tremendous mix of traffic lights, neon signs, illuminated buildings, and large dark patches. I always try a matrix reading first that includes moderately bright lights like neon signs, but not any direct lighting like headlights or bare street-light bulbs, and I shoot a few test shots to see if the reading is accurate. It's not always possible to judge what you're getting on the LCD, but in a lot of night situations, it's your best guide. The histogram (discussed in Chapter 8) is useful to show you if all of your highlights are crammed up against the right edge, but again, with headlights and street lamps, you are going to get some burned-out highlights, no matter how good your overall exposure.

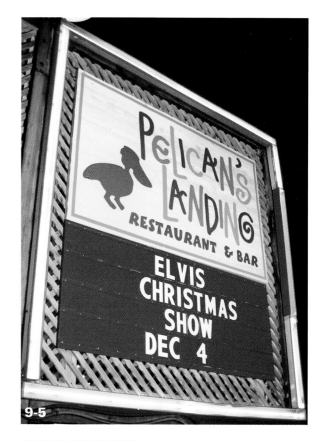

9-5

ABOUT THIS PHOTO *Elvis is alive and well and living in Texas. I photographed this sign by putting the camera in the automatic exposure mode and letting the flash fire. Shot with a compact digital camera and exposed at 1/4 sec., f/3.2 at ISO 100, with a flash, handheld.*

The biggest exposure danger with night traffic and light scenes is, oddly enough, letting too much light into the camera, because that causes the brighter areas to overexpose with no detail, and it's in these bright areas that you find most of the fun colors. The good thing about metering and exposing these situations is that you're not really after a precise reading; again, what you need is an exposure that captures the colors well without burning out the highlights. You can let the dark areas take care of themselves generally, and try to crop them out during the shooting or later in editing.

tip Carry a small flashlight with you when you shoot at night; it makes reading camera controls and finding accessories in your camera bag much easier. A miner's type headlamp is also great because you can use it hands-free and it's always shining where you're looking.

HALATION

If your night compositions include any bright point-light sources like street lights or spot lights, you'll frequently encounter a flare-like phenomenon called *halation* that causes the lights to spread past the edges of the actual light (see 9-6) and take on a "glowing" appearance. Halation is caused by intense sources of light scattering on the sensor, causing the area of light to grow or bleed. I actually like the effect of bright lights "glowing" in night shots, and unless it's a big distraction, I just ignore it. There isn't much you can do to prevent it from occurring anyway, other than hiding the light source behind some other subject — hiding a street lamp behind a street sign, for example. Back in the 1970s, when everyone had a pocket full of creative filters wherever they went, "star" filters were popular, and they caused small point-sources of light to turn into multi-pointed star shapes — so buying a star effect lens filter is another creative option you

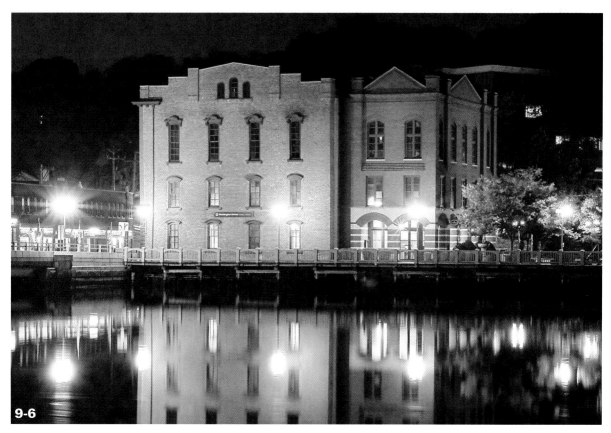

9-6

ABOUT THIS PHOTO *Halation from walkway lights is obvious in this shot of the Inn at National Hall in Westport, Connecticut. Photographed with a 24-120mm Nikkor zoom lens and exposed at 8 sec., f/18 at ISO 200, on a tripod.*

might consider. You can buy these filters as either screw-in filters that mount to the front of the lens or rectangular filters that slide into a universal mount, such as the Cokin system. The star effect often happens naturally as a result of the lights hitting the lens iris.

> **tip** Even if you're using a tripod, long exposures require a gentle touch on the shutter release button. One method of releasing the shutter without shaking the camera is to use your camera's self timer. Another is to use an electronic cable release or a remote release. There are a number of types of remote controls on the market, both corded and wireless, but they are made for specific camera models, and so you should read your camera manual before buying one.

A WORD ABOUT SHARPNESS

As you probably know by know, I am a fanatic about using a tripod, and I think that if you're going to do serious night photography, you should own a very good tripod. That said, a lot of night photography is done when you're not expecting to be shooting — like when you're out on the town for the night or even just taking a walk around the block to look at holiday lights. While you might have your compact camera with you, it's unlikely you'd have a tripod handy. Similarly, when you're traveling, unless you're entirely masochistic, you probably won't haul a tripod with you (at least not at night when you're out seeing the night lights). I don't blame you.

With this in mind, there are times at night when sharpness has to take a back seat to just shooting fun pictures. Often capturing the mood of a night scene is far more important than rendering every detail with critical sharpness. One thing you can do is to invest in a camera (or lenses for your dSLR) with vibration-reduction features, because these can give you several extra stops in low light. Also, if you enjoy shooting at night, pay special attention to the ISO range the next time you're shopping for

a camera; a top speed of at least 1600 is very useful and if you can find a camera with a top speed of 3200, night shooting will be much simpler.

Whatever steps you take to improve sharpness, don't let the thought of creating blurry night shots keep you from taking pictures. I'd rather have a bunch of great, somewhat softly-focused night shots of Times Square at midnight than to have no photos at all.

A WORLD OF NIGHTTIME SUBJECTS

If you were to never shoot another daytime subject again but limited your shooting only to pictures taken after dark and in dim locations, you'd still find a tremendous variety of subjects to photograph — and you'd probably have the most interesting photo collection around. If you happen to live in a rural area, you may not find as many bright neon signs and theater marquees as you would if you lived in the big city, but you would still find fun subjects all around you. Here are some tips on shooting nighttime subjects.

TRAFFIC STREAKS

Traffic streaks are the quintessential nighttime subject, and they're easy and a lot of fun to create. All you need is a dark location with a moderate amount of traffic, a steady tripod, and a good vantage point. I prefer high vantage points like overpasses or rooftops, because they let you look down on the pattern of light as it streaks through the frame, rather than just looking at it at eye level. To get the shot shown in figure 9-7, I parked on the top floor of a mall parking garage and shot the cars exiting toward the highway. I was only able to shoot one frame before a security guard chased me off the roof. Considering the exposure was more than a half-minute long, I was lucky he didn't spot me sooner.

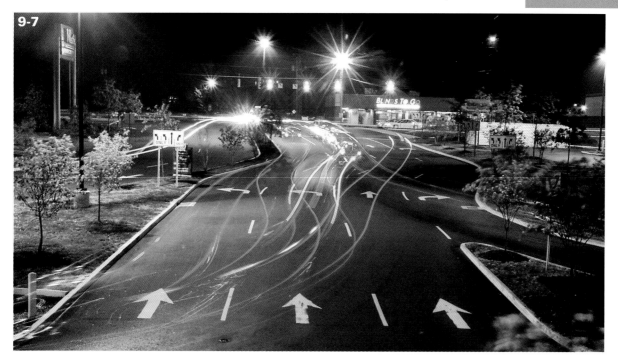

9-7

Capturing patterns of headlights and taillights is simply a matter of leaving the shutter open long enough to record what you think will be an interesting trail of lights. If you're photographing two-way traffic, of course, you can get both headlights and taillights, and often the headlights overpower the scene. If you can find a vantage point where most of the traffic is moving away from you, you won't have to worry about the imbalance of brightness on one side of the frame.

To make the exposure, set your camera to its manual-exposure mode (if your camera has one) and then set the shutter speed to "bulb." In that position the shutter stays open from the time you press the shutter release until you let it go. For that reason, it's very useful to have a locking cable release that lets you lock the shutter open for as long as you need. If your camera doesn't have a manual-exposure or bulb mode, your shots are limited to the longest shutter speeds available, but they often work fine.

Exposure times aren't critical and I generally set a small aperture — I start with f/22 or f/29 — for good depth of field and then leave the shutter open until I think I've captured a good flow of traffic. Check the LCD after each exposure, and you'll know whether or not you need to open the aperture a bit or use longer shutter speeds. Visually it's usually best to open the shutter before traffic enters the scene and keep it open until it's passed all the way through the frame; otherwise, you'll have a lot of partial streaks in the shot.

NEON SIGNS

Neon signs are one of my absolute favorite subjects — they're bright, they're colorful, and a lot of them are very retro-looking, which I find fascinating. Photographing neon is incredibly simple because your matrix meter reading is usually very accurate, and you can be off by a stop or two and still get great photos. Most neon signs are also

bright enough to shoot handheld if you bump the ISO up to 400 or 800 (although if I'm working on a tripod, I keep the ISO at 200).

One strange little phenomenon you might notice as you photograph neon is that the halation from the tubes grows or contracts, based partly on exposure time and the aperture you're using (I tend to use a small aperture of f/22 or smaller, mostly to keep everything in sharp focus). If you see too much of a glow, or too little, try altering your aperture (and your exposure time) and see if

it cleans up the image a bit. Also, while I always take an overall shot of the sign, I also take various close-ups and try to create interesting abstract designs from the sign. I spent about 20 minutes taking about 50 or 60 shots of the motel sign shown in figures 9-8 and 9-9. Because the sign is just sitting there and digital pictures are free, I usually shoot at least several dozen images from different angles and distances, bracketing exposures if I'm not sure how the glow is being recorded.

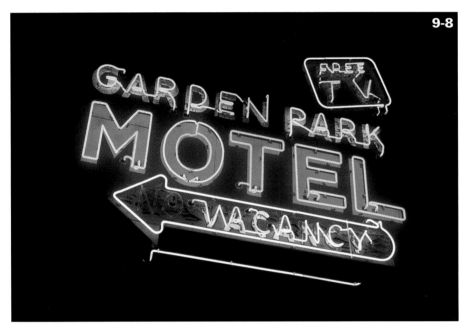

9-8

9-9

ABOUT THESE PHOTOS *If you're ever bored on a Saturday night, take a cruise along the local strip looking for old neon signs — they make great photos. I found these on Route 1 in Norwalk, Connecticut. Both were shot with a 24-120mm Nikkor zoom lens, and exposed at 1/15 sec., f/11 at ISO 200, on a tripod.*

CARNIVAL LIGHTS

If you haven't guessed already from looking at this book, I spend a lot of time wandering through carnivals with my camera and tripod in tow. I think I have a latent desire to be a carney, and taking pictures of it is my way of running away with the carnival. Even the most dirt-poor of traveling carnivals usually has quite a fascinating assortment of games, rides, and food booths that are colorfully lit. In fact, sometimes the smaller the carnival, the more it looks like Hollywood on wheels.

One of the most fun subjects to photograph, of course, is the Ferris wheel. Where else are you going to find a 70-foot-tall circle of colorful spinning lights to photograph? The first time I ever photographed a Ferris wheel, I was 16 years old and a policeman working the show came up to me while I was shooting and asked me what shutter speed I was using (it turns out he was the police force photographer). I told him I was shooting at something like a quarter-second to record the colors and he said, "Try shooting it for 10 or 20 seconds and see what happens." So I took his advice and shot a roll of exposures ranging from 10 second to 30 seconds. When I got the slide film processed, I flipped out! Instead of a normal shot of a static wheel were these amazing circles of color gliding through the night. I've been shooting Ferris wheels that way ever since, as you can see in figure 9-10.

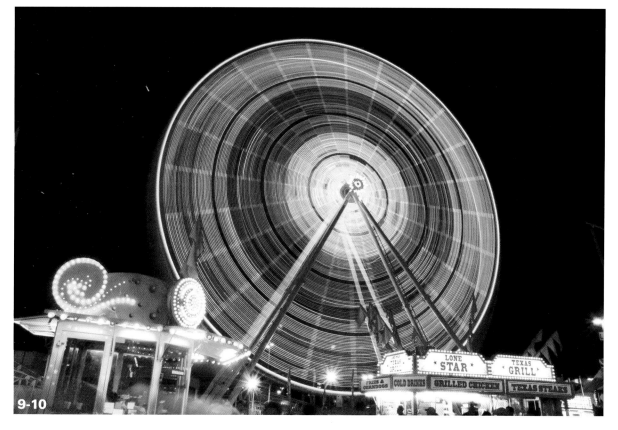

9-10

ABOUT THIS PHOTO *The best shutter speed for any moving ride depends on the speed of the ride and the effect that you're after. I shot this quickly moving Ferris wheel using an 18-70mm Nikkor zoom lens at 2.5 sec., f/22 at ISO 200, on a tripod.*

So that's my advice to you: Forget normal exposures when it comes to motion rides and put your camera on a sturdy tripod; set a small aperture (f/16 or smaller if you're shooting with a dSLR); and play with very long exposure times. As for food booths (see 9-11) and games, the best thing to do is to arrive in late afternoon and shoot during the twilight hour when the booth lights are coming on but there is still some natural light — you'll have a much easier time finding handheld shutter speeds (although I would raise the ISO to 400 or 800, at least), and the daylight helps to open up dark areas that aren't illuminated.

CITY SKYLINES

No matter how hectic and intense most cities feel by day, by night they morph into a sparkling fantasy of lights and shiny glass surfaces and colorful storefronts. You simply can't ask for a more glamorous landscape subject. The toughest part about

shooting city skylines is just finding a good vantage point — one that provides enough distance for you to see the shapes and patterns of architecture, and yet is close enough so that you can fill the frame. In New York, for example, a lot of the best photos are made from across the East River in Brooklyn or the Hudson River in New Jersey.

If you're traveling and you want to shoot the city at night, always ask for a room with a good city view. I'm always willing to pay extra for a better view (and most hotels are aware of the extra value). The shot in figure 9-12 of Tokyo's Shinjuku district is an ambitious and extraordinary photo taken from a hotel room window on the 20th floor by a former online student of mine, Gavin Zau. Gavin is an extremely talented and dedicated amateur photographer who is lucky enough to travel the world almost constantly for his job, and he spends whatever free time he can afford shooting some amazing travel shots. Here is how he describes shooting this scene:

ABOUT THIS PHOTO *I shot this ice cream vendor just as twilight was approaching and he had flipped on the neon signs. A few minutes later, much of the scene descended into dark shadows. Shot with an 18-70mm Nikkor zoom lens at 1/60 sec., f/4.5 at ISO 200, handheld.*

"The photo was taken from my hotel room window looking down at the street. I turned off all interior lights to avoid reflections off the window glass. I also moved the curtains away to avoid getting their reflections. I then put a pillow on a table near the window for the long exposure, and used a self-timer to avoid shaking the camera when I pressed the shutter."

Gavin says he also waited until there was a good flow of traffic in the street below — a great detail to add to the shot.

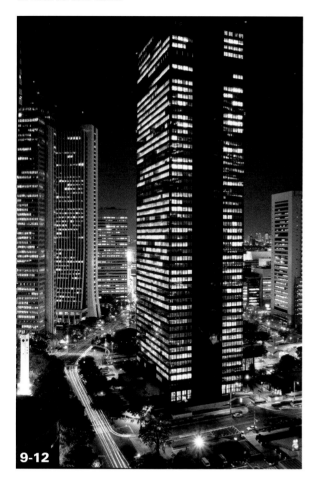

9-12

ABOUT THIS PHOTO *The Shinjuku district in Tokyo, as seen from a hotel window, makes a fantastic nighttime city shot. Shot with a 20mm Canon lens and exposed at 8 sec., f/11 at ISO 200. ©Gavin Zau.*

If you're just day-tripping into the city, you can often find observation decks or upper-floor restaurants where you can shoot good skyline shots. Twilight is an ideal time to shoot, because the deep blue that lingers in the sky provides a beautiful and colorful contrast to the city lights. Bracket your exposures by a stop or two in both directions and you have a better chance of getting one exposure that balances the sky and skyline nicely. If your camera has a RAW format, it lets you adjust both exposure and white balance after the fact.

CITY STREET SCENES

When you're at street level in a big city at night, you're looking straight into the face of the beast — and what a beautiful face it is. No place, and I mean no place I've ever been, is as exhilarating to photograph as Times Square at midnight on a hot summer night (see 9-13). There are more lights and neon signs and excited people per square foot than almost any place I can think of — and photographing all that glamour and excitement is a tremendous amount of fun. You can spend hours in one location there and never shoot the same view twice. Bring a lot of memory cards.

Capturing the essence of a scene like Times Square or the Las Vegas Strip (or, for that matter, the downtown of any big city on a busy night) is largely a matter of finding the most intense and colorful zone of energy, and then capturing as much of that in one frame as possible. My trick for capturing scenes in Times Square, for example, is to stake out one likely spot and then let the city come to me. I shoot from several different locations, but I tend to stay in each one for a half-hour or longer.

Because there is a vast contrast between the darkest and brightest areas, I try to meter to get a good exposure for the brightest signs, and then I bracket a stop or two on either side of that reading. I usually shoot in the manual mode because that allows me to take careful readings of a particular area and prevents the meter from being led astray by car headlights or a person walking by the camera (and, as you can see in figure 9-13, in New York, people will be inches from your lens). I have to say, though, that I have shot point-and-shoot images in various cities at night, and I have always been pleasantly surprised by how well the images were exposed.

If specific depth of field is my biggest concern (and it usually is), then I bracket by changing shutter speeds. But if my goal is to get traffic streaks moving through the frame, I set a particular shutter speed and don't worry as much about the depth of field (although at very slow shutter speeds, you're going to get small apertures, so depth of field usually isn't an issue). It's a bit tougher to get motion-freezing shots (see 9-14) of places like Times Square because while there is a lot of light from signs and marquees, the actual street level is a mix of bright headlines and dark areas.

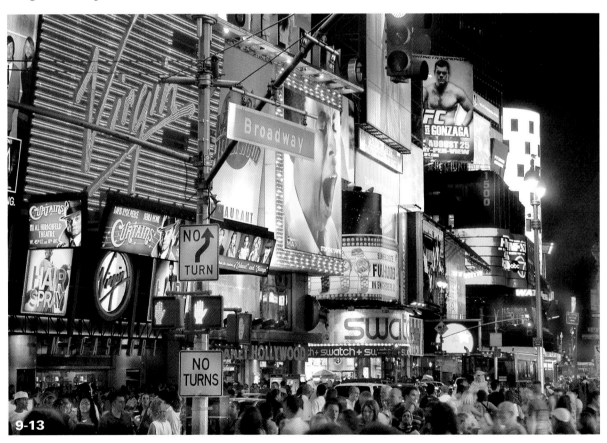

9-13

ABOUT THIS PHOTO *If you're looking for light, color, and action, Times Square at midnight is the place to be. Photographed with a dSLR with an 18-70mm Nikkor zoom lens, exposed at 1/20 sec., f/4.5 at ISO 800, handheld (resting on a traffic barrier).*

Incidentally, neither of the shots of Times Square was shot with a tripod, but in both cases, I found either traffic barriers or garbage cans so that I had something steady to lean on. City shots at night aren't always as sharp as you'd like, but I think the color and excitement more than makes up for a bit of image softness. Still, if you're going on location specifically to shoot, a tripod can enhance your images immeasurably.

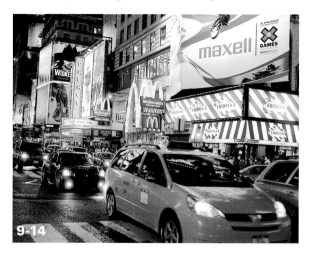

9-14

ABOUT THIS PHOTO *I like to include traffic in shots like this because they reflect a lot of the lights above and around them. Shot with an 18-70mm Nikkor zoom lens, exposed at 1/25 sec., f/3.8 at ISO 800, resting on a traffic barrier.*

NIGHT MARKETS

If you're lucky enough to live near (or travel to) a city that has night vendors and outdoor food markets, and hunger doesn't overcome your desire to take pictures, then you have a wonderful existing-light subject to photograph. The trick to getting good shots of night markets is really just to be there and have your camera set to its highest ISO (unless you work at twilight, which provides a few extra stops of illumination), and slowly mingle among the vendors. As most professional travel shooters will tell you, being there is half the battle, and then making friends among vendors — buying a snack or making a small token purchase — will get you great access to your subjects.

Gavin Zau (he shot the picture of Tokyo in figure 9-12) spends a lot of his off time on business (and personal) trips wandering these markets, and he comes home with a lot of really fun images. The shots of the *chaat* vendor on Juhu Beach in Mumbai, India (see 9-15), and a Hong Kong food vendor (see 9-16) are two of his candid night-market shots; both show just how interesting — visually and culturally — such subjects can be. Gavin describes the Hong Kong scene: "Every evening, the stalls come out and block off the road. They sell shirts, electronic gadgets, and souvenirs. They also have many restaurants and many set-up tables in the street." It's the perfect environment for nighttime shooting.

Avoid using your flash if you can because, as Gavin's photos so nicely show, working by available light creates far moodier and more exotic-looking images. Learn to lean against building corners or to prop your elbows on tables, and you'll find that you can shoot safely to 1/4 second — or even longer if you're using image-stabilized cameras and lenses. And always try to include some actual or implied action because it increases the interest of the photos a great deal; even if you get some motion blur, it only enhances the mood.

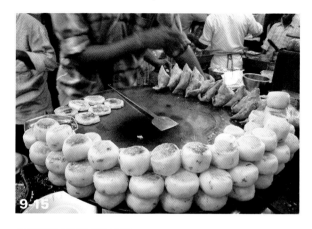

9-15

ABOUT THIS PHOTO *A chaat vendor preparing his offerings on Juhu Beach in Mumbai, India, captured by existing light only. Photographed with a Canon EF-S 17-55mm f/2.8IS lens. Exposed at 1/50 sec., f/11 at ISO 800, handheld. ©Gavin Zau.*

ABOUT THIS PHOTO
A colorful and action-filled shot of a food vendor on the Kowloon side of Hong Kong makes for a wonderful travel photo. Photographed with a Sigma 18-50mm f/2.8 lens; shot at 1/60 sec., f/7.1 at ISO 1600, handheld. ©Gavin Zau.

SPOTLIT BUILDINGS

In large cities and small towns, it's usually easy to find buildings like churches and government centers that are spotlit for dramatic effect, and they make great after-dark subjects. The best time to shoot architecture like this is just after the sun has set when there is a lingering blue sky. I photographed Notre Dame Cathedral (see 9-17) just after sunset, when the sky was a bright turquoise blue and the spotlights had just come on — a really magical time of day. This is a good time to use your center-weighted metering feature if you have one, by taking a reading from an area of average brightness that doesn't include any deep shadows or actual spotlights. If you don't have center-weighted metering, use the matrix meter, but try to include a mix of both light and dark areas. Again, if you have to use a higher ISO, go ahead and max it out — there's no sense in getting camera shake if you can avoid it, and the only price you pay is a small amount of digital noise.

SPARKLERS AND TIME EXPOSURES

If you're looking for a really creative challenge in night photography, making time exposures of people playing with sparklers is a fun way to spend an hour on a summer's night (see 9-18). By keeping the shutter locked open (you need a "bulb" setting in your manual-exposure mode, and it's easier if you own a locking cable release) and having someone wave around a sparkler, you can trace some fascinating patterns of light. And if you have an accessory flash handy, you can also capture a freeze-frame portrait simultaneously.

In order to capture the frames here, I enlisted the help of my friends Lynne and Sarah. You can do this with less than three people (let the subject light his or her own sparklers), but it's easier as a three-person job because having a person to light the sparklers and then step out of the frame makes things go much more smoothly.

ABOUT THIS PHOTO
With spotlighted buildings, a lot of the work has been done for you by lighting designers — and Notre Dame Cathedral is certainly no exception. Shot at twilight with an 18-70mm Nikkor zoom lens, exposed at 1/10 sec., f/3.5 at ISO 800, handheld.

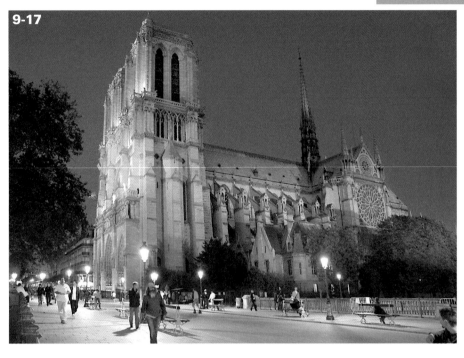

9-17

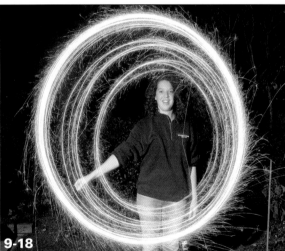

9-18

ABOUT THIS PHOTO *Shooting sparkler portraits is a lot of fun. Here I had my friend Sarah create light circles with the sparkler and then used a flash to capture her. Photographed with a 24-120mm Nikkor lens, exposed at 38 sec., f/18 at ISO 200, on a tripod.*

caution Sparklers are safe but they get very hot, so use caution — this isn't something you should do with young children. if sparklers aren't legal where you live or if you want to use young children as your subjects, you can use a pen-light flashlight as your light source instead.

Basically, the technique consists of two actual exposures on one frame: a time exposure to record the light tracings and then a flash exposure to record the person. If you don't want your subject to show, you can eliminate the flash step. The actual steps you need to use depend somewhat on whether your camera has a full-manual mode with a bulb setting or if you're using a camera that only has a night-scene mode:

1. **Find a dark location with a distant background.** It's simpler to eliminate the possibility of a garage or streetlight (or house light) showing up in the scene if you choose a dark corner of the yard.

2. **Set your camera to either the manual or night-scene exposure mode.** I prefer using a full manual exposure mode, but you can follow this technique with a night-scene mode. If you have the option to use "rear-curtain sync" flash mode, choose that. It fires the flash just before the end of the exposure. Also, because I used a dSLR to create these photos, I was able to use an accessory flash (off camera) and fire it any time I chose during the exposure. If you're using a dSLR and you have an accessory flash, this is a much more flexible way to make the flash exposure.

3. **Set your aperture to a small opening to help you maintain sharp focus.** The exact aperture isn't critical, and you can make test exposures to see how your settings are working.

4. **Use a tripod if you have one, and use a flashlight to help you frame the scene.** Have your "lighter" person (in this case, Lynne) hold a flashlight on your subject as you begin each exposure to help you compose the scene and focus in the darkness. (Turn the flashlight off as soon as you begin the exposure sequence.) Using a flashlight not only helps you frame the scene more carefully, but the light from it helps your camera focus (although many cameras are capable of focusing in darkness using a built-in focus-assist light). If your camera won't focus even with the flashlight and you have a manual-focus mode, choose that.

5. **Make a test exposure to see if you need to adjust the aperture of the flash power.** If you're using an accessory flash, you can probably adjust the flash power. (If the flash portion is too dark, increase the power or move closer — if it's too powerful, reverse that.) Have your subject make a test pattern with the sparkler. You may also want to reframe the scene to be sure the sparkler pattern is staying in the frame. Once you have a good basic exposure and good framing down, continue to the next step.

6. **Have your assistant light a new sparkler and then open the shutter or begin the exposure.** It's much simpler to start the exposure after the sparkler is lit.

7. **Tell your subject to create some sort of light pattern using the sparkler.** I had Sarah draw circles in front of her in some exposures, make a peace sign (see 9-19) in others, and write her name several times in other frames. She drew great circles, which helped, and I also had her shrink the circles as the exposure neared an end. I also used Lynne as a subject in a few shots, and she drew huge flowers in mid-air.

8. **Just before the sparkler goes out, fire the flash.** If you're using a manual flash, you can decide when to fire the flash. If you're using a night-scene mode with a point-and-shoot camera, then the flash just fires at the end of the exposure. Because I was using manual mode and a separate flash, I was able to tell my subjects when to smile, and then I'd fire the flash (otherwise, they would have to stand there and grin the whole time).

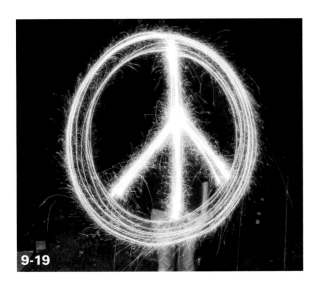

9-19

ABOUT THIS PHOTO *I challenged Sarah to draw a peace sign with a sparkler — it took a few practice shots, but I was amazed at how nicely this one turned out. Shot with a 24-120mm Nikkor lens at 27 sec., f/18 at ISO 200, on a tripod.*

9. **Review your photos and reshoot if you need to.** Including test shots (and I shot separate tests of just my subject and just the circles), we shot about two-dozen images. About eight or ten were keepers. The speed of the sparkler's motion affects the image to some degree: The faster it moves, the thinner the lines, and the slower it moves, the wider the lines become.

FIREWORKS DISPLAYS

Fireworks displays are another fun summer subject that can test your nighttime photo skills. There are actually two methods, and I describe each one briefly. I prefer the first method, as I can capture a series of bursts in a single frame, but I

have to admit that at times, I opt for the second method because it's simple and it works when it comes to capturing single bursts.

- ■ **Method 1: Keep the shutter open to capture multiple bursts.** This technique requires a tripod and a locking cable release, and involves keeping the shutter open for a lengthy time exposure to capture several bursts in one frame. To use this method, set your camera up on a tripod and, with a wide-angle lens or wide zoom setting, aim the camera at an area where you think there are going to be a lot of explosions. If you're lucky and you have an interesting foreground, like the harbor in figure 9-20, then you must also take care to frame the composition. Once you have the camera in position, set the shutter speed (in manual mode) to "bulb," and leave the shutter open until you think you've captured an interesting array of explosions.

You can cover the lens between bursts with a piece of black cardboard or a lens cap, but once you start the exposure, you really have to guess as to whether various explosions landed in the frame — and how many you've actually captured. Aperture really doesn't matter that much because it's the long shutter speed that controls the exposure, but I usually set a small aperture if there is a foreground scene to maximize depth of field. I typically leave the shutter open for between a minute and five minutes, covering it between bursts. Once you think you've got a good shot, just close the shutter.

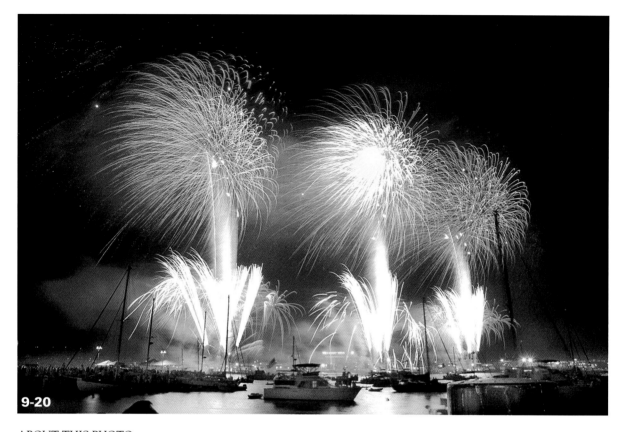

9-20

ABOUT THIS PHOTO *A single long exposure of 18 seconds was used to capture this extraordinary fireworks display produced by the Mashantucket Pequot Tribal Nation in New London, Connecticut. Shot using an 18-70mm Nikkor zoom lens, exposed at 18 sec., f/22 at ISO 200, with a tripod.*

You won't always be lucky enough to have a cool foreground to work with, but you can still use this technique to capture a sky full of explosions (see 9-21). This is largely a hit-or-miss technique when it comes to the sky, though. This is because with a dSLR, the viewfinder is blocked off during shooting so you can't see what you're shooting, and even with a camera that has an optical finder, you risk bumping the camera if you try to look during the exposure. In other words, shoot as many long exposures as you can and keep your fingers crossed.

■ **Method 2: The single exposure.** It's simpler to capture fireworks with a single exposure than you might think. Just raise the ISO slightly (to around 400), and then wait for a burst in the sky and fire. Surprisingly (especially for someone who uses the more complicated first method quite often), this technique works very well; its limitation is that you can only capture in that frame what you see in the sky at that instant, as in figure 9-22. Exposure is really up to the camera, but if you notice the shots are too dark or too light, you can either adjust the ISO speed or the exposure compensation.

230

ABOUT THIS PHOTO

Getting a bunch of explosions in one frame is largely a matter of luck and shooting a lot of pictures. Shot using an 18-70mm Nikkor zoom lens, exposed at 10 sec., f/8 at ISO 400, mounted on a tripod.

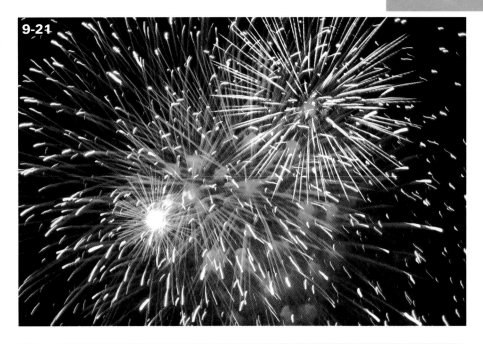

ABOUT THIS PHOTO

A single exposure was used to capture this isolated fireworks explosion. Because I was hand-holding the shot, I was able to track the explosion across the sky with my 18-70mm Nikkor zoom lens as the burst unfurled; exposed at 1/20 sec., f/4, ISO 1600, handheld.

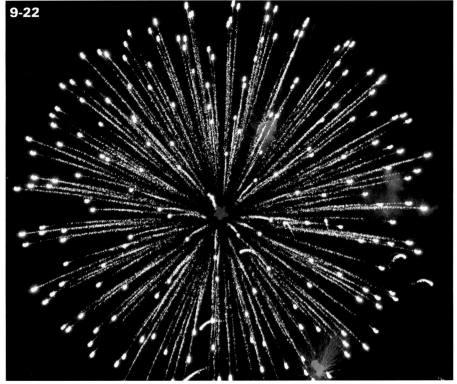

Assignment

Searching for the Lost Art of the Neon Sign

I can't imagine that there's a city or town anywhere in the world that doesn't have some interesting neon signs hiding somewhere — whether it's at the local pub, pizza joint, or perhaps at a motel. So for this assignment, pack up your camera (and maybe your tripod) and head out in search of that eternally colorful and bright beacon of the night: the neon sign. I think neon is one of the most beautiful and yet underrated (and sometimes it seems, forgotten) art forms, and I'm betting that you can prove me right.

I found the neon horse shown here while driving up Route 1 in Florida — on a nighttime shooting trip when I was specifically looking for neon signs. I nearly drove off the road when I saw this, because I was having a slow night and would have settled for a good beer sign in a bar window. This sign remains my all-time favorite neon shot. Taken with a 105mm Nikkor lens, 1/15 sec., f/8, at ISO 800 with a tripod.

 Remember to visit www.pwassignments.com after you complete this assignment and share your favorite photo! It's a community of enthusiastic photographers and a great place to view what other readers have created. You can also post comments, and read encouraging suggestions and feedback.

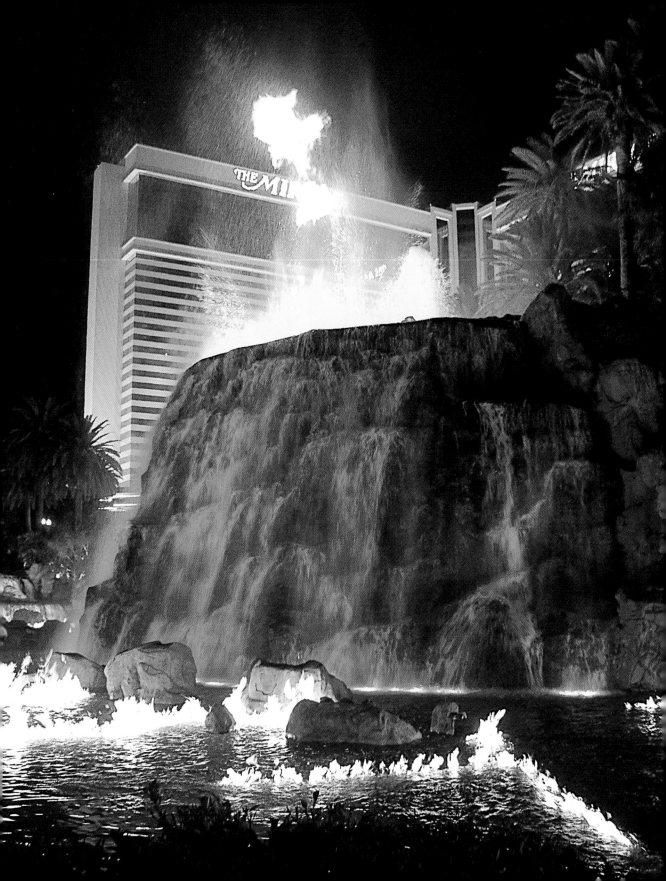

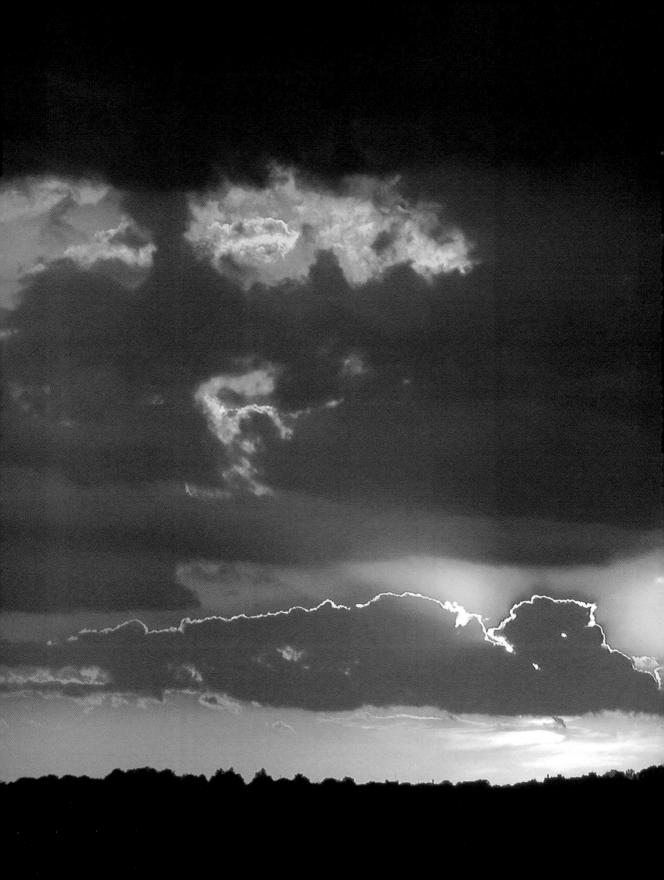

SPECIAL CONSIDERATIONS: WEATHER AND NATURAL PHENOMENA

So far in this book, I've talked a lot about how to get good and creative exposures for everyday subjects, quite a bit about how to get the best possible exposures for very difficult subjects, and also how to get successful exposures of night subjects. This covers a lot of ground, and if you can master the techniques involved in those subjects, there are very few situations left that will confound you. In fact, if you've successfully completed all of the assignments in the book so far, you deserve an "exposure expert" merit badge (or at least treat yourself to an ice cream cone).

Every once in a while, however, you're going to encounter a nature- or weather-related subject that falls into its own unique exposure category—let's call them natural phenomena. Subjects like fog, rain, rainbows, and autumn colors each present their own special exposure considerations. In this chapter I offer some advice on how to handle a number of these special situations, but my guess is that if you look at the photos before you read the text, you will already have a good idea of how they should be handled. And that means that the concepts presented so far are already becoming a part of your photography consciousness.

And if you promise not to skip ahead, at the close of this chapter, I also provide some tips on shooting outstanding photos of two of the most fun subjects of all: sunrises and sunsets.

CHANGES IN WEATHER

Having lived most of my life in New England, I can tell you that the old weather cliché, "if you don't like the weather, wait five minutes—it's bound to change," is a lot truer than most photographers would like. It often seems that no sooner have I hopped out of the car to set up the tripod and photograph a pretty sunny scene than I start to feel raindrops on my back. The funny thing is that I also spend a lot of time in the

southwest deserts and in Florida, and after I've been shooting in beautiful sunshine for a week or two, I start to miss those unexpected changes in weather—including the raindrops.

x-ref

For more advice on exposing for snowy conditions, see Chapter 8.

Changes in weather not only provide variety to the look of landscapes and outdoor scenes, but they instigate shifts in the emotional climate as well, and that is a wonderful thing. While it's certainly simpler to take good pictures in nice weather, I find that a sudden bank of fog or a passing rainsquall can instantly transform an ordinary scene into an unexpectedly dramatic one. Sometimes the changes are gradual and you can see them coming—fog creeping into an early-morning harbor scene, for example. Other times the changes are so sudden that there's simply no way you could have prepared mentally for the transformation, and that's when having a plan for handling those situations is invaluable.

FOG AND MIST

In his poem, *Fog*, Carl Sandburg wrote:

The fog comes

on little cat feet.

It sits looking

over harbor and city

on silent haunches

and then moves on.

tip

You can read an excellent Wikipedia article on fog at http://en.wikipedia.org/wiki/Fog.

And Sandburg (who, incidentally, was married to famed photographer Edward Steichen's sister Lilian) was right: Fog does just creep in silently, and it usually fades away just as quickly and mysteriously. While it's there, however, fog has a wonderful ability to transform common landscapes and scenes into romantic and evocative photos. It was the soft morning mist that attracted me to the shot of the swan (see 10-1), for example, and with hundreds of swan photos in my files already, I probably would have passed the swan by otherwise.

If you're lucky enough to live near a river or lake or in a hilly area, fog and mist are fairly common occurrences, and they occur most frequently when the humidity is very high and there is a drop in air temperature. Both fog and mist (mist is really just a less intense form of fog) tend to appear after a cool night before the sun has risen too high, causing the air to warm. As the sun rises higher in the sky, the moisture evaporates and the fog and mist begin to thin rapidly, and so it's important to shoot as quickly as possible or the atmosphere literally burns off. On a number of occasions, I've watched the fog disappear as I tried to decide on a composition.

10-1

ABOUT THIS PHOTO *Nearby subjects seem less affected by fog because there is less moisture scattering light toward the lens. Taken with a 70-300mm Nikkor lens and exposed at 1/200 sec., f/7.1 at ISO 200, handheld.*

Fog is particularly appealing when it's used with a thematically linked subject, as in the harbor shot in figure 10-2. Because we associate harbors and fishing boats with fog and mist, they seem to go naturally together and, in fact, we almost expect to see fog in photos of harbors and fishing boats. Long lenses intensify the look of fog (see 10-3) because they compress the fog and the subject, causing detail and colors to soften and melt away in the fog.

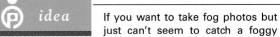 *idea* If you want to take fog photos but just can't seem to catch a foggy day, consider buying an inexpensive "fog" filter for your lens. Fog filters mimic the look of fog and mist by diffusing the entire image, and you can buy them in varying degrees of intensity. You probably won't fool anyone into thinking it was real fog, but the effect can be attractive, nonetheless.

10-2

ABOUT THIS PHOTO *Fishing boats heading out to sea in a morning fog are a quintessential New England scene. Photographed with a 24-120mm Nikkor zoom lens in the wide position, and exposed at 1/80 sec., f/5.6 at ISO 200, on a tripod.*

ABOUT THIS PHOTO
For this shot I exaggerated the appearance of fog by using the same Nikkor zoom lens (24-120mm) set to its longest focal length. Exposed at 1/100 sec., f/5.6 at ISO 200, on a tripod.

10-3

Fog is also a great addition to travel shots, especially mountainous shots, like Gavin Zau's spectacular shot of a twisting mountain road (see 10-4). The shot, made through the window of a cable car ascending the mountain, depicts the "tianmanshan" ("tianman" means "sky door") at Zhang Jia Jie in the Hunan province in China. By framing the scene with care so that both the road and the scene appear to disappear into the mountain fog, the mystery of the scene is enhanced nicely.

Exposing for fog is tricky because the moisture reflects a lot of light, fooling the camera into thinking there is more light than is really there. If you photograph a foggy or misty scene using a matrix meter reading, for example, the scene will undoubtedly be underexposed and the fog will

appear as a dark gray, rather than the lilting, gentle blue color that you want. To bring the tones back to a softer color, use exposure compensation (or bracketing) to add between a stop and one-and-a-half stops of additional light. Because thick fog can sometimes appear too blue, I usually set the white balance to "cloudy" in order to warm it up just a touch.

> **tip** Longer telephoto lenses magnify the effects of fog, and so if you want fog to appear thicker, then choose a longer lens. But remember that the more you magnify the lens, the more the reflected light fools your meter, and so you may have to add additional compensation as the focal length increases. Also, don't depend on your LCD screen with fog, because images tend to look somewhat brighter on the LCD.

10-4

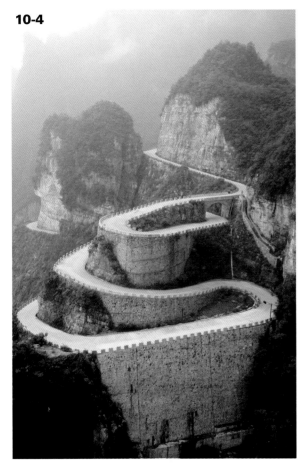

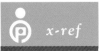

x-ref For more on exposure compensation and how the feature works, see Chapter 3.

RAINY DAYS

It's tempting to stash the camera and head for the nearest café (or stay home and guard the TV) when the rain starts to fall, but like fog and mist, rain also has its pretty side. Rain has some unique photographic advantages: It saturates colors, puts a glossy surface on subjects like leaves and grass and, at night, it drips colorful reflections across rain-soaked streets.

You don't necessarily have to get soaked to get good photos of rain, either. It's easy to hide out under an awning or in a doorway, which is exactly what I did to get the shot of the umbrella-hidden people in figure 10-5, watching (of all things) a fountain show at Longwood Gardens during a downpour. Your car also makes a nice dry vantage point from which to shoot (and has the added advantage of letting you listen to music while you work). I took the wet and somewhat abstract view of Monument Valley in figure 10-6 through the windshield of my car as the headlights of another car approached during an intense thunderstorm.

Rain really doesn't create any exposure problems other than the fact that overcast skies force you to shoot at slower shutter speeds, open up the lens, or raise the ISO. Rainy days, like mist and fog, also steal a lot of warmth from scenes, and so it's best to add some warmth back using the cloudy day or open shade white balance. If the rain is falling hard enough, you can also intentionally slow down the shutter speed to turn the rain into long streaks (again, see 10-5), or you can try and use a faster shutter speed to freeze the raindrops.

STORMY SKIES

Stormy skies are a great by-product of rainy days, and you usually get two opportunities to shoot them—before and after the storm. Cloud formations, especially when combined with colorful sunset lighting, often put on transient sky shows that are hard to fathom, even when you're standing there watching them. In fact, I often venture out into storms at sunset, hoping that it will break up and that the sky will become intense with color

ABOUT THIS PHOTO
*Colorful umbrellas make a
great subject on a rainy day,
and if you're in a crowd, they're
easy to find. Taken with a com-
pact digital camera and
exposed at 1/40 sec., f/4 at ISO
100, on a monopod.*

10-5

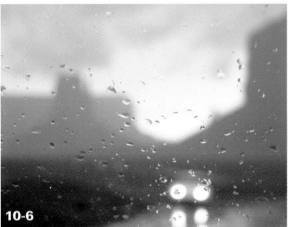

10-6

ABOUT THIS PHOTO *Any place that provides shelter is a good
place to shoot from on a rainy day—including your car. Taken with a com-
pact digital camera and exposed at 1/30 sec., f/3.7 at ISO 100, handheld.*

caution Digital cameras and water don't mix
too well, but don't stop shooting
just because of some raindrops. One way to stay dry is
just to duck into a doorway or under a porch roof;
another is to find a willing friend to hold an umbrella
over you. Another proven trick that photographers use
is to put your camera into a plastic bag and poke a hole
just big enough for the lens to stick out. Whichever
method you use, try to keep rain off the lens surface too,
or better yet, put a UV filter over the lens to protect it—
they're inexpensive and available at any camera shop.

and passion, as it did in figure 10-7. I've shot as
many as 100 pictures in a 15-minute period imme-
diately after a storm because the cloud formations
morph and re-invent themselves so quickly that
no two shots are alike. Exposing for clouds is pretty
straightforward: I usually take a matrix meter read-
ing directly from the clouds and then use about
one stop of minus exposure compensation to
darken the clouds even further.

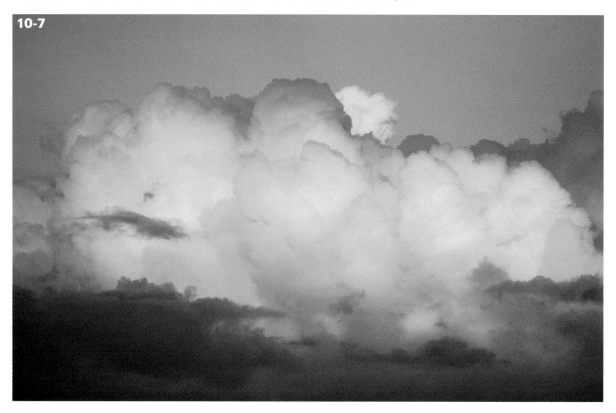

10-7

RAINBOWS

If you're lucky, an added bonus to a rainy day is a rainbow. Rainbows are such a rare treat that it's tough not to stop everything to photograph one. One of the keys to getting a good rainbow image is, of course, trying to predict them a few minutes in advance by keeping an eye on the sun position as it breaks out of a dark sky. Rainbows occur directly across from the sun, and so if you can see the sun beginning to break through the clouds, turn your back on it and face the darkest area of sky.

It's also great if you can find a pretty or interesting foreground to use beneath your rainbow, but unless you're a storm chaser, it's largely a matter of luck. I photographed the rainbow in 10-8 in Nevada's Valley of Fire State Park after enduring several hours of a nonstop downpour. When the sun unexpectedly broke out, I raced down a trail with a tripod on my shoulder and cameras swinging from my neck, looking for a nice rock formation. I climbed about 15 feet up on a boulder to get a clear shot of the rainbow as it grew in the gray sky.

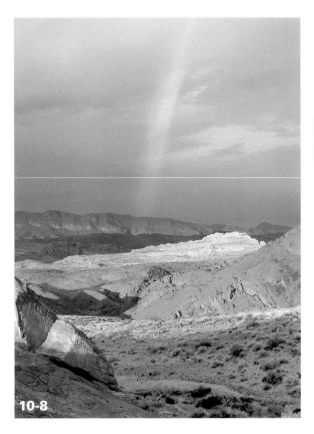

10-8

ABOUT THIS PHOTO *There's only one way to find rainbows, and that's to go storm chasing and hope for the sun to pop out. Photographed in Nevada with an advanced compact digital camera, and exposed at 1/250 sec., f/4.5, ISO 100 on a tripod.*

Exposing a rainbow is not complicated, but don't let especially dark clouds fool your meter into overexposing the scene. Instead, aim your meter (I prefer to use a center-weighted meter) right at the rainbow and then, to saturate the colors even more, bracket a stop or two under that reading. Rainbows are rare (unless you're lucky enough to

live in Hawaii), and so my advice is to shoot them whenever you see them, even if they're not perfect. You can always use a partial rainbow as a background in a homemade greeting card or as a theme icon in a digital scrapbook.

> **tip** If you own a polarizing filter, keep it handy when you're out chasing rainbows. By rotating the filter in its mount, you can intensify the colors of the rainbow. Be careful, though: Rotate it too much and you'll erase the rainbow! Keep an eye on the viewfinder, of course, and when the colors look their boldest, it's time to shoot.

AUTUMN SCENES

Autumn leaves are so colorful and inspiring that it would seem hard to take a bad photograph of them. But their beauty can be a bit deceptive when it comes to photographing them, because often when you download the photos, the colors lack the intensity and saturation that you saw in person. I think that the reason is as much related to composition as exposure, but both are at work.

Photographs of fall foliage are often most evocative when you cram the frame full, as I did in this shot of a sugar maple in figure 10-9, taken in the Berkshire Mountains near Lee, Massachusetts. By filling the frame with just foliage, you intensify the colors and eliminate open space and other distractions that can dilute their power. In terms of exposure, like all shots of vivid color contrasts, you can enhance color saturation with a slight underexposure of about one stop from the meter reading.

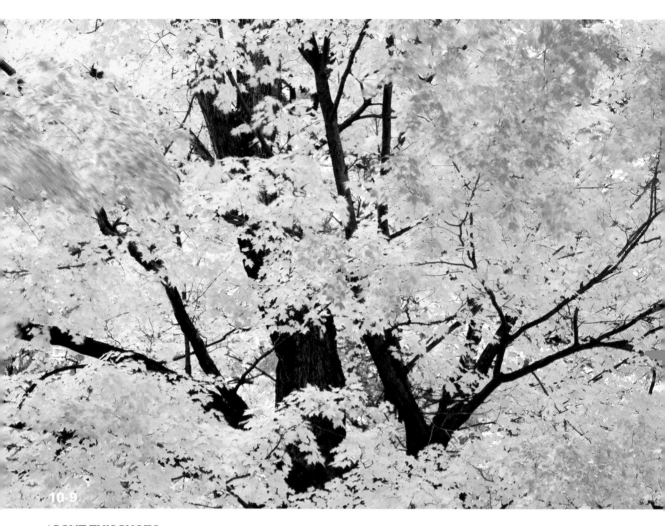

10-9

ABOUT THIS PHOTO *Filling the frame to the edges intensifies the colors of autumn foliage. Taken with an 80-200mm Nikkor zoom lens, shot at 1/4 sec., f/9 at ISO 200, on a tripod.*

With broader landscape shots, shooting early and late in the day lets you position the sun behind or to the side of the scene; this creates a "glowing" effect that really makes the colors pop out. The soft sidelight in Derek Doeffinger's shot of an upstate New York park (see 10-10) brings out both the colors and textures of the scene and causes the foliage to glow. After a rainstorm (see 10-11) is another good time to shoot because the wet leaves produce rich, saturated colors.

> *tip* If you are using a dSLR, a polarizing filter can be useful when photographing fall foliage because it removes some of the small surface reflections from the foliage, allowing their colors to become more saturated. To use the filter, just look through the viewfinder and rotate the filter until you see the effect that you're after.

ABOUT THIS PHOTO
*Sidelighting is particularly
effective with foliage.
Photographed with a dSLR
camera and a 17-35mm Nikkor
zoom lens. Exposed at 1/50 sec.,
f/7.1 with –2/3 exposure com-
pensation at ISO 320. ©Derek
Doeffinger.*

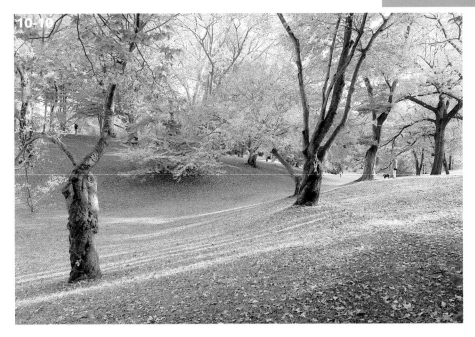

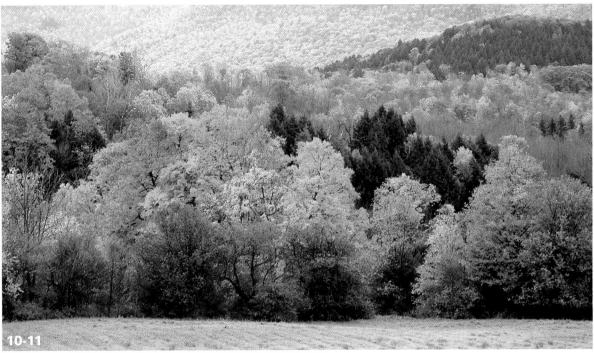

ABOUT THIS PHOTO *Rain gives and takes: It brings down fall leaves, but it also saturates the colors.
Photographed with an 18-70mm Nikkor zoom lens, exposed at 1/40 sec., f/13, ISO 200, on a tripod.*

SUNSETS AND SUNRISES

Sunsets and sunrises are almost like ice cream on a hot summer day—they're virtually impossible to resist and just as rejuvenating. There's something very soulful and mesmerizing (perhaps even somewhat *symbolic*) about all of that color and drama gathering in the sky at the beginning and end of each day. And the great thing is that, no matter where you are in the world, all you have to do to find the sunrise or sunset is to face the right direction at the right time of day. Because I'm not a morning person (the understatement of all time), I'll refer only to *sunsets* here, but if you are a very early riser, you can insert the word "sunrise" where appropriate.

When I was in high school and beginning to get seriously interested in photography, I had a powerful hankering (as John Wayne might say) to be out in the Wild West shooting scenic images of canyons and deserts and cowpokes (whatever they were) minding the range. Unfortunately, I was stuck in the suburbs in Connecticut, and the wildest scenery I had available was a nearby beach on Long Island Sound. A nice beach, but no Sonoran desert.

I soon discovered, however, that if I went to those beaches at the right time of day—sunrise or sunset—they would be magically transformed into splendid scenic settings. The wildness (or, in my case, tameness) of the location simply didn't matter. Over the years I've shot some great sunset photos in all sorts of locations (including the Sonoran desert), and no matter how many thousands of sunsets I've photographed, I've yet to tire of their beauty.

Waiting for great sunsets is a bit like treasure hunting. While some days and some places produce more outrageous sunsets than others, there is always the potential for a breathtaking sky to burst forth. I was literally packing up my tripod one heavily overcast Sunday afternoon when the sun suddenly broke through and created the surprising scene in figure 10-12.

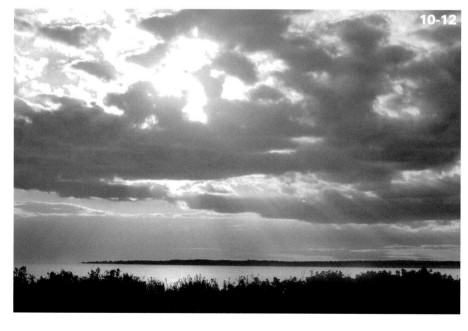

10-12

ABOUT THIS PHOTO
You can't always predict great sunsets; this one took me completely by surprise. Photographed with an 18-70mm Nikkor zoom lens, exposed at 1/640 sec., f/13 at ISO 200, on a tripod.

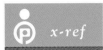

x-ref For more about the quality of light and shooting at extreme times of day, see Chapter 7.

Getting great photos of sunsets is relatively easy because nature has done a lot of the creative work for you, but with a little added thought and some attention to how you compose and expose them, you can transcend the "average" sunset photos to take very dramatic photos. Here are a few suggestions for creating dynamic sunset shots:

■ **Scout your locations long before sunset and know where the sun is going to set.** Wherever I go, I carry a small pocket compass with me so that I have a good idea of where the sun will set. Then, as the day wears on, I start to look for potential foregrounds—a harbor, a dead tree on top of a hill, or some fishermen on a jetty, as in figure 10-13. A shot of a fiery sky all by itself isn't half as exciting as a sailboat silhouetted in front of that sky. You

need to provide the viewer with something interesting to latch onto—preferably a subject that thematically complements the setting—a lone silo on a hilltop farm, for example. Think "simple" and you'll be on the right track.

Even in the sparsest of environments, I can usually find something to use as a foreground design element. While looking for a saguaro to silhouette in the Arizona desert one afternoon, I knew the sun was about to slip behind the horizon and I simply couldn't find a good shot. Then I noticed a stand of ocotillo whips nearby—a classic desert plant—and so I framed them in silhouette (see 10-14) just as the sun dipped behind a mountain.

■ **Meter away from the sun.** If you're including the sun or a particularly bright area of sky in your compositions, be sure to meter well away from it. The best place to meter from is in an area of average sky to the left or right of the

ABOUT THIS PHOTO
I sat on a cliff overlooking these fishermen and waited for just the right moment to shoot, watching the sky turn more and more orange. Taken with a 300mm Nikkor prime lens and exposed at 1/20 sec., f/7.4 at ISO 200, on a tripod.

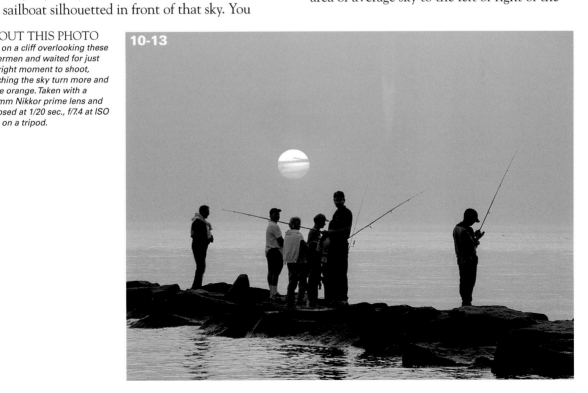

10-13

sun. If you include the sun in your composition when you're metering, you'll end up with a grossly underexposed shot where the sun may be bright, but everything else will be lost in blackness. Even when you're creating a silhouette, it's important to meter away from the sun. In the photo of the couple on the jetty (see 10-15), I metered the sky about

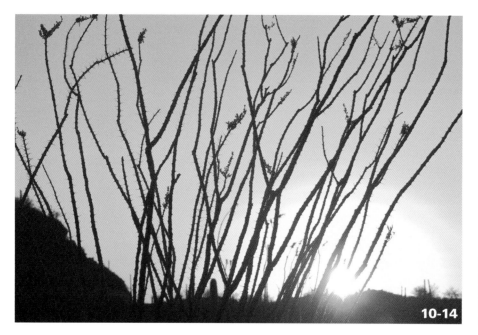

ABOUT THIS PHOTO
Finding interesting foregrounds is one of the challenges of sunset photography. Photographed with a 70-300mm Nikkor zoom lens, exposed at 1/320 sec., f/9 at ISO 200, on a tripod.

10-14

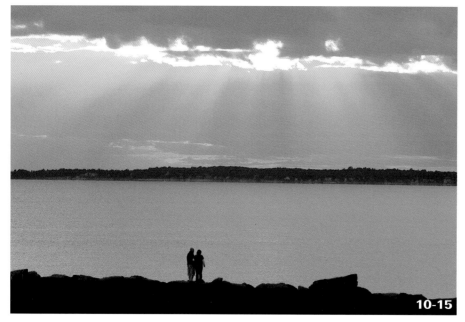

ABOUT THIS PHOTO
Take care where you meter in a scene, avoiding both dark and very bright areas. Taken with an 80-200mm Nikkor zoom lens, exposed at 1/250 sec., f/8 at ISO 200, on a tripod.

10-15

halfway between them and the sun. Had I metered the water behind them, the sky would have washed out, and had I metered a very bright area where the sun was coming through the clouds, the water would have gone far too dark to see the couple's shapes.

■ **Use the longest lens you have to exaggerate the size of the sun.** If you're trying to make the sun look really huge in the shot (see 10-16), use the longest lens that you have available. It's not always necessary to have a big sun and, in fact, sometimes it's nice to have no sun at all, but a long lens compresses the foreground into the sunset and also greatly magnifies the size of the sun.

 caution | To avoid damaging your eyes, never look directly at the sun though the lens—avert your eyes to the side of the frame.

■ **Hide the sun by placing it behind something opaque.** At times, the sun is just too overpowering for a scene, and the only thing you can do is to hide behind something that's visually strong enough to handle it—a tree, a building, or even a friend walking on the beach. Placing the sun behind your subject creates a silhouette, of course, but if you're using a very long lens, you can create an interesting "aura" around the subject, as I did in figure 10-17 using a saguaro cactus to hide the sun.

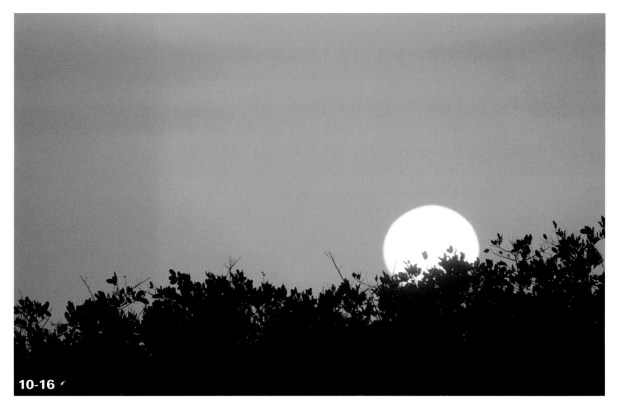

10-16

ABOUT THIS PHOTO *I used a whopping 400mm lens to create this exaggerated sun while shooting in a Florida marsh. Taken with a 400mm Nikkor prime lens, exposed at 1/320 sec., f/5.6 at ISO 200, on a Rue Groofwin Pod.*

10-17

■ **Bracket your exposures by a full stop or more.** One of the fun things about photographing sunsets, in terms of exposure, is that there is rarely a wrong or "bad" exposure. By adjusting the exposure, all you're usually doing is increasing (with underexposure) or decreasing (with overexposure) the saturation of the colors—and sometimes the results can be so different that you end up with several different frames of the same scene that you like equally. That's exactly what happened in the shot of the small abandoned dock. I shot a group of shots at what I thought was the best reading (see 10-18) and then decided to lighten the shot by overexposing it by two stops (see 10-19). Yes, I could just as easily have altered the exposure during editing, but it's a lot simpler to just bracket while shooting and save yourself some editing time.

10-18

10-19

Assignment

The Fun Assignment: Shoot a Sunrise or Sunset

For me, shooting sunrises and sunsets has always been as much relaxation therapy as photographic challenge—and I hope it will be the same thing for you. Your assignment for this chapter is to photograph a sunrise or a sunset with an interesting foreground. Use your imagination and your knowledge of your own area to find a shot that is both pretty and representative of where you live—such as photographing a local railroad bridge at sunrise or sunset over the city skyline. Find an interesting foreground subject and then silhouette it against the sky.

I took this photograph while on a weekend shooting trip to Galilee, Rhode Island. I had been wandering around the huge fishing boats all afternoon, and I knew that if I could position the sun behind the rigging of one of the boats, I'd have the shot I was after. The sun only barely broke out of the clouds, but because I had pre-scouted the exact view I wanted, I was able to fire off a dozen shots of the rigging, silhouetted against a pretty sunset sky. Taken with a 70-300mm Nikkor zoom lens at 1/80 sec., f/9, at ISO 200.

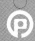
Remember to visit www.pwassignments.com after you complete this assignment and share your favorite photo! It's a community of enthusiastic photographers and a great place to view what other readers have created. You can also post comments, and read encouraging suggestions and feedback.

FLASH PHOTOGRAPHY

FLASH 101

FLASH MODES AND TECHNIQUES

ADVANCED TECHNIQUE: WIRELESS MULTIPLE FLASH

In 1931, a professor of electrical engineering at Massachusetts Institute of Technology named Harold E. Edgerton (affectionately nicknamed "Doc") invented a tool that would forever change the face of photography, art, science, and human vision. Edgerton's invention was the first repeatable short-duration light source — more popularly known as *electronic flash* — and it fired at incredibly brief durations as fast as one-millionth of a second (today's flashes, by comparison, fire at relatively slower speeds of from 1/1000 to 1/20,000 second). Photos made using this revolutionary lighting technology revealed secrets in the motion of high-speed subjects that had never been witnessed by human eyes before. One famous early photo from 1964 showed a bullet passing through a playing card, with the bullet frozen in midair. Other Edgerton photos captured the intricate nuance of a drop of milk splashing in a dish, a bullet piercing an apple, and a light bulb being smashed by a hammer (you can clearly see each fragment of glass as it explodes into space).

Prior to Edgerton's invention, photographers were forced to use continuous light sources to illuminate dark places or, later, flashbulbs that were good for exactly one exposure and were then tossed away (usually burning the photographer's fingers — including mine — on the way to the trash). Today, of course, Edgerton's invention is a part of every digital camera, and we rely on it without hesitation (or burnt fingers) to brighten even the darkest of places. The advantages of electronic flash are innumerable: Batteries aside, it's free once you own it, it can be used tens of thousands of times, and, just as important, the duration of its bursts are so brief that you can capture pictures of your children's smiling faces faster than they can turn their smiles into smirks.

Electronic flash, in fact, has many technical and creative uses that go beyond shining light into dark corners; these include lightening shadows in outdoor portraits, illuminating close-up subjects with enough light to supply good depth of field, and letting you use multiple units in a wireless array to light complex subjects such as sports, wildlife, and still-life pictures. For what Edgerton brought to photography and to life, we can never be grateful enough.

In this chapter, I explain the various flash tools that are available, why some are more useful than others, and the basic techniques of using flash. I also briefly introduce you to some of its more complex applications.

FLASH 101

There are basically two types of flash available for digital cameras: the flash that is built into almost all cameras (many professional-level dSLR cameras don't have a built-in flash), and more powerful and versatile accessory units that mount on top of the camera. Both types of flash have their uses and their advantages, and I use both on a regular basis. Accessory flashes are more powerful and more versatile, and I'll talk more about when it's time to think about owning an accessory flash unit later in the chapter. For many applications, though, your built-in flash is quite a handy tool because it lets you bring adequate light to any subject, regardless of how much light exists in the scene naturally.

TTL FLASH

Virtually all flash units (both built-in and accessory units) are designed to provide completely automatic TTL, or through-the-lens, exposure, and it's an extremely accurate system. As you will no doubt recall from Chapter 3, TTL exposure works by measuring the light at the plane of the sensor. That is exactly where and how flash exposure is measured, but with a slightly more

complicated technical scenario (one that fortunately happens without you having to do much of anything other than turning on the flash — and even that is often handled automatically).

Although there are some variations depending on which exposure mode you're using, when you take a flash exposure, the camera sets the lens aperture and shutter speed, based on the existing ambient light. When you press the shutter to take a picture, the camera then turns on the flash and measures the amount of flash as it bounces off the subject and hits the sensor plane. Once the camera detects that sufficient flash has reached the subject, the camera shuts off the flash. The amount of flash that hits your subject does not change in its intensity but rather in its duration. The longer the flash is allowed to remain on, the more light hits the subject.

tip Because a built-in electronic flash uses a TTL system that measures and controls flash based on the amount of light reaching the camera's sensor, it automatically compensates for light lost when your variable-aperture zoom lens shifts to a smaller aperture as you increase the focal length. The camera also compensates for light lost due to filters placed over the lens.

Because light travels at 186,000 miles per second, this whole complex on/off sequence happens in the literal blink of any eye. All flash exposures are extremely brief (usually measured in thousandths, if not tens-of-thousandths of a second), and the closer you get to your subject, the shorter that duration becomes. That is why even a basic flash unit can stop even the fastest of high-speed subjects (like a hummingbird in flight, as you'll see later in this chapter) in mid-motion.

x-ref For a refresher on how TTL light metering works, see Chapter 3.

BUILT-IN FLASH: ADVANTAGES AND DISADVANTAGES

The biggest advantages of using a built-in flash are that it's incredibly simple to use and that it's always ready. Also, most built-in flash units are very good at balancing the flash with the existing light. In the birthday party scene (see 11-1), for example, I needed the light of the flash to get enough illumination on the face, but I wanted it to have the ambient warmth of the candle light, and the auto-flash mode did a perfect job.

In most cases, your built-in flash turns on automatically when the camera decides there isn't enough light to take a picture with existing light, but there are other mode options, and I discuss those next. At the very least, the camera warns you of a low-light situation, and you have to push a button or use your menu system to initiate the flash. In any case, the exposure is entirely automatic and the camera does its best to balance ambient and flash light, both indoors and out.

There are other advantages with a built-in flash that are hard to ignore: There is nothing else to carry, you can take a burst of extra light with you wherever you take the camera, and, within a certain distance range, it provides all of the light that you need for most subjects. I used the built-in flash of my compact camera to take the photo of a breakfast room (see 11-2) in a hotel in Paris, for example, and it did a wonderful job of supplementing the existing light. Most built-in flash systems also provide a good assortment of flash modes (covered later in the chapter) that let you do everything from filling shadows in a daylight portrait to balancing the flash with ambient light at night.

The primary disadvantage of a built-in flash is that the shooting distance is fairly limited — usually within a range from about 3 to 5 feet minimum to 10 to 15 feet maximum. Once you go outside this range, you either overexpose the

ABOUT THIS PHOTO
Most built-in flash units do a good job of balancing the flash and the existing room light in low-light situations. Taken with a compact digital camera, exposed at 1/60 sec., f/3.5 at ISO 400, handheld.

ABOUT THIS PHOTO
Light-colored walls and fairly bright room lights helped to create nice, even lighting in this interior shot with a built-in flash. Shot with a compact digital camera and exposed at 1/30 sec., f/1.8, ISO 100, handheld.

images (if you're working inside the minimum distance range), or underexpose (if you're working beyond the maximum distance range). The distance range is usually more extensive with a dSLR than a compact camera, but your manual can provide you with the exact range.

Keep in mind that flash is only accurate for one subject distance (typically the best exposure is provided for the subject that your lens is focused on); subjects closer than that distance sometimes appear brighter, and those farther away appear darker. Usually the fall-off in light is fairly rapid, and so it's important to stay as close as possible to your flash unit's optimal distance range, as I did when photographing my cat Sailor deep in thought (see 11-3).

Perhaps the biggest disadvantage of a built-in flash is its location. Because the position of the flash is fixed on the front of the camera, the light is always coming at your subject directly from the camera position. This direct line-of-sight of the flash causes several problems: One is that it creates a phenomenon known as *red eye* that we're all familiar with, where portrait subjects appear to have a demonic-looking red glow in their eyes.

caution Using flash of any kind drains a lot of battery power. The more you use your flash, the faster your camera's batteries (with in-camera flash) or your accessory flash unit's batteries lose power. If you plan to do a lot of flash shooting, always carry a lot of extra batteries.

11-3

ABOUT THIS PHOTO *Staying within your built-in flash unit's distance range makes it easy to get perfectly exposed pictures. Taken with a 70-300mm Nikkor zoom lens and exposed for 1/60 sec., f/4.5 at ISO 200, handheld in auto-flash mode.*

(There is a red-eye reduction mode built into most flash units and I discuss that later in this chapter.) But a larger problem is that the lighting from direct flash is usually very harsh, very contrasty, and totally unnatural-looking. Also, because the flash is going straight out from the camera, it bounces back from any reflective surface such as windows.

ACCESSORY FLASH

If you do enough flash photography in enough different types of situations, you soon realize that your built-in flash has serious creative limitations — particularly if you're shooting more demanding subjects like formal portraits, close-ups of flowers, and any type of wildlife photography that requires (or would benefit from) a flash. Eventually you may look at your flash photos and, while admiring the benefits the extra light adds to your work, you'll come to disdain the look and limitations of such a basic flash. When that day arrives (and it might never arrive if you're not demanding of your flash's versatility), you'll know that it's time to investigate owning an accessory flash unit.

Accessory flash units are available for many advanced zoom and virtually all dSLR cameras. They can be attached to the camera through one of three methods: using a *hot shoe* (a small mounting shoe on top of the camera that has direct electronic communications with the camera); using a *flash bracket* that typically attaches to the camera via the tripod mount; or using a *sync cord*. If you're using a bracket attachment, you still need to use a sync cord, one end of which inserts into the flash and the other into the camera body. This cord provides the communication link that is provided by the shoe in the hot shoe configuration.

Mounting the flash to your camera via a hot shoe is probably the more common (and simpler) method, but it has some limitations. Even though shoe-mount flash units have some directional flexibility, they have somewhat less flexibility than bracket-mounted flash units that, because they are free from the camera body, can be aimed in almost any direction. Also, because bracket-mounted flash units are farther away from the lens axis, they can provide a more naturally angled light — aiming down on the subject from a foot or two above, for example. On the other hand, the bracket is one more thing that you have to buy, carry, and set up. Wedding and location portrait photographers who need the added power and flexibility frequently opt for a bracket-mounted flash.

The third option is to handhold the flash and connect it to the camera using only a sync cord. The advantage of a sync cord is that you can hold the flash in any position you want and are not constrained by a bracket. In figure 11-4, for example, I used a cord to hold the flash above and to the left of the night-flowering *Cereus* blossom. Sync cords are inexpensive (photographically speaking, at least) and available in almost any length you want, and the only disadvantage of using one (other than losing them, and I've lost a few dozen) is that you need a third hand (or an assistant) to operate the camera and the flash.

ACCESSORY FLASH ADVANTAGES

There are two primary advantages to owning an accessory flash unit: power and flexibility. Power has to do with the actual strength of the light from a flash and flexibility includes factors, such as the tilt, swivel, and zoom capabilities of a flash.

■ **Power.** While your built-in flash may have a maximum distance range of, say, 15 feet, it's not uncommon for an accessory unit to have

ABOUT THIS PHOTO *A sync cord lets you position the flash wherever you need it to get the best lighting effect. Taken with a 24-120mm Nikkor zoom lens using a Nikon SB800 flash and exposed at 1/30 sec., f/5.6 at ISO 200, on a tripod.*

11-4

a range of 20 to 40 feet (the actual distance depends on the ISO speed you're using and the focal length of the lens). You might think that being able to light a subject 40 feet away is overkill, but when you're using a technique like *bounce flash* (aiming the flash at a wall or ceiling to soften the light that hits your subject), you're not just measuring the distance from the flash to the subject; you are measuring the distance from the flash to the reflecting surface (a wall or ceiling, for example) and then to the subject — and that is where power is not only useful but necessary.

Power in an accessory flash unit is measured in terms of its *guide number*: The higher the guide number, the more power the flash offers. Guide numbers, which are explained later in the chapter, are very important if you're doing a lot of manual calculations for flash exposure, but all you really need to know at a basic level is that bigger is better. Don't buy a flash based on a high guide number alone, but don't discount its importance.

■ **Flexibility.** Many accessory flash units have both tilting and swiveling heads, which means that you can aim the light (to bounce

it off of a ceiling or wall, for example) rather that just aiming it directly at your subject. The benefit of bouncing a flash is that you get a much softer light. If you aim the light at a white ceiling, for example, you are using the white area of the ceiling as a reflector, which creates a broader and much softer illumination.

The swivel feature adds further flexibility by enabling you to not only tilt the vertical angle of the flash, but to rotate it side-to-side, as well. When used in tandem, the tilt/swivel motions allow you to aim the flash in virtually any direction and provide a great deal of flexibility in the bounce-angle of the flash.

Many advanced flash units also have a zoom head, which lets the flash automatically match the spread of the light of the flash output to the focal length of the lens in use. If you are using a dSLR with a 24-135mm lens, for example, the flash adjusts the angle of its illumination to match the viewing angle of the lens. This is important because flash power decreases rapidly as it covers wide areas, and so if you're shooting with a much narrower angle of view (as with a moderate telephoto lens), there is no point in wasting flash power by covering the wider view. The ability of the flash's output to match the lens' focal length saves you battery power and increases your shooting distance dramatically.

ACCESSORY FLASH DISADVANTAGES

With so many advantages, what then are the disadvantages of using an accessory flash? Cost is one factor. A high quality dedicated flash unit will probably cost in the range of a few hundred dollars or more. If you do a lot of flash photography (family gatherings, weddings, parties) it's probably a worthwhile investment. Most

manufacturers make dedicated flash models for a particular camera in a variety of price ranges (flash power is usually the main difference), so be sure to check all of the available models. Also, third-party manufacturers are usually somewhat less expensive.

Weight and camera-bag space are other (though I think minor) concerns. While a flash unit doesn't weigh more than a few ounces, it does require batteries (generally four AA batteries) and that adds more weight to your camera bag. Also, flash batteries are one more thing that needs to be charged — so that's an extra chore. And, of course, a big flash sitting on top of your camera can sometimes be intimidating to your subjects and has a tendency to make situations seem a bit more formal. Still, the advantages of more power, greater distance, and better lighting quality far outweigh the disadvantages.

DEDICATED FLASH

While most camera manufacturers make a full line of accessory flash units designed to work with specific models of camera, there are also several third-party flash manufacturers (Metz and Sunpak are two of the better-known brands) that offer *dedicated* flash units that are designed to communicate fluently with a specific brand and model of camera. Dedicated flash units use a sophisticated series of electronic connections to carry on a continuous conversation with the camera body regarding camera and lens settings. As you change the ISO or the lens aperture, for example, the flash instantaneously makes adjustments in its power settings. If you switch to a lower ISO or a smaller aperture (both of which would call for more light), the flash will automatically adjust its output to create a good exposure. In addition, if you are working in a fill-in flash mode (where the flash provides just enough light to fill shadows in a portrait, for example), the

flash and the camera's metering and exposure system compare notes to provide the best combination of flash and ambient-light exposure.

The exchange of information between camera body and flash unit is so complex that the flash knows what lens you're using and what ISO your camera is set to the instant that you mount the flash and turn it on — eliminating the tedious chore of transferring this information from camera to flash that photographers had to perform with pre-dedicated units.

A MINI PRIMER ON FLASH GUIDE NUMBERS

All flash units, whether built-in or accessory, are assigned a guide number by their manufacturer and this number is the indicator of their relative power. The higher the guide number is, the more powerful the unit and the greater the distances you can cover with the flash with any given lens and aperture combination. You'll find the guide number for your flash in either your camera or flash manual. Although the advent of TTL flash units and TTL metering have reduced our reliance on guide numbers somewhat, they are still quite useful — particularly if you're working with a non-dedicated flash unit (one that wasn't designed for your camera).

Accessory flash units have substantially higher power than built-in units and therefore higher

guide numbers. For example, the built-in flash of my Nikon dSLR has a guide number of 36 (at ISO 100), but the maximum guide number of my Nikon SB800 accessory flash is 185 (also at ISO 100). What practical difference does this make? The primary advantages of having a higher guide number are that you can use smaller apertures (more depth of field) and/or work at greater distances. My built-in flash has a maximum range of about 9 feet at f/4 at ISO 100, for example, while my accessory unit would let me shoot at (roughly) a whopping 46 feet at the same aperture and ISO.

Guide numbers are usually stated in both meters and feet (in that order) and are typically stated for use at ISO 100. Also, because some flash units have a zoom head that matches the focal lengths of certain lenses, you often see the guide numbers for a certain flash unit stated as a range. For example, the guide numbers for my Nikon SB800 flash are listed as follows:

Guide Number (ISO 100, m/ft.): 38/125 (at 35mm) to 56/184 (at 105mm)

In other words, the guide number with a 35mm focal-length lens is 125 at ISO 100. The guide number increases to 184 when the lens focal length increases to 105mm. The reason the guide number increases as the focal length of the lens gets longer is because the flash has to cover a much narrower angle of view and so less light is wasted.

Among the very useful bits of information you can ascertain using the guide number includes knowing what f-stop to use for a good exposure if you know the distance to your subject. All that you have to do is divide the guide number by the distance and you'll have the correct lens setting. For example, if the guide number is 160 and your subject is 10 feet away, just divide 160 by 10 and the aperture for a good exposure is f/16.

> **note** Although the flash power does not change with built-in or accessory flash units in their normal modes, some accessory units have the capability to adjust the power or intensity of the light. If you adjust the power output of the flash, then the intensity of the flash does change. Read your manual to find out more about your flash unit's power adjustments.

You can also use the guide number to figure the maximum distance by simply dividing the guide number by your maximum available aperture. If your widest aperture (it lets in the most light) is f/4, for example, and your flash has a guide number of 80, you can be 20 feet away from your subject and get a good exposure. Again, in the days before TTL flash exposure, understanding how to apply these calculations was invaluable.

Because the guide numbers are usually stated for ISO, you have to modify your calculations if you increase (or decrease) the ISO you're using. The distance range your flash covers increases (by a factor of 1.44x) each time you double the ISO. So if you're using a flash that offers a maximum distance of say, 20 feet, at ISO 100, you can increase the range to 28.8 feet (20 × 1.44) by doubling the ISO to 200. (Is your head swimming yet?) The practical value of knowing this is that if your flash just isn't powerful enough to reach a subject (a wild animal attacks your poor Aunt Sally, for example, and you'd like to step back a bit before you capture the moment) at ISO 100, just increase the ISO until you find the distance you need.

The flash range doubles every time you multiply the ISO by a factor of four — in other words, going from ISO 100 to 400 doubles the useful range of your flash. So if Aunt Sally and the beast are 10 feet away at ISO 100 and that's your maximum distance for a good exposure, but you'd like to get to 20 feet for safety, just multiply the ISO by a factor of four. At ISO 400 you can sit in the car 20 feet away and capture Sally's valiant battle, perfectly exposed.

BOUNCE FLASH

While flash is a great tool when it comes to supplying a big burst of light in dimly lit situations, the quality of light from direct flash is very often harsh and unforgiving. Rather than shaping or flattering your subjects with a soft caressing light, it blasts them head on with an intense but very flat light. Direct flash is particularly unattractive when it comes to individual or group portraits because rather than capturing the intimacy or character of the existing light, it replaces the ambient light with a flat two-dimensional front lighting. One way to soften the light of flash and create a more attractive lighting with portraits or still life shots is to bounce the light from a nearby surface — usually the ceiling or a nearby wall. This technique works because the larger a light source is the softer the light is, so bouncing the flash off a large surface softens the light. Also, because the light is coming from above (or from the side) it creates a gentle shaping or modeling to faces (or still life subjects) that is not there with direct flash.

Using bounce flash is very simple if you're using a TTL flash/camera combination because the flash remains on until the camera tells it that there is enough light for a good exposure. In the days before TTL flash using bounce flash required a bit of quick mathematics involving flash to subject distance, ISO speed, and the flash guide numbers. Thankfully TTL technology has eliminated all of those calculations and made using bounce flash as simple as using direct flash.

There are, however, some things to be careful of with bounce flash. It's important, for example, to use a white bounce surface because the flash picks up the color tint of a colored wall or ceiling. Also, the flash has to travel a much farther distance since it first has to travel to the bounce surface and then from that surface to the subject — and that added distance requires a lot more flash power so batteries run down much faster if you're doing a lot of bounce flash. If, for example, your subjects are 10 feet away, using direct flash would mean that the flash only has to travel 10 feet. But

if you're bouncing off the ceiling, you have to consider the distance from the flash to the ceiling and then add in the distance from the ceiling to the subject — which quite often dramatically increases the distance.

When using bounce flash, whether you're bouncing from a side wall or the ceiling, you also have to be careful to set the angle of the flash head carefully so that the beam of light from the flash is falling precisely on the front of your subjects and not landing in front of or behind them. You'll get a feel for setting this angle with experience, but in the beginning it's best to take a few test shots so that you can see where the light is falling. Pay attention also to shadows created by the flash. When you're bouncing from a ceiling, the shadow naturally falls behind the subjects (particularly in a portrait) and is usually hidden by the subjects. If, however, you're bouncing from a nearby wall, the flash may create distracting shadows (from noses, for example) going from one side of the subject to the other. You can usually moderate the shadows by slightly altering the bounce angle, but it's something to keep an eye on.

BOUNCE REFLECTORS

What do you do when there isn't a good bounce surface or when the ceilings or walls are too far away to be practical? The simplest solution is to use a portable bounce reflector or diffuser such as those offered by LumiQuest, shown in 11-5. These reflectors come in a variety of different styles, some that you bounce the flash into and others that you shoot through to soften the light. When it comes to diffusion devices, there are two basic styles: One type is designed for accessory flash and they mount to the flash unit and the

11-5

ABOUT THIS PHOTO *LumiQuest's newest product, the Soft Screen. This diffuser is designed for the built-in pop-up flash of many digital cameras. ©LumiQuest.*

others are designed to soften the light of built-in flash units and mount directly on the cameras (and are positioned over the flash).

While bounce reflectors and accessory diffusers generally don't create the same soft light as a ceiling might, they are far more predictable and offer far more precise control — on top of which, they entirely eliminate the need to find an existing bounce surface. Even more importantly, because the flash and the bounce surface are so close to one another, far less illumination is wasted and so you can work at substantial distances and still get strong illumination — and without draining batteries so quickly. These accessories are very inexpensive and fit into a camera bag or jacket pocket and are well worth owning.

FLASH MODES AND TECHNIQUES

As you no doubt know if you have read your camera manual (and flash manual if you're using an accessory flash), this is not your father's Oldsmobile you're driving. Between the exposure modes built into your camera and those built into accessory flash units, there are enough flash options to keep your eyes spinning for hours. The trick to understanding and taking advantage of all these flash-exposure methods is to take them one at a time as you need them. Learn one method, and then move on to another. If you try to understand all of the possible combinations at once, your friends will find you sitting in a corner weeping.

Using a built-in flash in various modes is very simple because all that you have to do is to set the camera (to a night portrait setting or for red eye reduction, for example), and the camera takes care of both the ambient and flash settings. You don't have to do a thing other than set the mode. When you're using an accessory flash, you have to first set the camera to the exposure mode you want and then set the flash to a mode that understands what the camera wants. It's actually very straightforward, and the communication between camera and flash happens instantaneously — provided you're using a dedicated flash unit that is programmed to be used with your specific camera. Always buy a flash that is dedicated to your camera — ask your dealer about this.

The following sections are a handful of the most common flash modes. Your camera may have fewer (or more) modes and they may have slightly different names, but they do essentially the same thing.

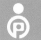

note Some electronic flash modes — such as red-eye reduction — only work in specific camera exposure modes. Check your camera manual to be sure the flash mode that you want to use is available in the specific exposure mode that you have set. Also, with some cameras, your accessory flash may not work if the built-in flash is in the raised ("on") position.

FILL-IN FLASH

Use this mode to fill in dark shadows outdoors. Portraits taken outdoors often have very distracting shadows in the eye sockets and under the chin and nose, and the only way to eliminate them is with some type of fill lighting. You could use a reflector (a piece of white board or a small commercially-made reflector will do), but using your fill-in flash mode is much simpler. In this mode the camera automatically creates a natural-looking balance between the available sunlight and the flash. Ideally you want the sunlight to be a bit brighter than the flash, so that the flash is only affecting the shadow areas. Fill is particularly helpful with top-lighted or backlit subjects. In this strongly backlit portrait of two sisters (see 11-6), for example, I used the built-in flash in my dSLR to open up the shadows and reduce the contrast.

Most cameras call this mode *fill-in* flash, but with others you may have to use what is called the forced or flash-on mode that tells the camera you want the flash to fire, even though there is sufficient ambient light. In either case, the camera produces a good balance between flash and existing light. The ideal goal of fill-in flash is to provide a flash exposure that is slightly less bright than the existing or ambient light exposure so that the picture has a natural look. Using too much flash can create an artificial feel to an image that makes the flash seem to overpower the daylight in an unnatural way.

ABOUT THIS PHOTO *Fill-in flash rescued this backlit portrait nicely. Without the flash, the faces would have been largely in shadow. Taken with an 18-70mm Nikkor zoom lens and exposed at 1/320 sec., f/4.5 at ISO 200, handheld.*

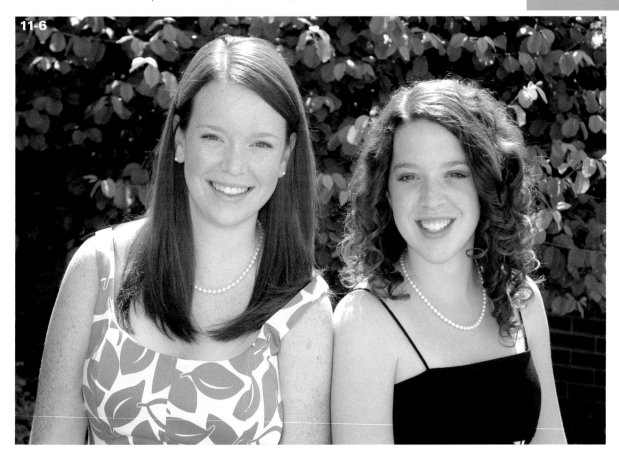

11-6

If you find that your camera and flash combination is providing too much flash, you may want to try to back off the flash exposure by a stop or so. Some accessory flash units have an exposure-compensation feature that lets you reduce the flash power by a specified amount (as with your camera's exposure compensation, it's typically adjustable in one-third stop increments). Often just reducing flash by a third or two-thirds stops is enough to create a more pleasing and natural-looking balance.

One issue that you may also face with some cameras, particularly in very bright light, is that the camera may not have a fast enough sync speed to get a good daylight exposure and still synchronize with the flash. All flash units (built-in units and accessory flash units) are designed to fire at very specific shutter speeds called sync speeds. When the camera is set to the proper sync speed the shutter opens and then the flash fires before the shutter closes again. If the flash were to fire too early or too late the shutter would cut off all or part of the flash exposure. Because many cameras are limited to a sync speed (typically 1/125 or 1/250 second) that is slower than the camera's maximum shutter speeds, the camera may not be able to find a shutter speed and aperture combination that is capable of exposing the existing light properly (again, this is usually only a problem in extremely bright situations) and firing the flash in sync. Your camera manual should explain the top sync speeds and how fill-in flash is handled in bright situations.

In situations where the light is particularly low and where your subject may be moving (photographing wildlife or sports in dim light, for example), you may run into a problem where the camera's shutter speed is substantially slower than the flash duration. If the camera's shutter is firing at 1/125 second and the flash is firing at 1/1000 second, for example, then the flash — and not the shutter — is stopping the action. When this happens, you may experience a phenomenon called *ghosting* where the image frozen by the flash's brief duration seems to be creating a secondary image that appears to be laid over the more dim background image. Sometimes the effect can be interesting and photographers will often take advantage of the somewhat surreal appearance of images created this way, but it is almost always noticeable.

> **note** One of the advantages of having higher flash-sync speeds available is that they provide you with more control and flexibility over depth of field. Being able to use a higher sync speed, for example, enables you to use a wider aperture to limit depth of field.

FLASH-FILL COLOR BALANCE

Electronic flash has a color temperature that is designed to be roughly the equivalent of daylight, or about 5500 to 6000K. Because the flash fires at a consistent color temperature and daylight color temperature is constantly changing, color balance is another issue that comes up in both fill-in flash and overall flash exposures. In certain situations, for example, the flash may appear noticeably more blue or orange than the existing light. In very blue daylight situations (at twilight or in deep shade,

for example) the existing light will probably have a considerably cooler color balance than the flash and so you may want to consider filtering the flash head with colored gels in order to balance the color of the two light sources. If you were to use the flash unfiltered you would probably end up with a cool ambient or background light and a flash fill that is warmer in tone.

> **note** In terms of lighting color, light that is more orange or reddish in color is referred to as having a warm color balance and light that is more blue is considered cooler. It might help to remember that tungsten light, which has an orange cast, has a color temperature of about 3200K, while daylight, which is more blue in color, has a color temperature of about 5500K.

You will occasionally run into the opposite problem when you're working in a room where the predominant light is tungsten (which is much warmer in tone than the cooler daylight-balanced flash unit). In that situation you might want to use a warming filter over the flash head so that the light from the flash more closely matches the tungsten color balance and is not detectable. Most flash manufacturers sell filter sets specifically for this purpose. Color balance usually isn't too much of an issue if the flash is the dominant light source, but it is something to keep an eye on.

> **note** If you are using a dSLR camera with older lenses — particularly manual focus lenses — some flash operations or modes may not be possible because of a lack of communication between the older lenses and the camera's electronics.

NIGHT SCENES OR NIGHT SCENES/PORTRAIT MODE

Use this mode to take outdoor flash portraits against the bright lights of a city or when you just want to light up a nearby subject against a twilight sky. In this mode, the flash fires to illuminate your main subject but the shutter stays open long enough to record the existing light. In figure 11-7, for example, I was out hiking in the desert at twilight and there simply wasn't enough daylight left to photograph the giant saguaros that I was hiking through. So I put my dSLR into the night-portrait mode, and while the flash illuminated the saguaro, the shutter stayed open long enough to register some light from the sky. I love the somewhat eerie combination of the very blue twilight and the flash-illuminated cacti. Look carefully and you'll notice a shadow around the arms of the saguaro, caused by slight camera movement between the flash and ambient exposures.

You can also have some creative fun in this mode by jiggling or panning the camera during the long exposure to make the background lights blur, and then let the burst of flash freeze the key subject. This is the trick I used in figure 11-8 to get a relatively sharp image of the Christmas ornament framed by streaks of colored lights.

In most night-scene modes, the flash fires at the beginning of the exposure (called *front-curtain sync*) and then the shutter remains open long enough to capture the ambient light. Some cameras also provide what is called *rear-curtain sync*, in which the flash fires at the end of the exposure. If you are photographing a moving subject, such as a car with headlights on, and you want the streaks of light to follow the car (as they would in a normal non-flash time exposure), then use rear-curtain sync. If you use front-curtain sync, because the flash fires first, you will see light trails *in front of* the moving subject, which looks unrealistic.

ABOUT THIS PHOTO
Shot outside of Tucson about 20 minutes or so after sunset using the night portrait flash mode. Taken with a 70-300mm Nikkor zoom lens, and exposed at 1 sec., f/5.6 at ISO 1600, handheld.

11-7

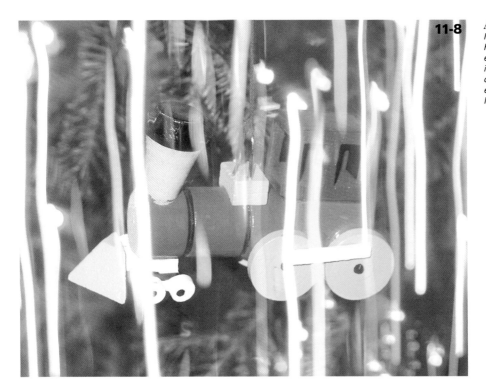

11-8

CLOSE-UP MODE

Many cameras have a close-up flash exposure mode that automatically fires the flash. While this may not be listed in some cameras as a "flash" mode per se, it really is one because if you set the exposure mode to close-up, it fires the flash whether you want it to or not. In many cases, using flash with a close-up subject is a good idea because the high magnification and close focusing often requires extra light for a good exposure. In photographing the tiny blossoms on a bleeding heart plant in my garden (see 11-9 and 11-10) I used the close-up exposure mode with my dSLR, which caused the flash to fire in the fully automatic mode.

If your camera doesn't turn on the flash and you still want to use the flash in close-up mode, you can simply put the camera in the close-up exposure mode and then put the flash into the forced or always-on mode; the flash fires and exposure is set automatically to give you a good flash exposure.

ABOUT THESE PHOTOS *I used a black background behind these bleeding heart plants to be sure that nothing would detract from the interesting and delicate flowers. In a situation like this, using a flash often provides the small aperture that you need to get maximum depth of field. Both were shot with a 105mm Nikkor prime lens and exposed for 1/125 sec., f/10 at ISO 200, in the close-up mode, using the built-in flash, on a tripod.*

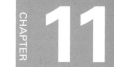

CHAPTER **11**

11-9

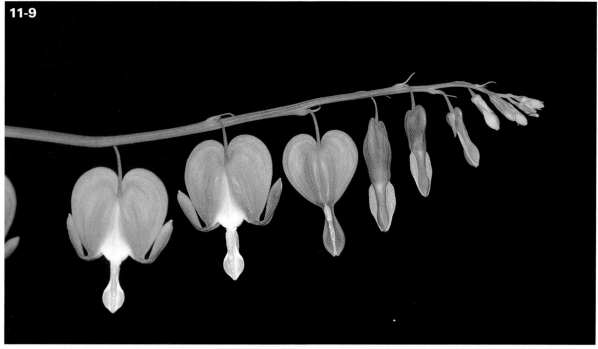

11-10

RED-EYE REDUCTION MODE

Use this mode to avoid getting "red eye" with portrait subjects. Red eye is caused when the light from the flash reflects off the back of the retinal surface in the eyes and creates red pupils in your subjects' eyes — a nice ghoulish Halloween look, but not too flattering most of the time. Most digital cameras have a red-eye reduction flash mode that prevents this. The feature works by firing a series of rapid pre-flashes that cause your subject's pupils to contract, thereby preventing the reflection. I photographed my friend and Connecticut radio personality Nick Jacobs doing his radio show by using the red-eye reduction mode (see 11-11). The only problem with using this mode is that the pre-flash takes a second or two to complete, and I find this sometimes detracts from the spontaneity of the moment. Often you can avoid red eye using other less invasive methods, like having your subject turn away slightly, as I did in figure 11-12.

FLASH OFF

Yes, on almost all cameras, you can shut the flash off. There may be times when you absolutely don't want the flash firing (shooting neon signs on the Las Vegas Strip, for example), and it's nice to be able to turn it off.

ADVANCED TECHNIQUE: WIRELESS MULTIPLE FLASH

One of the most intriguing advances in flash photography in recent years has been the introduction of truly wireless flash technology. Wireless flash lets you fire one or more remote flash units simultaneously with your on-camera flash (built-in or accessory). Professionals have long used remote multiple-flash systems to photograph subjects like sporting events and wildlife, but often had to rely on either hard-wired flash units (can you imagine stringing flash cables to the roof of

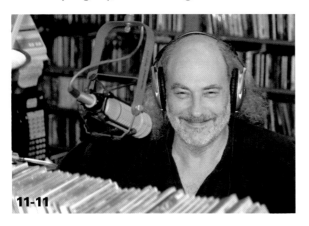

11-11

11-12

ABOUT THESE PHOTOS *Using the red-eye reduction mode is sometimes annoying because the pre-flashing delays the firing of the shutter for an instant, but it's worthwhile anyway because it saves you time in removing red eye in editing. Both photographed with an 18-70mm Nikkor zoom lens and exposed at 1/60 sec., f/4 at ISO 200, using the red-eye reduction flash mode, handheld.*

Madison Square Garden to photograph a basket-ball game?) or expensive and complex wireless transmitters.

Today many dSLR camera systems offer a much more simplified and somewhat less complicated method of firing extra flash units without any wires. These wireless photo systems use either a beam of light from the main (camera-mounted) flash unit or radio signals to fire additional acces-sory units without being connected to the camera in any way. You can also buy separate transmitters and receivers to do this if your camera lacks the technology. Yes, it's expensive and there is a learning curve, but if you have a passion for pho-tographing something that would benefit from using multiple flash heads, it's nice to know the technology exists and is accessible to the average photographer (not that you're average in any way, of course).

The exact number of flash units that you can fire simultaneously depends both on the type of wire-less system you're using and, probably to a larger degree, your budget. In practical terms, however, you would probably not use more than three or four remote units at a time because once you get beyond this number not only does the lighting itself get increasingly complicated, but you begin to run the risk of flash units spilling some of their light directly into the camera lens, rather than hitting the subject. If you were photographing a close-up of a mushroom in the woods, for exam-ple, you would probably use the on-camera flash to provide the overall illumination and then arrange the remote units to give the subject tex-ture and form.

Some wireless remote systems (like the one used by the Nikon Speedlight system) allow you to arrange groups or clusters of flash units and con-trol each group separately using separate commu-nication channels. In this way you can use one group of flash units to perform different tasks: using one group as the main light, for example, and another as fill light to balance the illumina-tion in the scene. By being able to control each group separately from the camera, once you place the flash units around the subject, you can adjust their power from the camera position.

Portrait photographers use wireless flash systems a lot for the obvious reason that it eliminates the need to run wires through a set. In the pre-wire-less days photographers had to be vigilant that not only would their subjects not trip over flash wires, but that they didn't show up in the photographs. Wireless flash alleviates both of these concerns. And again, by being able to adjust the flash power of various units from behind the camera, you can save a lot of time (not to mention energy) walk-ing from flash to flash to adjust settings.

The real advantage of using multiple flash units, however, is that you can create realistic lighting with a distant subject — like sporting events or wildlife. If you're photographing a deer drinking from a known watering spot, for example, you can hide one or more flash units in a tree near the edge of the stream to get enough light on the deer, but you can be shooting from a remote dis-tance so that you aren't scaring your subject. As long as you are within the range of the remote flash units, they fire precisely when you trip the shutter on your camera.

One of my former students, Tom Callahan, has taken on an ambitious project of photographing Anna's Hummingbirds in flight in his backyard in Arizona. In the relatively short time that Tom has been photographing these incredibly beautiful (not to mention small and fast) subjects, Tom's shooting scenario has grown from using a single on-camera flash to as many as four wireless flash units controlled by a separate transmitter. After considerable experimenting with flash placement, he has arranged his wireless flash units near a fountain where the hummingbirds are known to come looking for a cool drink. His results are amazing (see 11-13, 11-14, and 11-15).

11-13

ABOUT THESE PHOTOS *Wireless flash is an extremely convenient way to arrange multiple flash units for photographing subjects such as wildlife and birds. Tom Callahan used a series of four remote flashes, controlled by a master transmitter on his camera to shoot these hummingbirds in flight and playing in a fountain. Figure 11-13 was exposed for 1/250 sec. at f/10 using a 170-500mm Sigma lens, figure 11-14 at 1/250 sec. at f/8 with a 400mm Canon lens, figure 11-15 at 1/250 sec. at f/8 with a 400mm Canon lens — all at ISO 100. ©Tom Callahan.*

11-14

11-15

While waiting for his desired subjects to show up (one of the toughest parts of any wildlife photography), he has also been able to photograph other birds such as the Western Lesser Goldfinches in 11-16 using the same wireless flash setup.

Using multiple remote flash units is somewhat complex in terms of learning where to place the flash units and how far they need to be from your subjects for maximum effect, but the technology is beginning to make the process simpler. Flash placement, as well as power settings, is largely a matter of experimenting and keeping copious notes. You will have greater success and probably understand the process better if you start with just one or two remote flash units and then if necessary, build out your setup from there. It's a great idea to find other photographers in your area who are already using multiple flash setups and talk to them about their experiences. In Tom's case, he educated himself through more than a year of trial and error. By reading books and asking questions of other photographers — and with a lot of experimentation — Tom has managed to capture world-class professional images of his backyard friends. (Of course, every time I hear from him, he's invested in yet another flash unit, so be prepared once you go down this road to explain your expensive hobby to your family.)

I've chosen to end the last chapter of this book with these photos because I want you to see what you can achieve with an intense desire to accomplish something that is uniquely your own with a moderate investment of time, materials, and experimentation.

11-16

ABOUT THIS PHOTO *You have to seize opportunities when they arise. While waiting for hummingbirds to visit his fountain (and multiple-flash setup) the photographer was able to capture these goldfinches. Photographed with four remote flash units and exposed with a 400mm Canon lens for 1/200 sec., f/8, at ISO 200. ©Tom Callahan.*

Assignment

Take a Nighttime Portrait with a Flash

Taking pictures of your family and friends in daylight is easy. Taking great shots of them outdoors at night is a more interesting challenge. But that's what I'd like you to do for this assignment: Grab your camera (and your accessory flash, if you own one) and a willing human subject, and head outside after sunset. Take a portrait that balances the flash and the existing light. Be sure to study your camera and flash manuals the night before.

I shot this photo of a street performer in Paris early one evening after watching him perform his wonderful clown-like routines for more than an hour. The sun set during his performance and the only light remaining was that in the twilight sky behind him, so I turned on the built-in flash and motioned to him to pose briefly. It took me literally seconds to compose and shoot the scene and then he drifted back into the evening. A great moment for me, and I like the photo a great deal. Taken with an 18-70mm Nikkor zoom lens and exposed for 1/60 sec. at f/4, ISO 200, handheld, using on-camera flash.

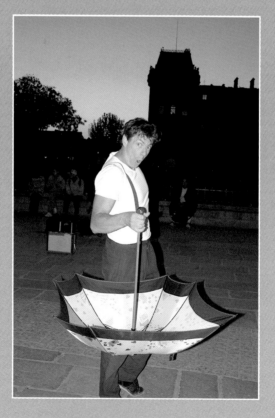

Remember to visit www.pwassignments.com after you complete this assignment and share your favorite photo! It's a community of enthusiastic photographers and a great place to view what other readers have created. You can also post comments, and read encouraging suggestions and feedback.

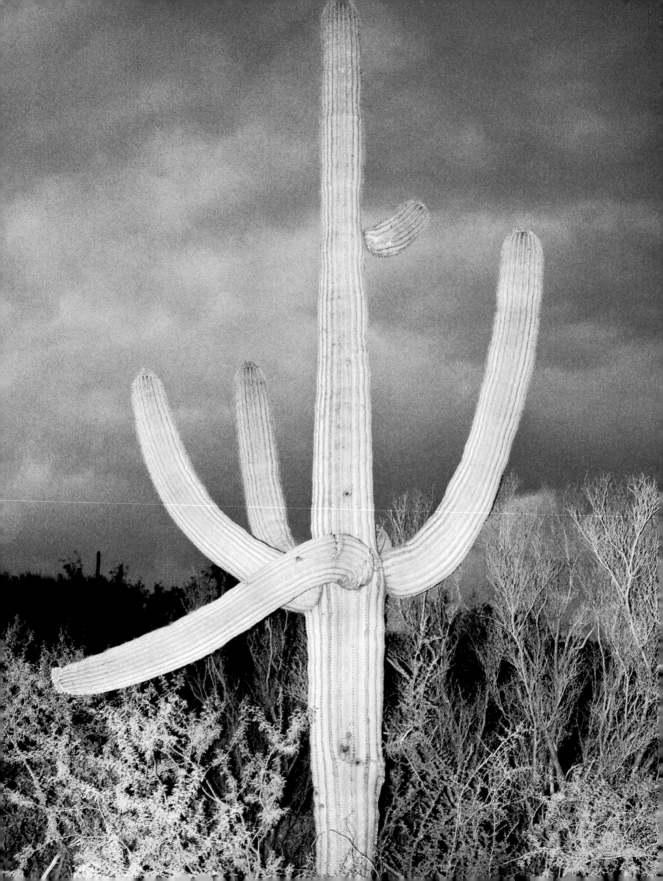

GLOSSARY

accessory flash Any flash unit that is separate from the camera itself, but that can be attached (via direct connection or wirelessly) to the camera.

ambient light The light, natural or artificial, that already exists in the scene. Often referred to as existing or available light.

aperture The opening, usually but not always circular, in the lens that controls how much light passes through the lens to the sensor. Lens aperture size is controlled by the f-stop setting and the smaller the number (f/2, for example), the larger the opening; the larger the number (f/16) the smaller the opening. The aperture, along with the shutter speed, are the two controls that regulate the light entering the camera.

angle of view The scope, described in degrees, horizontally and vertically of what a lens sees. Wide-angle lenses, for example, have a broad angle of view.

Aperture Priority mode An exposure mode that lets you set the lens aperture (f-stop). The camera chooses the correct corresponding shutter speed.

Auto exposure mode In this exposure mode the camera chooses both the aperture and shutter speed settings and typically turns the built-in flash on when the light gets too dim for safe handheld shutter speeds. On many cameras using this mode also sets the white balance automatically and doesn't allow overriding any exposure settings.

backlighting Light that strikes a subject from behind. A subject is backlit when it is directly between you and the light source.

ballhead One of two main types of tripod heads (the other kind is pan/tilt). The head consists of a metal ball in a locking collar and allows you to position the camera in any direction. The head mounts at the top of the tripod base or legs and the camera (or quick mount) mounts to the ballhead via a threaded connector.

bounce flash The technique of bouncing the light from an electronic flash off of another surface, typically a ceiling or wall. This requires a flash with an adjustable head or off-camera capability.

bracketed exposure A series of exposures of the same subject from the exact same position, typically one stop overexposed and underexposed from the exposure setting recommended by the meter. The purpose of a bracketed exposure is to capture slight variations of the suggested exposure; useful in difficult situations.

cable release A cable, either mechanical or electronic, that allows you to release the shutter of the camera without physically touching the camera — it is very useful for long exposures where pressing the shutter release button might jiggle the camera.

camera obscura A dark box, ranging from shoebox to room size with an opening at one end that allowed a light image to form on the opposite end of the box. A predecessor of the modern camera and used for centuries by artists as an aid in drawing. According to Wikipedia, Abu Ali Al-Hasan Ibn al-Haitham (965-1039 CE), is credited with the discovery of the camera obscura.

catch light A small, usually circular, reflection of light in a portrait subject's eyes.

CCD chip CCD is short for charge-coupled device. This is the type of chip used as a sensor in most consumer digital cameras.

center-weighted meter A light metering mode in which the center area of the viewfinder is given significant priority in measuring the light reflecting from a scene.

CMOS chip Short for Complementary metal oxide semiconductor. It is an alternate type of sensor chip used in digital cameras. CMOS chips typically produce lower signal noise.

color cast An overall color shift or tint usually caused by a mismatch between light source and white balance.

color temperature The measurement, in Kelvin, of the color of a particular light source. Daylight for example has a color temperature of between 5000 to 5500 Kelvin, depending on time of day and sky conditions.

continuous lighting Any source of light that provides a constant illumination (the sun and incandescent bulbs, for example).

contrast range The ratio of tones between the lightest and darkest tones in a scene. Also referred to as the *dynamic range*.

crop factor The factor used to calibrate the difference in field of view (and therefore effective focal length) between a 35mm frame and that of a digital sensor in a dSLR camera. Because a 35mm frame is bigger than the CCD sensor on a dSLR, lenses designed for 35mm will have a longer effective focal length when used with them. The lens focal length is multiplied by the crop factor to estimate the effective focal length of the lens with that sensor. A 100mm lens used on a camera that has a 1.5x crop factor, for example, will have an effective focal length of 150mm (100mm x 1.5=150mm).

depth of field The near-to-far distance in a scene that is in acceptably sharp focus. Factors include lens focal length, subject distance, and aperture. See also *aperture* and *focal length*.

depth of field scale A series of markings on a lens barrel, typically in both feet and meters, that indicates the depth of field for a given aperture setting and subject distance.

design Another word for composition. It is the arrangement of subject elements within a scene.

diffuser Any type of translucent material placed in front of a light to soften its intensity; or a device used to bounce flash to make the light softer.

digital noise See *noise*.

digital zoom A feature found on many digital cameras that simulates an extensive zoom range by digitally cropping the image. The results are vastly inferior to an optical zoom. See also *optical zoom*.

directional light Light that strikes a subject from a particular (and usually obvious) direction. Examples are backlighting, sidelighting, frontlighting. See also *backlighting* and *sidelighting*.

dSLR Digital single-lens-reflex camera. A camera design that uses a 45-degree mirror behind the lens to bounce the image into an optical viewfinder.

dynamic range See *contrast range*.

exposure The amount of light that reaches the sensor determined by a combination of aperture and shutter speed settings.

exposure bracketing See *bracketed exposure*.

external flash See *accessory flash*.

fill-in flash The technique of using flash outdoors (usually in bright sun) to open up shadows and reduce contrast. Most frequently used in portraiture to lighten facial shadows. Also called fill flash.

f-stop Another word for lens aperture (see *aperture*). Also, the number indicating the size of the lens opening.

flash sync speed The shutter speed(s) at which the camera syncs with the flash. In order for the camera to record the light of the flash, it must be synchronized so that the shutter is open when the flash fires. Cameras are designed to sync only at certain specified shutter speeds.

focal length In simplest optical terms, the distance from the front lens element to the point where the light rays come into sharp focus when the lens is focused at infinity. With camera lenses, typically measured in millimeters.

focal plane The plane at the back of the camera where the lens image comes into sharp focus; also, the plane position of the digital sensor.

golden hour Approximately the first hour to 90 minutes after sunrise and before sunset when the light from the sun is warmest and at a low angle. It is considered a favorite time to shoot outdoor scenes, particularly landscapes.

graduated neutral density filter A lens filter that holds back light in one portion of the filter, fading to an area of clear filter, and designed to hold back light from only a portion of a scene. Most common use: to hold back bright sky lighting while exposing for dark or shadowed foreground detail. These are extremely useful in landscape photography.

gray card A card that reflects 18% of the light striking it that, in photographic terms, represents the exact middle tone between pure black and pure white. All photographic meters are calibrated to provide a correct exposure based on 18% reflectance.

high key Any scene in which light tones and values predominate: a white rose against a white background, for example. See also *low key*.

histogram A feature found on most digital cameras that provides a graphic representation of the tonal range in a particular scene in the LCD screen. On most digital cameras the histogram is only viewable after the image is made.

hot shoe A device for connecting an accessory flash unit to your camera.

JPEG JPEG is the standard method for compressing image data and was developed by the Joint Photographic Experts Group. Compression makes image files small enough to store greater quantities of them on memory cards. JPEG image files are considered lossy in that they get rid of some of the image data when they are compressed.

Kelvin The color or temperature of light is measured in Kelvin (K), named after the nineteenth century physicist William Thomson, 1st Baron Kelvin (1824-1907). In the light spectrum, 5500K is white (daylight at noon is typically measured close to 5500K), and higher color temperatures are blue and are cooler in appearance; lower temperature colors, like yellow, orange, and red, are warmer in appearance (tungsten lamps, for example, are 3200K).

low key Any scene where the majority of tones are relatively dark. Usually this is when a darker subject is shot against a darker background — a black cat against a brown wall, for example. See also *high key*.

light meter A device, either built into a camera or handheld, for measuring the light that falls on a subject (incident meter) or that is reflected or emitted from the subject (reflected meter). These readings are used to determine the correct f-stop and shutter speed combination.

light quality Describes how hard or soft the existing light is. Bright midday sun is hard light, while an overcast day has soft light. Typically, soft light presents less contrast problems than harder light.

macro lens Lens used for extreme close-up pictures (or a macro setting in a zoom lens that has macro capability).

metering modes A series of options that describe the pattern the camera's light meter uses to measure the light. These modes include: center-weighted, matrix, and spot metering.

neutral density filter A lens filter used to cut down on the intensity of light entering the lens. The filter only cuts the quantity of light and has no effect on color.

noise A pattern of color specks or dots across and most frequently seen in areas of even illumination, such as shadows or sky areas. There are a number

of causes including interference from neighboring pixels and amplification of weaker signals. Also called *digital noise* and is caused by using high ISO speeds and photographing in low-light situations.

optical zoom The actual focal length range of a particular lens based on its optical design. See also *digital zoom*.

panning The technique of moving the camera parallel to a moving subject during a long exposure, the result of which is a relatively sharp subject against a blurred background.

polarizing filter A rotating lens filter that is capable of reducing reflections from nonmetallic surfaces (glass, water, etc.) by filtering out certain angles of light waves. Polarizing filters are also able to darken blue skies (by removing reflections from airborne moisture) and saturate colors. Auto-focus lenses require what is known as a *circular polarizing filter*.

RAW A digital camera recording format that captures uncompressed image files in their native form with a minimum of in-camera processing. Special RAW converter software is required to open these files. Different camera manufacturers use proprietary RAW schemes (and each has its own unique file-name suffix) for creating and saving these image files.

rear curtain sync An electronic flash mode in which the flash fires immediately before the camera's shutter closes (meaning at the end of the exposure).

red eye A phenomenon that occurs when light from a flash bounces off the rear retinal surface of the eye causing (in humans) red pupils. Animals have a similar reaction but the color of the reflection is often green or yellow.

red-eye reduction A flash mode in which the flash emits a series of pre-flashes that cause the subject's pupils to contract and thereby reduce or eliminate red eye.

reflective light meter A light meter that measures light reflecting from a scene (all in-camera light meters are reflective meters).

selective focus Intentionally limiting focus to a specific area of the subject for creative effect by restricting depth of field.

Shutter Priority exposure mode In this exposure mode you set the shutter speed and the camera selects the correct corresponding aperture setting.

shutter speed The length of time that the camera's shutter remains open to create an exposure; typically measured in full seconds, hundredths of a second and thousandths of a second.

sidelighting Light that illuminates a subject from the side.

slave A light-sensitive triggering device that is used to wirelessly fire off-camera accessory flash units.

soft light Gentle light that is created from a large, diffuse light source.

spot meter A light meter that measures only a tiny area of a scene — typically anywhere from a 1- to 5-degree angle of view.

tripod A three-legged camera support used to steady the camera during long exposures.

TTL An acronym for Through-The-Lens light metering, which means that the light is measured at the sensor plane of the camera.

white balance A method of neutralizing color shifts in the existing light source by matching the color response of the digital sensor to the color temperature of the light.

white card A pure white piece of cardboard used in establishing a custom white balance.

Zone system A system of setting accurate exposure and modulating tonal response (primarily in films) developed by Fred Archer and Ansel Adams in 1941.

continued

continued

continued

continued

continued

Develop your talent.

Go behind the lens with Wiley's Photo Workshop series, and learn the basics of how to shoot great photos from the start! Each full-color book provides clear instructions, ample photography examples, and end-of-chapter assignments that you can upload to pwassignments.com for input from others.

LIGHTING
PHOTO WORKSHOP
CHRIS BUCHER
978-0-470-11433-9

MACRO PHOTOGRAPHY
PHOTO WORKSHOP
HAJE JAN KAMPS
978-0-470-11876-4

COMPOSITION
PHOTO WORKSHOP
BLUE FIER
978-0-470-11436-0

PORTRAIT AND CANDID PHOTOGRAPHY
PHOTO WORKSHOP
ERIN MANNING
978-0-470-14785-6

EXPOSURE
PHOTO WORKSHOP
JEFF WIGNALL
978-0-470-11435-3

PHOTOS THAT INSPIRE
PHOTO WORKSHOP
LYNNE EODICE
978-0-470-11955-6

Available wherever books are sold.